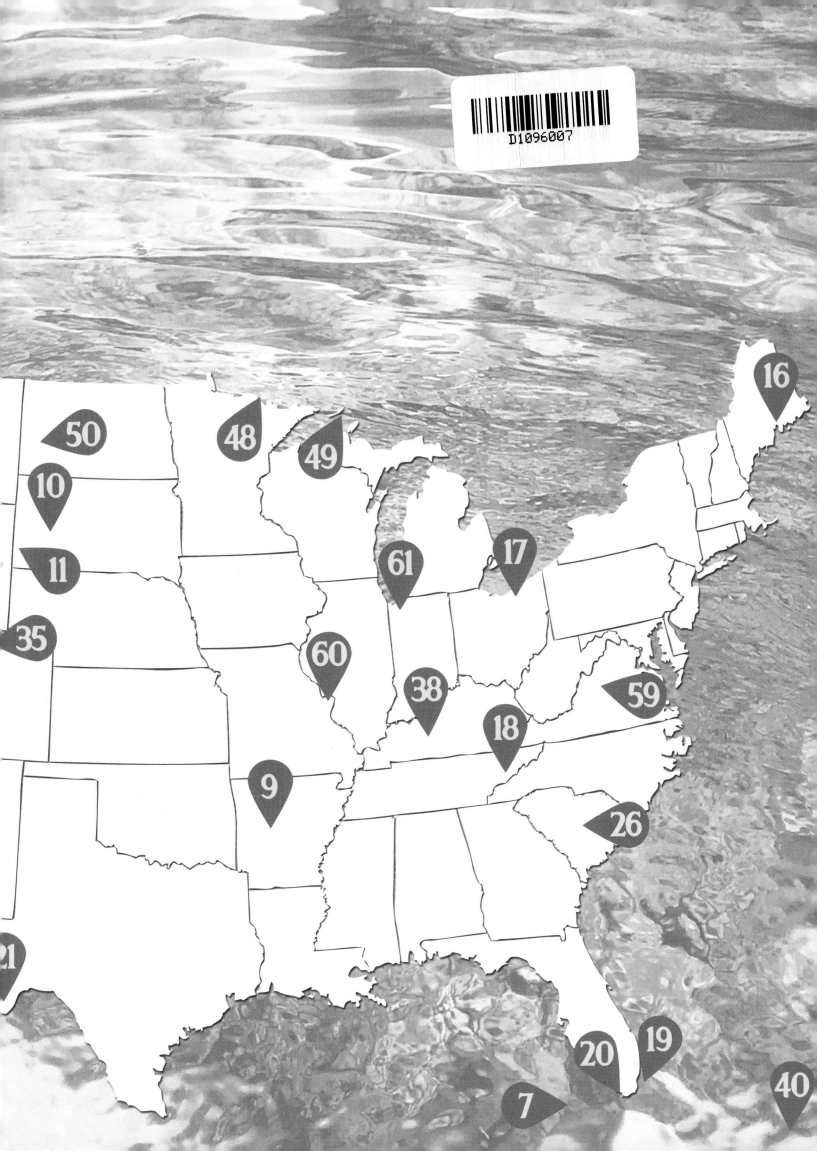

Texas Poets Laureate **karla k. morton** and **Alan Birkelbach** visited every US National Park. This map represents the order in which they visited the parks beginning June 20, 2016. This key gives the park name and the page number where the park appears in the book.

1. Yellowstone National Park, 1

2. Grand Teton National Park, 77

3. Great Sand Dunes National Park, 229

4. Mesa Verde National Park, 25

5. Joshua Tree National Park, 213

6. Channel Islands National Park, 157

7. Dry Tortugas National Park, 201

8. Guadalupe Mountains National Park, 125

9. Hot Springs National Park, 65

10. Badlands National Park, 153

11. Wind Cave National Park, 21

12. Black Canyon of the Gunnison National Park, 217

13. Glacier Bay National Park, 169

14. Denali National Park, 49

15. Wrangell-St. Elias National Park, 189

16. Acadia National Park, 61

17. Cuyahoga Valley National Park, 221

18. Great Smoky Mountains National Park, 89

19. Biscayne National Park, 161

20. Everglades National Park, 85

21. Big Bend National Park, 109

22. Saguaro National Park, 209

23. Petrified Forest National Park, 117

24. Great Basin National Park, 193

25. Zion National Park, 57

26. Congaree National Park, 225

27. Glacier National Park, 29

28. Yosemite National Park, 5

29. Haleakala National Park, 45

30. National Park of American Samoa, 197

31. Hawai'i Volcanoes National Park, 41

32. Redwood National Park, 133

33. Lassen Volcanic National Park, 37

34. Crater Lake National Park, 17

35. Rocky Mountain National Park, 33

36. Canyonlands National Park, 121

37. Arches National Park, 145

38. Mammoth Cave National Park, 105

39. Carlsbad Caverns National Park, 81

40. Virgin Islands National Park, 113

41. Pinnacles National Park, 233

42. Sequoia National Park, 9

43. Kings Canyon National Park, 97

44. Death Valley National Park, 205

45. Capitol Reef National Park, 137

46. Bryce Canyon National Park, 73

47. Grand Canyon National Park, 53

48. Voyageurs National Park, 141

49. Isle Royale National Park, 101

50. Theodore Roosevelt National Park, 149

51. Katmai National Park, 165

52. Lake Clark National Park, 185

53. Kobuk Valley National Park, 181

54. Gates of the Arctic National Park, 173

55. Kenai Fjords National Park, 177

56. Olympic National Park, 93

57. North Cascades National Park, 129

58. Mount Rainier National Park, 13

59. Shenandoah National Park, 69

60. Gateway Arch National Park, 237

61. Indiana Dunes National Park, 241

62. White Sands National Park, 245

THE NATIONAL PARKS

Photo by Kelly Kirkendoll.

Books by karla k. morton

Wooden Lions
Accidental Origami
Constant State of Leaping
Hometown, Texas: Young Poets and Artists Celebrate Their Roots
Passion, Art, Community: Denton, Texas, in Word and Image
Names We've Never Known
karla k. morton: New and Selected Poems
 (TCU Press Texas Poet Laureate Series)
No End of Vision
Stirring Goldfish
Becoming Superman
Redefining Beauty
Wee Cowrin' Timorous Beastie

Books by Alan Birkelbach

Alan Birkelbach: New and Selected Poems
 (TCU Press Texas Poet Laureate Series)
Waking the Bones
Rogue Waves
Bone Song
No Boundaries
Weighed in the Balances
Smurglets Are Everywhere
Meridienne Verte
No End of Vision
Threads
Translating the Prairie

THE NATIONAL PARKS

A Century of Grace

karla k. morton Alan Birkelbach

TCU
Press

Fort Worth, Texas

Library of Congress Cataloging-in-Publication Data

Names: Morton, Karla K., author. | Birkelbach, Alan, author. | Murphey,
 Michael, 1945- writer of foreword.
Title: The national parks : a century of grace / karla k. morton, Alan
 Birkelbach.
Description: Fort Worth, Texas : TCU Press, [2020] | Includes
 bibliographical references. | Summary: "Two Texas Poets Laureate visit
 each and every US National Park, in the order in which each was
 designated. The sixty-two parks are illustrated with scores of gorgeous
 color photographs and accompanied by essential information for readers
 wishing to visit each iconic site, along with a poem by each author
 highlighting the awe-inspiring experience presented by these stunning
 natural wonders"-- Provided by publisher.
Identifiers: LCCN 2020025714 | ISBN 9780875657639 (cloth)
Subjects: LCSH: National parks and reserves--United States. | National
 parks and reserves--United States--Poetry. | LCGFT: Nature poetry.
Classification: LCC E160 .M69 2020 | DDC 973--dc23
LC record available at https://lccn.loc.gov/2020025714

Cover photo: Ofu Island, National Park of American Samoa.
Endsheets map by Laura Kayata / SPARK Creative Services

Design by Fusion29, Inc.

TCU Box 293800
Fort Worth, Texas 76129
817.257.7822
www.prs.tcu.edu
To order books: 1.800.826.8911

This book is dedicated to all Rangers:
past, present, and future.

Thank you for what you do.

Ranger Charles Hanion.

CONTENTS

FOREWORD BY Michael Martin Murphey xii

Voyageurs Song xiii

1872: Yellowstone National Park WYOMING, IDAHO, MONTANA 1
The Howling
Lamar Valley

1890: Yosemite National Park CALIFORNIA 5
1890s
Mariposa Grove—The Fallen Monarch: Reach

1890: Sequoia National Park CALIFORNIA 9
I Dare You
Seeds

1899: Mount Rainier National Park WASHINGTON 13
Tahoma: Lesson Number 58
Grove of the Patriarchs

1902: Crater Lake National Park OREGON 17
Crater Lake Blue
Crater Lake: Immeasurable

1903: Wind Cave National Park SOUTH DAKOTA 21
Hourglass Theology
Wind Cave

1906: Mesa Verde National Park COLORADO 25
Mesa Verde/Hovenweep
Axis Mundi

1910: Glacier National Park MONTANA, CANADA 29
Wildfire
What We Abandon

1915: Rocky Mountain National Park COLORADO 33
The Answer
I ask you

1916: Lassen Volcanic National Park CALIFORNIA 37
Angle of Repose
Ishi

1916: Hawai'i Volcanoes National Park HAWAI'I 41
A Hand atop a Smoldering Tattoo
Hawai'i Volcanoes: Crush

1916: Haleakala National Park HAWAI'I **45**
Maui
Biking Down Haleakala

1917: Denali National Park ALASKA **49**
Alaskan Mnemonics
The Train to Denali

1919: Grand Canyon National Park ARIZONA **53**
The Grand Canyon: Completely Fogged In
Grand Canyon: Imaginings

1919: Zion National Park UTAH **57**
Mukuntuweap: Zion, the Place of the Gods
The Lilliputians Every Morning

1919: Acadia National Park MAINE **61**
October Sunrise, Cadillac Mountain
Acadia

1921: Hot Springs National Park ARKANSAS **65**
Let the People Go
Rejuvenation

1926: Shenandoah National Park VIRGINIA **69**
Blue Ridge: The Shenandoah
Shenandoah: The Expiration of Anguish

1928: Bryce Canyon National Park UTAH **73**
Mule-Backed on Wallapie among the Hoodoos
Thor's Hammer

1929: Grand Teton National Park WYOMING **77**
Song of the Tetons
Grand Teton

1930: Carlsbad Caverns National Park NEW MEXICO **81**
Mapping the Underworld
Rule of 3

1934: Everglades National Park FLORIDA **85**
Unexpected Beauty: The Everglades
The Shore from Flamingo

1934: Great Smoky Mountains National Park NORTH CAROLINA, TENNESSEE **89**
White Bear
Obscured Truth

1938: Olympic National Park WASHINGTON **93**
A Fallen Nurse Log: A Douglas Fir 87 Steps Long: Hoh Rainforest
Walking the Beach at Kalaloch

1940: Kings Canyon National Park CALIFORNIA **97**
The Sequoia
Travel Plans

1940: Isle Royale National Park MICHIGAN 101
In the Beginning: Isle Royale National Park
The Day after the Hike

1941: Mammoth Cave National Park KENTUCKY 105
Spelunking
November Diary at Echo Springs

1944: Big Bend National Park TEXAS 109
The Hunger to Know
The Rio Grande and the Langford Hot Springs

1956: Virgin Islands National Park US VIRGIN ISLANDS 113
Manzanilla de la Muerte: Little Apple of Death
Virgin Islands - Annaberg Ruins

1962: Petrified Forest National Park ARIZONA 117
Discovering Arrowheads in the Petrified Forest
Petrified Forest: Petroglyphs

1964: Canyonlands National Park UTAH 121
Fonts of Canyonlands
Walking Away from Words

1966: Guadalupe Mountains National Park TEXAS 125
Guadalupe Mountain
Guadalupe: Up in the Light, Down in the Dark

1968: North Cascades National Park WASHINGTON 129
The Wild Cascades: Still They Climb
Desolation Pottery

1968: Redwood National Park CALIFORNIA 133
Enchanted
Redwood: Cathedral

1971: Capitol Reef National Park UTAH 137
Small-Leafed Globemallow
Two Sets of Letters

1971: Voyageurs National Park MINNESOTA 141
Lake Namakan
Voyageurs

1971: Arches National Park UTAH 145
Arches
Song While Hiking to Delicate Arch

1978: Theodore Roosevelt National Park NORTH DAKOTA 149
Elkhorn Ranch, in the Floodplain, beneath the Cottonwood Trees
Feast

1978: Badlands National Park SOUTH DAKOTA 153
Horseback through the Badlands: the Borealis
The Bering Land Bridge and the Badlands

1980: Channel Islands National Park CALIFORNIA 157
Channel Islands
Channel Islands: Spirit of the Dead Watching

1980: Biscayne National Park FLORIDA 161
Vatic
Kayaking at Adams Key

1980: Katmai National Park ALASKA 165
Late August in Katmai,
Numbers on Naknek

1980: Glacier Bay National Park ALASKA 169
Quietus, Late August, Alaska: Salmon Carried Off by Eagle
Arctic Lesson

1980: Gates of the Arctic National Park ALASKA 173
The Hungers
Gates of the Arctic: Washed

1980: Kenai Fjords National Park ALASKA 177
Kenai Fjords
Kenai: Communication and Respect

1980: Kobuk Valley National Park ALASKA 181
Kobuk Valley
The Sand Dunes

1980: Lake Clark National Park ALASKA 185
Lake Clark
After Flying over Iliamna and Redoubt We Played Horseshoes

1980: Wrangell—St. Elias National Park ALASKA 189
Egression
To Walt Whitman

1986: Great Basin National Park NEVADA 193
The Cirque: Nevada Great Basin
Great Basin National Park

1988: National Park of American Samoa AMERICAN SAMOA 197
Aitu
Ofu

1992: Dry Tortugas National Park FLORIDA 201
Desideratum
Prayer for Epiphany

1994: Death Valley National Park CALIFORNIA, NEVADA 205
Rain Shadow and the Racetrack Phenomenon
Racetrack at Death Valley: The Sailing Stones

1994: Saguaro National Park ARIZONA **209**
Pilgrimage: Saguaro National Park
The Scorn of Fortuitous Things

1994: Joshua Tree National Park CALIFORNIA **213**
The Rocks Speak
A Minimum of Direction

1999: Black Canyon of the Gunnison National Park COLORADO **217**
Resting in a Holy Spot: Where White Waters Turn Still
Types of Falling

2000: Cuyahoga Valley National Park OHIO **221**
Hara-kiri: Cuyahoga, the Lesson Park
Cuyahoga National Park

2003: Congaree National Park SOUTH CAROLINA **225**
Cedar Creek, Deep in the Congaree
Congaree: Seeing It

2004: Great Sand Dunes National Park COLORADO **229**
Great Sand Dunes
The Perseid Meteor Shower and The Party Line

2013: Pinnacles National Park CALIFORNIA **233**
Remus Street, Pinnacles
Pinnacles: Hiking the Talus Caves

2018: Gateway Arch National Park MISSOURI **237**
"And the Thing Was Done"
Gateway Arch

2019: Indiana Dunes National Park INDIANA **241**
Terminal Snow
Mount Baldy

2019: White Sands National Park NEW MEXICO **245**
How to Carry the Moon
Letter From the Dunes

AFTERWORD BY Dave Schlom **248**

Acknowledgments **249**

About the Authors **250**

FOREWORD

Here is what karla k. morton and Alan Birkelbach know. We are the only creatures on the planet Earth who are wandering sojourners seeking meaning in Nature. No other creature on Earth is a tourist. We humans search endlessly for something in other species that will teach us what we should do and why we should do it. All the other creatures seem to live out their destiny precisely, but only humans are historians and futurists. Only humans are scientists who analyze the world, take it apart, and try to reconfigure it—then wonder at the inexorable glory of the wilderness left untouched.

Only humans create drama out of the emotional catharsis of living. We speak poetry as an attempt to express our singular longing. That is what karla k. morton and Alan Birkelbach do, and that is why this book exists.

The national parks of America are a collection of extraordinary places that present an exquisite array of wonders that make every visitor allowed inside the gates want to make an artistic statement. People flock to experience untouched "wilderness," and thereby the wild is no longer wild. The parks must be developed to accommodate the visitors who long to experience the feeling of the unvisited. Then the signs appear: "Warning do not feed the wildlife!"

The poets who wrote this work are acutely, sometimes playfully aware of a great irony . . . the irony of being a species that long to buy a ticket to see "Nature" being Nature. The poets are constantly asking, "Why am I here? Where do I belong in this absolutely overwhelming, humbling, impartial array of Thunderbeings and Microbes? How can Nature be somehow welcoming and forbidding at the same time?"

The poets of this work confront the ultimate confounding Word that permeates every blade of grass and branch, every wave of mighty and small body of water, every mountain and pebble, every mystifying ruin of the halls of the ancients. . . . "I AM THAT I AM!"

These poems offer the consideration that any person who gets to see sixty-two astounding natural wonders of nature in this lifetime is blessed beyond comprehension. As one reads these words and confronts these photographs, two words dominate the mind: *humility* and *gratitude*. What other society in the history of the world has had the vision to set aside the most remarkable, stunning works of nature within its borders so that artists, scientists, and everyday people can have access to them? Many nations have now been inspired to follow what is, as Wallace Stegner has pointed out, America's best idea.

At the time of the writing of this foreword, every national park is closed because of a pandemic. That the poets who created this work got through the gates of all sixty-two parks just in time to complete this unique poetic tribute makes this book a miracle. These poets felt called. These poets trembled to walk in the footsteps of John Muir and Aldo Leopold and many others. These poets took considerable risks to go on this adventure, but most notably a creative risk of walking in the footsteps of giants of conservation. They do so with respect for those who have walked these trails before them—and that is a kind of voice in itself. Yet their contribution is something other than a plea for preservation and conservation. These poets dare to take the greatest challenge of all: they speak of forces and dynamics that leave most people speechless. You can feel the humility they felt in every line of poetry. This book is the story of two pilgrims who cry out to the Universe with outstretched arms, knowing they can never truly grasp all that is seen and unseen in America's national parks.

— MICHAEL MARTIN MURPHEY

Texas-born singer-songwriter, rancher, and conservationist Michael Martin Murphey is a founder of the music scene that exploded in Austin, Texas, in the 1970s. He is internationally known for his classic song "Wildfire" and lyrics and melodies that are evocative of American Southwest life. He has been inducted into the Western Music Association Hall of Fame and won the Western Heritage Lifetime Achievement Award from the National Cowboy & Western Heritage Museum as well as conservation awards from the US Department of the Interior. He is founder of Murphey Western Institute and Wildfire Productions.

Voyageurs Song

lyrics by karla k. morton and Alan Birkelbach
Music and vocals by Michael Martin Murphey

Song on the water.
Hands on the oar.
You'll hear us before
you see us from shore.

Three thousand miles
measured in smokes.
Our packs are loaded,
Days counted in strokes.

We out drink you,
out think you,
we carry more weight.
We can steer any rapid
and not lose our gait.
Red sashes and buckskin—
We're Voyageur men!
Pass us the keg
and we'll tell you again.

On the shore of Isle Royale
we bid all adieu,
then loaded the furs
in the birch-bark canoe.

No journey too tough.
No river too rough.
Two hundred pounds on our backs–
Not Enough!

We out drink you,
out think you,
we carry more weight.
We can steer any rapid
and not lose our gait.
Red sashes and buckskin–
We're Voyageur men!
Pass us the keg
and we'll tell you again.

Three hundred beaver
we hold in one arm

While we dance every jig
and sing every yarn.

Our oar strokes are deeper,
our voices more sweet,
just ask all the Chippewa girls that we meet.

We out drink you,
out think you,
we carry more weight.
We can steer any rapid
and not lose our gait.
Red sashes and buckskin–
We're Voyageur men!
Pass us the keg and we'll tell you again.

Yellowstone National Park

WYOMING, IDAHO, AND MONTANA

Established in 1872, Yellowstone was the first national park named, and it set the standard for every national park to come. It covers over 2 million acres, 96 percent of it in Wyoming. The park is a geothermal wonderland. Sitting on a still active caldera, the landscape includes mountain peaks, dizzying canyons, seemingly unending forests, and geysers of myriad height and ferocity. How can such grand beauty exist? Indeed, the same thing was thought over a hundred years ago when the first non-native visitor stumbled upon it. The world laughed and thought his story of boiling pits of earth just an active imagination. It wasn't until fifty years later that it was verified.

We chose Yellowstone to begin our national parks journey because it was the first. We arrived on June 20—the Summer Solstice and the Strawberry Full Moon—quite the grand beginning for such an adventure!

- kk

The Howling
June 20, 2016

It is musk of buffalo.
It is Lewis and Clark and Colter
being led through the wilderness
by a teenage girl.

It is creation–
standing on the edge of steam and fusion
and boiling muds of earth
beneath a night sky black as Sacajawea's braids,

where we can still glimpse
the end of the universe between the stars—
those beautiful bulbous, noxious gases
from whence everything came.

Like the Shoshone,
we flee deep within her sacred borders
to save ourselves;
to be healed from the world.

And as the solstice full moon
peeked over Lake Yellowstone,
and rose like a strawberry god,

white wolf crooned, coyote howled,
and buffalo huffed
as his shadow roiled across
his steaming hoof-prints.

Perhaps self-awareness
made its great leap into his bison brain,
and he fell to his knees
as did I—defenseless to this great awe,

needing the unleash of guttural gratitude–
to cast forth praise,
to loose animal exclamations
onto that ancient Benevolence out there,
somewhere,
in that shooting-star sky.

- kk

Lamar Valley

Will you look on it? No eye is wide enough.
Here. I will stand beside you, back to back,
and we will rub shoulders like opposing lovers.
If I look here and so and you look there and point
even then we will only barely grasp
the breadth of it.

We could recruit a score of willing viewers and still
our hearts would barely range the metaphor.

I tell you: when I drove up I climbed out
and I stood there, higher, and watched them,
dark as reversed stars on a green sky.
Will you look on it with me? Do you not realize what
we are seeing:

Buffalo, shaggy gods, as unconcerned in their
Olympian grazing as if we were just the wind, a magpie,
a dragon-fly. It isn't that they have no use for us.
Do the stars at night care that we stare up at them?

Is this place only a river, a green grassy plain,
a landscape complete?

So many places we feel the right
to claim and bless—but this is not one.
I do not remember the drive there
or the river source. Did it dream out from between
some hidden mountains—could we walk there?
Dare we?

And now, weeks later, I understood:
There was no measure of it.
How dared we let our eyes try to grasp the hazy
far extent?
There was a mist there.
I could see it. Who tries to know what lies beyond
that pall?

Shall we go back? Will you look on it with me?
Shall we be beatified by the very hymn of it,
made holy even so with our meager eyes,
our frail and temporal flesh?

- *AB*

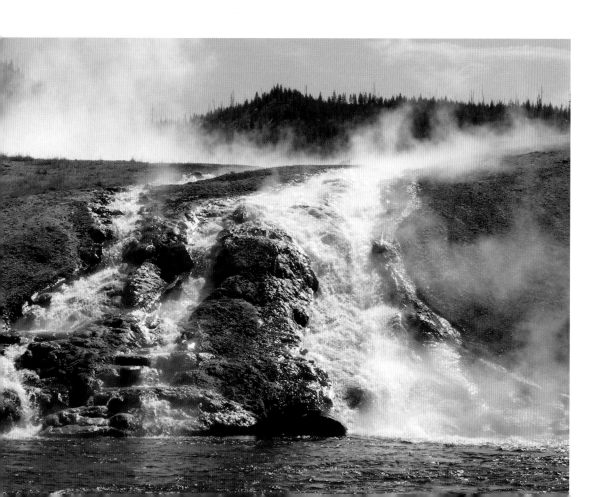

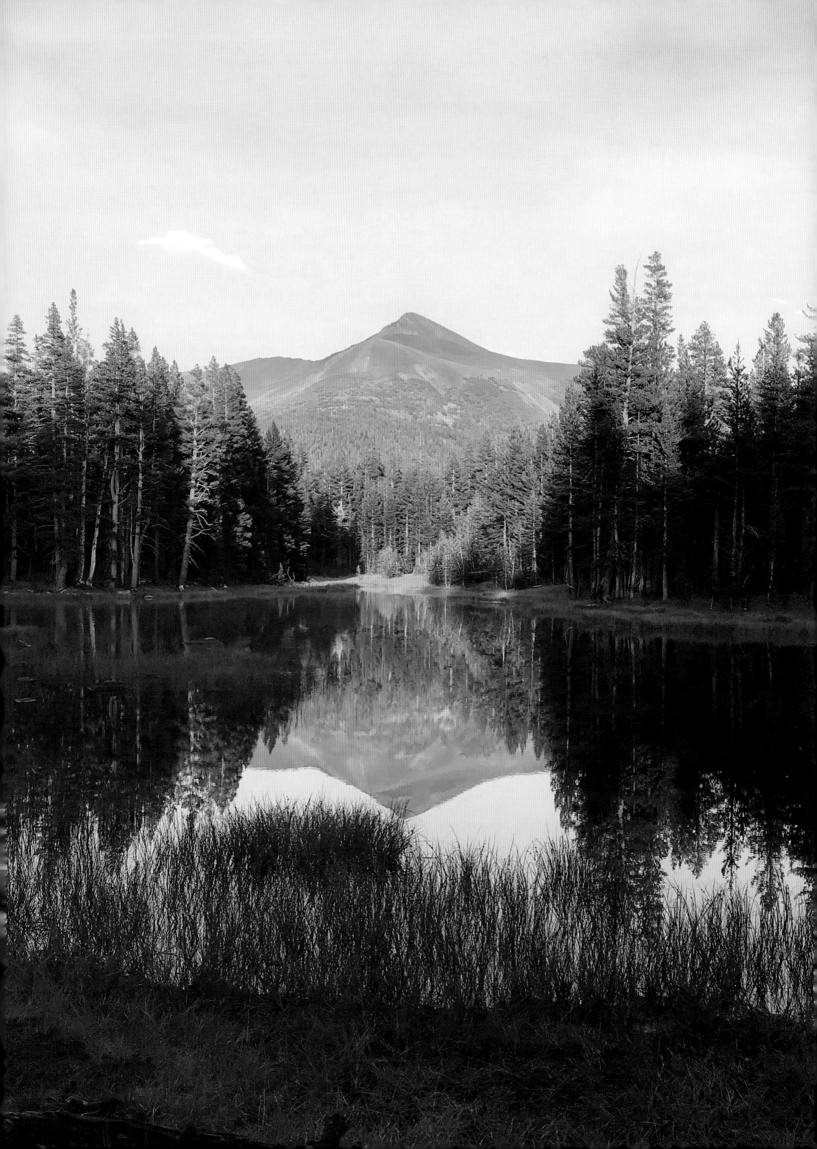

Yosemite National Park

CALIFORNIA

Yosemite is massive. There are almost countless numbers of waterfalls, trails, and giant trees. Glaciers still cling to some of the mountains. And bears still roam the woods.

A full description of Yosemite could fill a volume. There are terms and place names within the park that have become part of national park lore: the hike up Half Dome, Hetch Hetchy, Tuolumne Meadows, Mariposa Grove, and the various lodges within the park. The walk up Half-Dome is one of the most strenuous and rewarding hikes in the entire national park system. This hike is reserved for only the hardiest adventurers. Much of the journey you pull yourself along on a chain run through metal posts set into the stone. There is a lottery to get tickets to climb, with no guarantee you will get a ticket. But if you do get one, get ready for the hike of your lifetime.

Make sure you take the time to visit Hetch Hetchy. This is a section on the Northwest part of the park that is both beautiful and a heartache. In 1882 the city of San Francisco was looking for a water supply to meet growing demand. In the city's eyes the Hetch Hetchy valley was an ideal location to build a dam. The problem was that the area was already part of Yosemite National Park. All parties agreed that this valley was remarkably similar to the Merced Valley area in Yosemite. The city's argument was, basically, why do we need two Yosemites? Conservationists argued that much of Yosemite was already too developed. But then San Francisco suffered a devastating earthquake, and public sentiment said that the additional water from Hetch Hetchy might have helped with fires. You can walk across the dam now and see, above the water line, some of the scenery that hints at what is now submerged.

Allocate several hours to walk through the Mariposa Grove of giant sequoias. It is now devoted exclusively to foot traffic—and the immediacy is hypnotic. Spend some time in Tuolumne Meadow, which is great for hiking and camping. During the summer the park can get crowded with hikers and campers. Plan your day. Actually, plan several days—Yosemite is massive. Take your time.

- AB

1890s

It must have been an end of an era,
motorcars in the park
replacing the carriage,
the wide back of pack mule,
tents folding for hotels.

I would like to have been that woman of 1890,
slipping into trousers for the first time,
finally swinging one leg across the horse–
a foot in each stirrup
like God intended.

And what women they were–
shooting grizzlies while frying trout;
bathing in the frigid Yosemite rivers.

Sometimes I wish
time could go backwards,
that we could all feel the might of equine between our
legs;
put our faith in four shoed hooves;
cell phones and television two hundred years away.

Our thoughts only of wood and warmth
and a safe spot to bed down;

maybe a Canyon like this one
to lie in;
to look up;
the incomprehensible stars cast across the night sky;
the pink muscle of dawn
all a girl needed
to conquer the world.

- kk

Mariposa Grove—
The Fallen Monarch: Reach

Sit right here and let me tell you how small I am.
Sit up close and let me tell you how small I am.
I'll whisper it to you.

I'm complaining and I shouldn't but my clothes don't fit.
I saw something and I'm complaining and my clothes
don't fit.
And my hat keeps blowing off my head.

I had driven for days and was feeling mighty large.
I had money in my pocket and was feeling large.
Until I took that path through the sequoias.

I stopped and stared and looked at the roots of the
Fallen Monarch.
I stared at the massive roots of the Fallen Monarch.
I reached my arms out and could not reach across.

When I finally fall, and it will be soon,
yes, when I fall and it's coming soon,
I will not be so large.

My family will not have to reach to mourn me.
Women will not have to reach to mourn me.
There will not be stories of the shade I once cast.

This is my complaint and my woe.
Seeing the Fallen Monarch filled me with woe.
I am whispering to you my ache.

Go there. Do not go there. You will never be that tall.
In all your years you will never be that tall.
Your hat will never fit again. You will know yourself
as small.

- AB

Mono Lake.

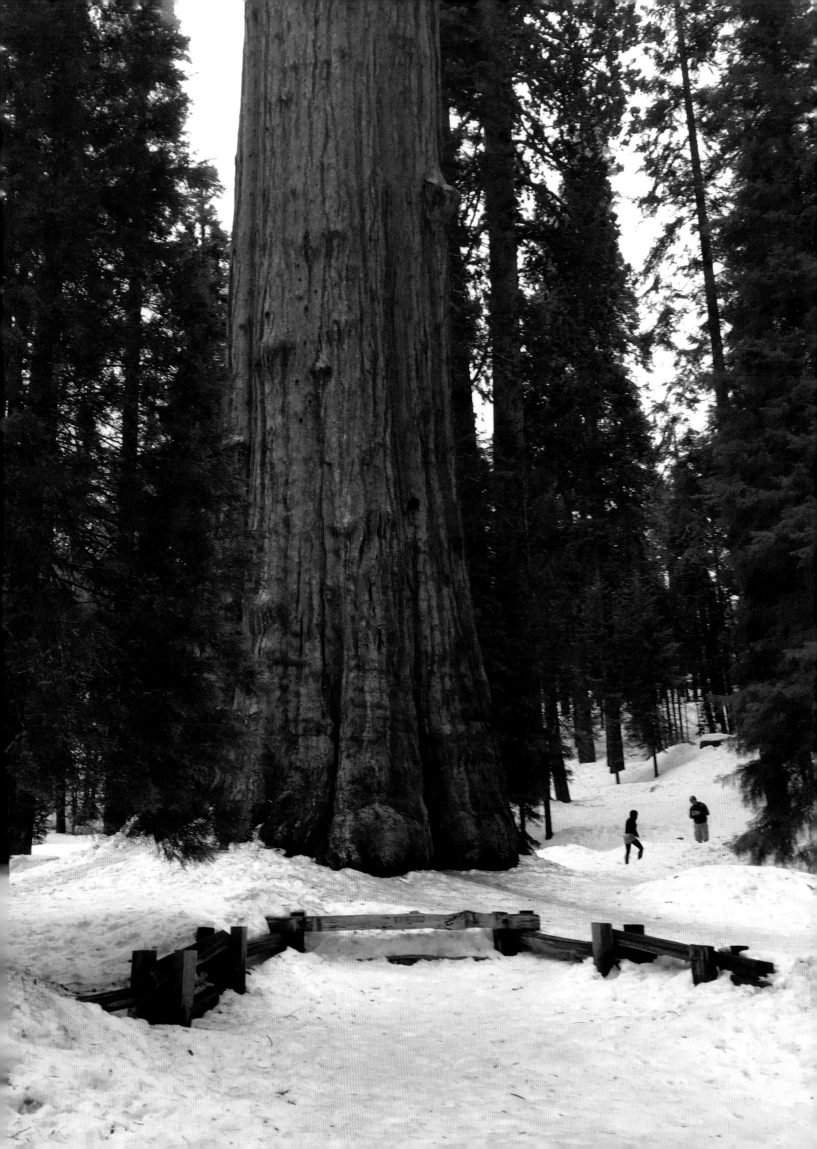

Sequoia National Park

CALIFORNIA

Sequoia National Park in California backs up to Kings Canyon National Park.

General Sherman, the largest tree in the world by volume, is in Sequoia National Park. It stands at 275 feet tall, and it dominates the grove of sequoia trees.

The first impression of this park will be the giant trees. The sequoias. The lodgepole pines. If you go in the winter, the sheer majesty of the landscape will be amplified by walls of white created by the snowplows. If you are lucky, you will see animal tracks along the surface of the snow. It will not be unusual to find the visitor center, camp store, or campgrounds closed because of excessive snowfall. In the summer, the lodges and campgrounds will be full. Plan ahead.

This is a year-round park—but incredibly beautiful in the winter. The snow can stack easily over fifteen feet high. Cross-country skiing and hiking are especially fun. Keep snow chains in your vehicle along with basic emergency tools. Be prepared to drive slowly along winding mountain roads. And be aware the road may close in winter.

The lodgepole pine trees hang onto the snow more than the sequoias. As you hike you will hear the gentle whuff of snow falling from branch to branch. Landmarks can disappear beneath deep snow. If possible, take a guided hike and let the Rangers show you the way. For the more energetic, try hiking the John Muir trail. It runs along the eastern edge of both Sequoia and Kings Canyon.

Ultimately, though, people come to this park for the trees. Take as many of the trails through the groves as you can. You will never tire of looking up at the far-off tops of green.

- AB

I Dare You

to turn off the television.
Better yet, give it away.

I dare you

to put your technology in a drawer
and pick up a book,
and sit on the stoop,

and let the words dance in the sunlight
before they slide in your soul.

I dare you

to find a rock,
or single stem, or pinecone,
and hold it in your palm
until it sings.

It's then the need
will well up inside you
to lace your boots
and find a walking stick that fits your hand

like an answer;
like desire.

And you will walk into the woods
and you will make sweet love
with the world.

- kk

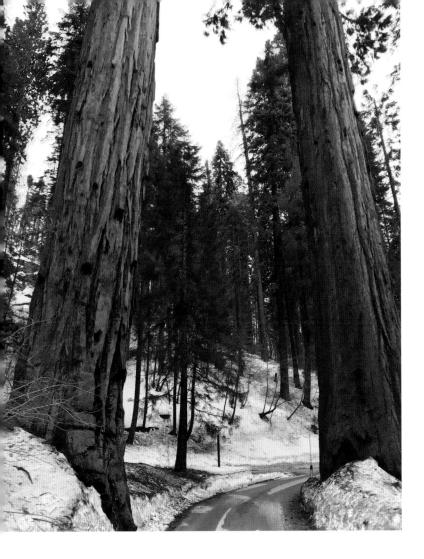

Seeds

*It's good to have the names of things. In case
the brain says at night, "you only have a few
days left."*

In spring
ignore your aching knees and squat down.
Pull your son in to your lips and whisper the
names of flowers:
whitethorn, parsnip, morning glory, pussypaws.
Over here is an open pine cone. Shake it for seeds.
What type of tree is it? Tomorrow you can find
out together.
It is a promise.

You wake up one morning
remembering what the brain said.
You bundle you and your son up
and step, shush shush, climbing onto the snow.

Down the sidewalk,
across the parking lot of Chambers Grocery,
across Meadows Park, and
then there is a hill, and a street
and a pathway, a walkway through a tunnel of snow
so deep you think it might swallow you.

Your son takes your hand.

And you remember the pine cones:
lodgepole pines, standing at the end of the snow,
at the end of fog. You can see that far and no farther.
As you keep walking, as the sun does its work,
they release great handfuls of snow,
branch to branch, falling, pieces of the morning's sky,
The two of you count them, disappearing, into the
deep white,
into the edge of vision,
like wisdom you did not have yesterday.

And over there, faint between the trees,
only suggestions on the surface of snow,
some tracks: a gray fox,
the spread paws of a mountain lion,
the cleft of a deer. How they were running,
their size, measuring their leap.

You wish you remembered more.
Your son puts his hand on your shoulder.
Snow lands on his eyelashes.
"It's okay, Dad.
Tomorrow we'll see birds
And we'll learn the names of feathers.
It'll be fun.
I promise."

- AB

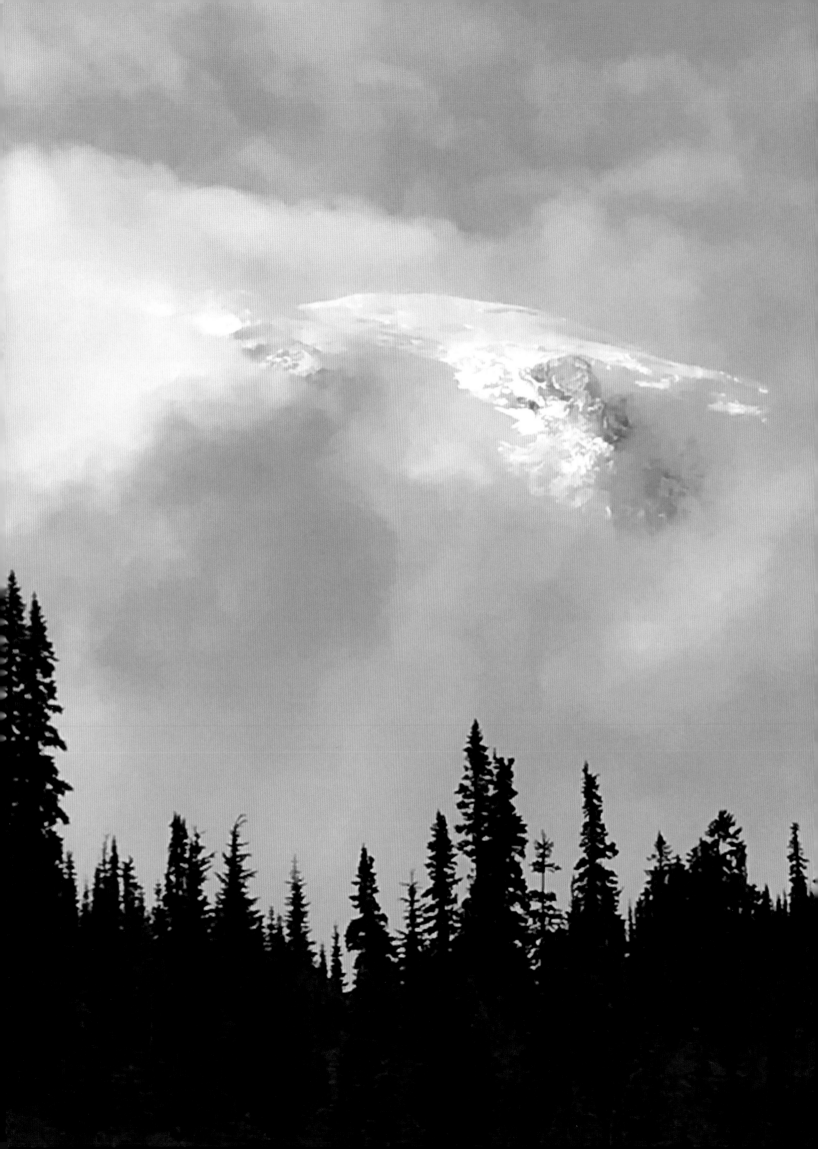

Mount Rainier National Park

WASHINGTON

Towering 14,410 feet above sea level, Mount Rainier, or *Tahoma*, as it is historically and affectionately called, is a beast. To catch a glimpse of her truly takes your breath away. She is the most seismically active volcano in the Cascade Mountain Range after Mount St. Helens, and is known for landslides and mudflows. She will, *most definitely*, erupt again.

None of this is news to the thousands who live in the surrounding area, or to the many Native Americans who called, and still call, this area home, such as the Nisqually, Puyallup, Muckleshoot, Yakama, and Cowlitz.

Established March 2, 1899, Mount Rainier National Park was the fifth national park named and the first national park to allow cars inside in 1907. Then the craziness of attendance began.

At only three hours from Seattle, it is still today a growing puzzle of how to balance the need and desire of so many people to visit an area, yet maintain that area's state of delicate wilderness. How do we save it from even the good intentions of ourselves?

Mount Rainier National Park encompasses over 230,000 acres with twenty-five major glaciers. In the Grove of the Patriarchs you will find Douglas Firs and Western Cedar trees five hundred to a thousand years old. Scientists say a major fire burned through the valley a thousand years ago, and these massive trees seen now were birthed from that time.

Imagine surviving this world—a thousand years of flood and storm and glacier and fire and eruption and, ultimately, man. This is no easy feat. And yet, these glaciers and grand trees have miraculously done just that.

- kk

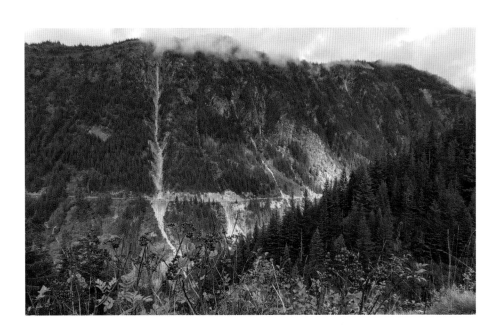

Tahoma:
Lesson Number 58

We've learned not to point at a mountain—
what the Yupik and Navajo
have *always* taught their young.

Fingers cast long shadows.

All morning we waited
in the meditation of rain and heavy fog
and in an instant, granted
the spectacular flash of her face!

What do you do then,
but grab hold of one another,
and let magic have its way with you?

There are some moments
too sacred for even
the phalange of a camera.

Let this be the way:
Purse your lips.
Air-kiss her direction.
Let praise rise up from your stillness
like a meadow of startled doves.

- kk

Grove of the Patriarchs

Those trees are giants that do not tremble
every time Rainier shrugs.

The marten and the red fox will pause,
waiting for more tremblors;

the birds will seek less troubled air;
even the mountain lion will be skittish;

the big-eyed tourists on the boardwalks
will run for the parking lot.

But the Patriarchs may take
a hundred years to shrug indifference.

These limbs have seen glaciers and lahars.
Their rings have already grooved

thousands of quivers and convulsions,
implacable stories hidden in their scarlet flesh.

- AB

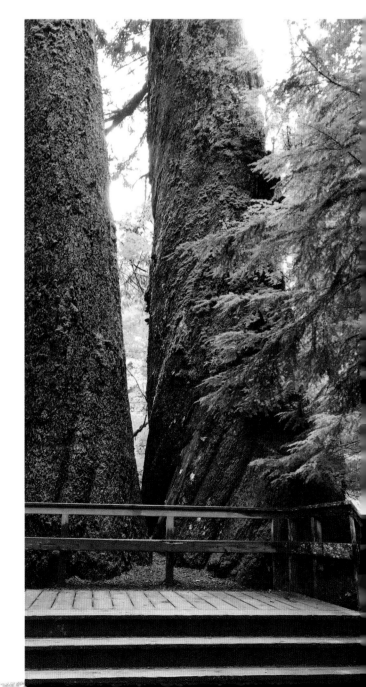

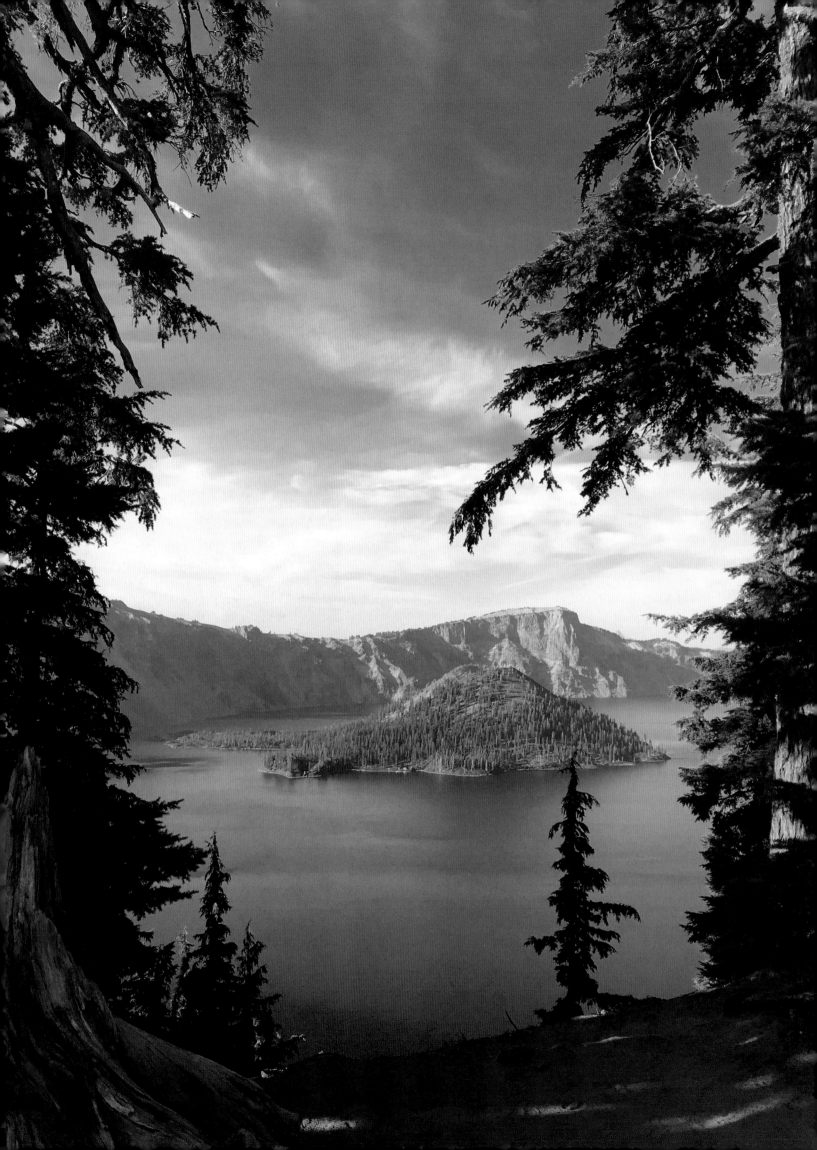

1902

Crater Lake National Park

OREGON

Over seven thousand years ago Mount Mazama erupted and then collapsed. Slowly the hole it left began to fill with rain and snow melt. There was no natural exit. Eventually a balance was achieved between evaporation and input.

Crater Lake is the deepest lake in the United States, over 1,900 feet deep. There are twenty-one square miles of water and the far rim, straight across, is five miles away. Of all the wonders in all the national parks there are a few exquisite moments that will literally take your breath away. Seeing the blue of Crater Lake for the first time is one of those moments. There is nothing exactly like this blue. No calving glaciers, no southwestern sky, no mountain flowers, no crayon in a full box—nothing equates to this blue. It is a blue out of a dream, how you always wanted blue to look. It will haunt you.

Sitting in the corner of the lake is Wizard Island, a dormant cinder cone volcano. Boat rides to the island are available during hospitable months. To board the boat you must hike down the only trail that ends at the lake's surface. If you have not chosen the boat tour, you are still allowed to fish from the shore. Fishing is actually encouraged; you just can't use live bait. Rim Drive, with several turnouts, circles the lake, and scattered around the park are a hundred-plus miles of trails. Pick up a map at the visitors center that indicates the various points of interests. Even better, buy an inexpensive trolley ticket. A Ranger will be on board providing history and insight.

The best time to visit Crater Lake is in the late spring, summer, or early fall. The wind can change quickly; dress in layers. Be aware that snow can make some roads unnavigable. The main sign for the park is on a removable metal stand. Snow poles stand at least fifteen feet tall. If you can get in then, you will be gifted the beauty of snow on the surface of the lake and the surrounding rocky rim. (The surface has not totally frozen in years.) Absolutely you should eat at the Crater Lake Lodge. After dinner go back into the lobby of the hotel and sit in front of the massive fireplace. Dream deep blue dreams.

- AB

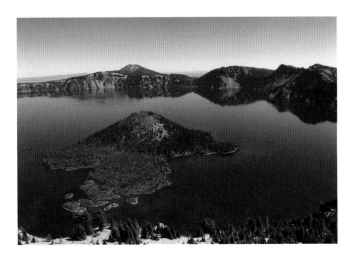

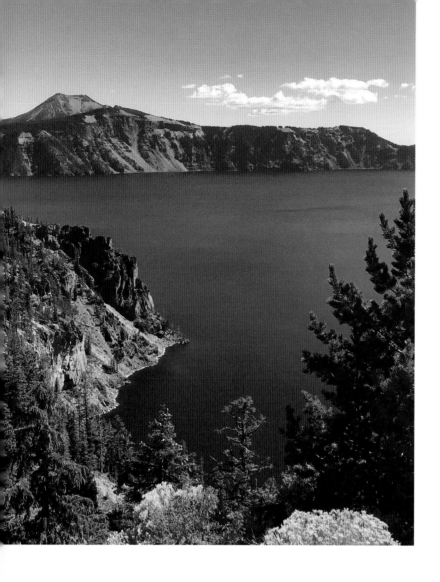

Crater Lake Blue

It is not Royal;
not Sky, not Cerulean,
though the edges bleed slightly
Caribbean.

It is neither Sapphire
nor Navy;
not Topaz or Lapis;
not opal-edged Glacial.

It is *Blue*,
a deep speechless Blue
that draws you in
and stutters the feet of your mule;

that leaves you stunned,
unaware,
dizzy from holding your breath,

your mind racing its corridors
trying to name a shade–
nonexistent
until you laid your eyes upon it;

a Born-Again Blue you
never shed;
that glimpse of God you felt–
yes, yes you did;

the silent gift of salvation;
that gentle blue-hued hand
of love.

- kk

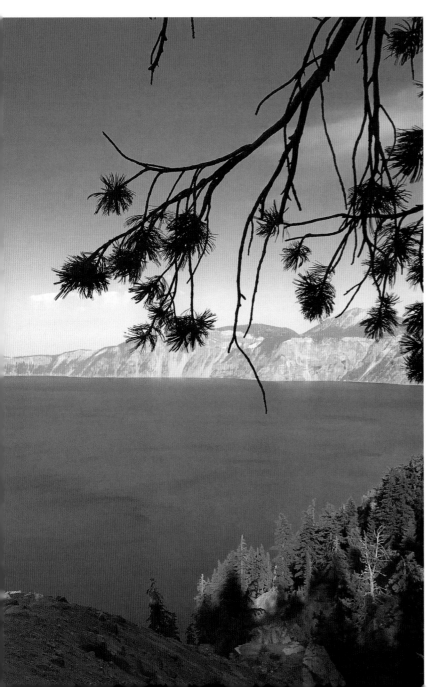

Crater Lake: Immeasurable

The question will eventually come up:

Which park, if any, would you have died for?

How to answer that question and not fall into the
depths of synesthesia?

When we are confronted with that unspeakable
thought,

while we stand there in the front of the auditorium,

our pencils feigning helpless innocence on
the podium,

our hands wanting to slap against our face and
hide us,

we will feel stripped and ashamed,

knowing, without ever having had to put it into
words,

that we had seen the depth and color of God's eyes.

- AB

Wind Cave National Park

SOUTH DAKOTA

Wind Cave National Park, located in the Black Hills, is sacred ground. Many Native American peoples have lived here at different times, including the Lakota, Dakota, and Nakota, but all believe that the Natural Entrance hole to the cave to be their point of creation—where people emerged from the earth.

They believe this cave leads to the Tunkan Tipi (Lodge of the Ancients), where all people of the earth lived, waiting until earth was ready for them. Once, a small group was tricked into emerging too soon, and were turned into bison. When the rest of the people were allowed up top, they were told to follow the bison herd. Indeed, they are Pte Oyate (the Buffalo Nation).

In recent history, brothers Tom and Jesse Bingham stumbled upon Wind Cave in 1881 while riding horses near the Natural Entrance. Jesse's hat blew off his head. He stopped to investigate and found the tiny eight-by-ten-inch hole in the earth blowing out strong, sweet-smelling wind. Later, he returned with friends to show them the phenomenon, placing his hat on the hole, but when he let go, that wind sucked his hat back into the earth. Historians say the hat was never found.

Other adventurers soon came, such as Charlie Crary and young Alvin McDonald, who discovered tunnel upon tunnel of mesmerizing cave formations, at least 143 miles of passageways beneath only 1.2 square miles of surface. A larger entrance was opened near the Natural Entrance, and that is where visitors to Wind Cave enter by Ranger-led tours.

Wind Cave is a mesmerizing gem of a national park, undeniably holy ground.

Enter with reverence. Exit with gratitude.

- kk

Hourglass Theology

This is for the Lakota,
for Black Hills shaped like buffalo,

for all things holy
that have been pierced and carved and crucified.
Father, forgive them. They know not what they do.

What is on the earth is in the stars.

Rivers like shed blood;
seven lost girls in the night sky
smiling in the mirror of seven earthly peaks.

What is in the stars, is on the earth.

This is for a people worn and spent from years of battle,
fighting for the right to follow the Buffalo—
their Great Sun—
as he moves across the land.

I sit at the Natural Entrance of Wind Cave—
a small hole breathing,

knowing somewhere above, in the cup of Big Dipper,
there mirrors a dark hole, just like this one,
where souls pass through.

And when we open our mouths,
we become the tip of tepee, the vortex;
the delicate rounds of our necks,
the thin conduit
joining two worlds in prayer.

Hallelujah, we whisper.
And the earth breathes out,
and the stars,
ever so slowly,
breathe in.

- kk

Wind Cave

Every one of our days is like this:
One day we are walking along
and our hat blows off,
and the next day, full of wonder,
we go back to that same spot
and our hat gets pulled into the earth.

There's no malice about it.
The earth breathes
and it spins and it's kind of indifferent.
But we make it about ourselves
because we are told there are few things
more stupendous than us.

It isn't quite true.
There are the stars of course.
And that bison over there.
And some granular liquid tower
that has taken a thousand years to grow.

There is a wonder even in the gutter,
a creation myth down in the guts of the earth.
Some cycle that pulls us down
then lifts us up,

makes us throw
our recovered hat
in a wild jubilation.

- AB

Mesa Verde National Park

COLORADO

Mesa Verde National Park was the first of its kind, established to "preserve the works of man." These famous man-made dwellings are only a part of it—but a vital part of it. Around 1190, people began constructing the fascinating cliff dwellings we see today in the rock alcoves of the cliffs. But by the end of the thirteenth century, everyone who lived in the Mesa Verde (translated as *Green Table*) were mysteriously gone—a great disappearance.

Perhaps it was a combination of depleted resources: trees and big game used up by more than five thousand people who lived in the area, plus a twenty-five-year drought that even killed the Three Sisters (their main sustenance: Beans, Corn, and Squash).

There are over five thousand archaeological sites dating back a thousand years. It is a glimpse into past lives. You will leave in awe of the precise construction skills witnessed in the ruins of Mesa Verde and its neighboring Hovenweep—just outside the park boundaries. The people who lived here were a strong people, climbing the cliffs with dug-out toeholds; powerful gatherings of families who only expected to live to be twenty-five years old.

Chances are you will leave with many more questions than when you arrived, which is exactly what history and knowledge moves us to do—study and research. The world has much to learn from these "primitive" people.

- kk

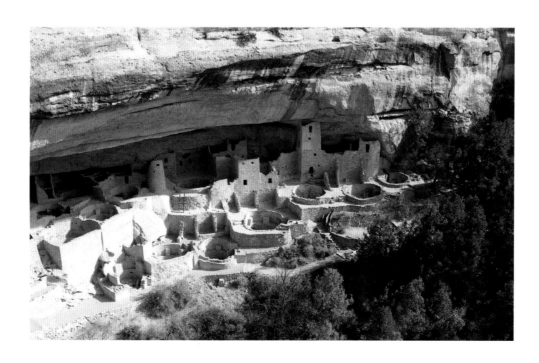

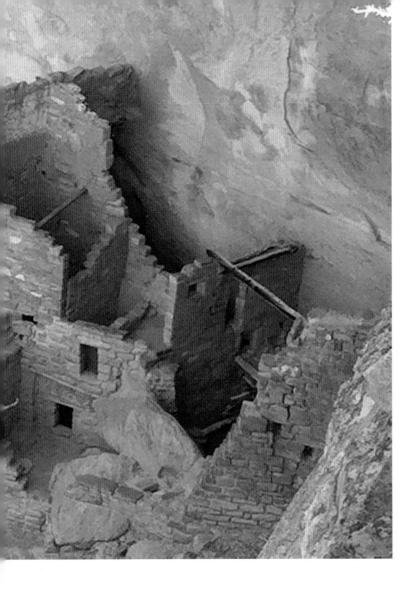

Mesa Verde/Hovenweep

As far as the eye can see was their land,
Ancient Puebloans.

Standing on that Mesa Verde,
we learned it was not green then,
big game hunted out, the land used up,
every tree gone, then a twenty-five-year drought.

There are ruins of gathering rooms,
rounds of empty kivas dug deep,
places still holy with Sipapu—
navel holes connecting the spirit world.

I thought, if I could just get my hands on them,
I would understand,
thousand-year-old pottery sherds—
thrown, fired, painted,
cups and bowls to gather water
ladle by ladle from seeping limestone.

What does one think born in a world
of Three Sisters and Anasazi war;
square holes in towers
to perfectly capture each solstice,
each Perigee Moon?

What does one person say to another
when they both know
all they will ever have on this earth
is twenty-five years?

In India, the word for *yesterday* and *tomorrow*
is the same.
On a night like this, we understand:

what makes us human
is the realization that we are all animals
with only one toe-hold at a time to this earth.

And the white owl hunts.
And the crickets creep.
And the winds howl high over Hovenweep.

- kk

Axis Mundi

As I get older
it's how we waste weekend mornings
that probably troubles me the most.

Consider the ruins here,
the sipapu and all the corn,
the little mummy dreaming on the shelf—
the only one left.

Those people had probably tracked,
and then tried to track again,
and finally come home empty-handed,
thin from looking for any deer, beaver, wild boar,
being willing to settle for squirrel,
or an unwary fish.

One day there would have been a meeting
and a decision—like there always is.
No one paid attention
to the sipapu any more.

And what will we do when we have exhausted
all that our neighborhood can bring us?
Will there be HOA meetings, final family reunions
around marble countertops and formica tables?

Will we leave the tv remote on the ottoman,
the Candelaria on the mantel,
the cups and saucers in regimented rows in
the cupboard?

What will we do when the corner convenience
store is finally and completely out of gasoline,
snack cakes, and ice

and all the retiree clerk can do
is sadly shake
his departing head?

- AB

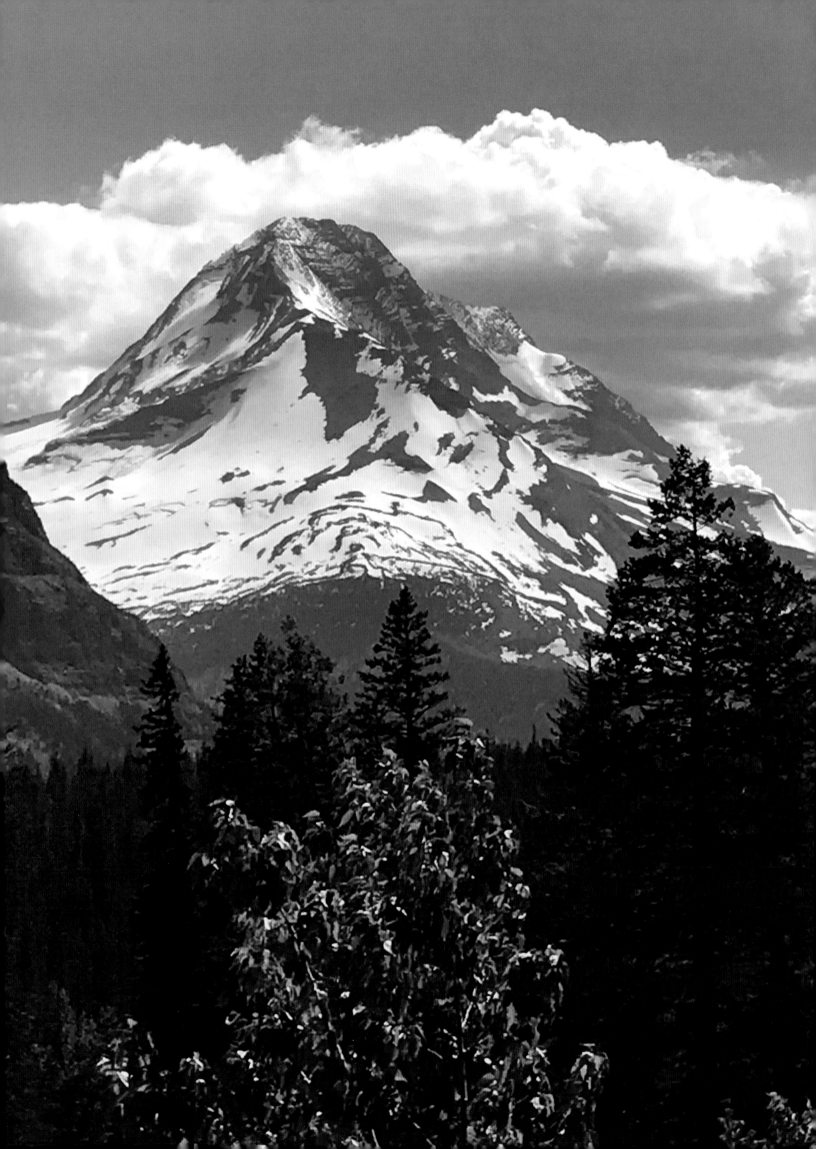

1910

Glacier National Park

MONTANA AND CANADA

Glacier National Park is one of the original parks, named before there was a park service. If ever there was a national park that was the perfect example of the early standard of monumentalism, then this is that park. It does not tolerate any nonsense. The best example of that is the Going to the Sun Road. This road, the only east-west conduit across the park, took eleven years to build and is fifty miles long. Considered to be an engineering marvel, its narrow lanes twist their way around granite mountains, pass through multiple rough-hewn tunnels, and seem to go perilously close to cliff edges that have no guard rail. To travel the Sun Road you need two people in the car: one to watch scenery and take pictures—and one to drive. The driver will not be able to look up from the road. Because of snow the road may not even be open until June and may close as early as September. Approximately midway, sitting on the Continental Divide, is Logan Pass. During the winter the snow at Logan Pass may be eighty feet deep. When we crossed, the first day it opened for the season in June, there were still deep drifts surrounding the visitor center.

The abundance of wildlife, the towering scenery, the lush growth are only facets of the majesty that is Glacier National Park. Every corner seems to display a waterfall, a burst of flower, a forest of towering pines. And then there are the glaciers. In that respect it is also a lesson park. In 1850 there were 150 glaciers. In 1966 there were thirty-five. By 2015 only twenty-five were left. While the grim predictions of every glacier being gone by 2020 did not occur, it barely lessens the inevitability that the glaciers are melting and will be totally gone in our children's lifetime—if not ours.

To complete your Glacier National Park experience you must eat at one of the lodges within the park. These lodges are part of the network of old-world lodges, constructed in the early years of the park service. The park service has kept the ambiance in place. Try to visit all the lodges if you can. They all have a unique character. (If you want to stay in one you must book reservations months in advance.)

Hint: Drive over into Canada. Go to the Prince of Wales hotel. Be there in time for High Tea. Trust me on this.

- AB

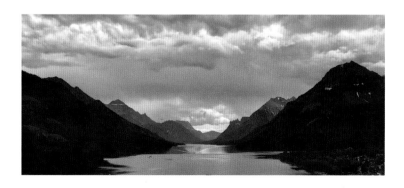

Wildfire

There is a pinecone sealed in so much resin,
it can only be opened in a wildfire.
Amen to that.

And there is a wildflower that can only
grow in the acidic, charred ash left behind.
Amen to that.

And Amen to
that man whose cabin is in the mountain next
to the nest of hatchling jays, and an old wolf
too crippled to outrun the advancing flames.

And Amen to
the firefighters on their knees with picks, chasing
embers flaring Aspen root to root to root.

And to the Summer Storms trying to answer
our prayers with its hail; its anxious lightning strikes,
Amen to that.

The Blackfeet believe there is a truth in each
strike, in each way the heavens reach out to earth.
Today I watched lightning strike three times; same
place.

Amen to that, I say.
Amen
Amen

- kk

What We Abandon

When it rains there is an exhalation.
I think it must be like the breath of saints.
If we are there.
If we are only there in time.
When they walk by.

What is the ester of glaciers?
Ice older than firsthand memory of Christ.
Alpine horns that have trumpeted for centuries.
Can you smell the wind from the moraines?

In fifty years these lakes will be blue instead of milk.
Nothing will accumulate.
Even the snow will forget to sleep, will not pull the
blankets over and over again.

What is the ester of glaciers?
I think it must be like the breath of saints.
If we are there when they walk by.
If we are only there in time.

- AB

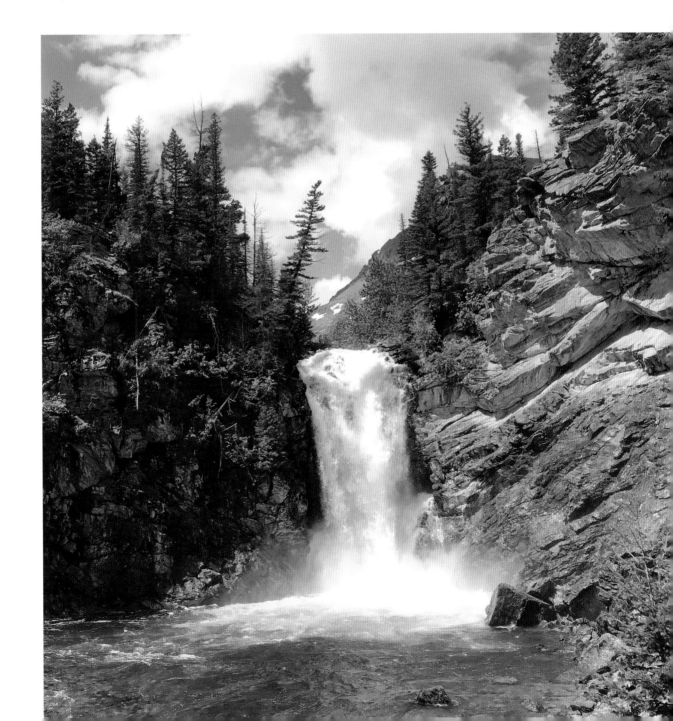

Rocky Mountain National Park

COLORADO

Like it is with so many national parks, there is just no bad time to visit Rocky Mountain National Park. Locals recognized its amazing beauty early, and the lobbying efforts for its 265,795 acres to have park status finally came through in 1915.

The Trail Ridge Road is the highway to take—an engineering feat of forty-eight miles across the park. Construction began on this famous road in 1926 and took six years to finish. It crosses over the Continental Divide.

We arrived with the snow storms, watched as they coated the vista in a magical white. The elk were in their rutting season, the males slamming antlers while the females grazed, unimpressed. The forest echoed with the bugling.

Humans have been in these Rocky Mountains for at least eleven thousand years, and no wonder—the flora, the fauna, the beauty—it's all astounding. There are at least sixty mountain peaks here above twelve thousand feet and as of this printing, five active glaciers. It is truly mesmerizing.

The drive to get here is spectacular, but the drive through the park is awe-inspiring. How could we mere homo sapiens not be drawn to such wonder?

- kk

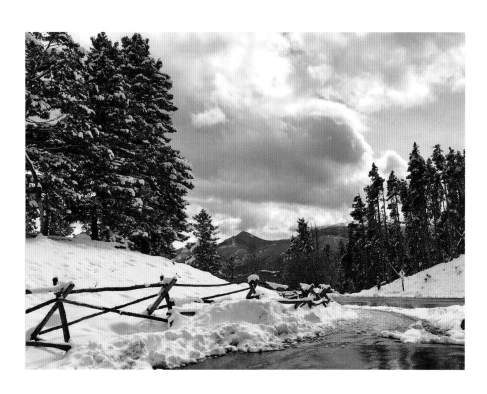

The Answer

To what purpose, someone asked,
is a National Park really–
but a glorified zoo people walk through—

a road to nowhere,
an afternoon hike,
a river traversed a few miles down
just to turn around
and paddle back upstream.

I asked him:
have you ever driven *Trail Ridge Road;*
let your eyes sink snow-deep into glaciers?

What did that do
to the unnameable places of your soul?

Every answer is found in the wilderness.

And when you return in twelve years
and the glaciers are gone,
what then will your soul do
on those hot dark nights
but flail within walls,
and sit destitute upon concrete
and worry
where all the white furry beasts go
when every ancient patch of snow
has melted into green.

- kk

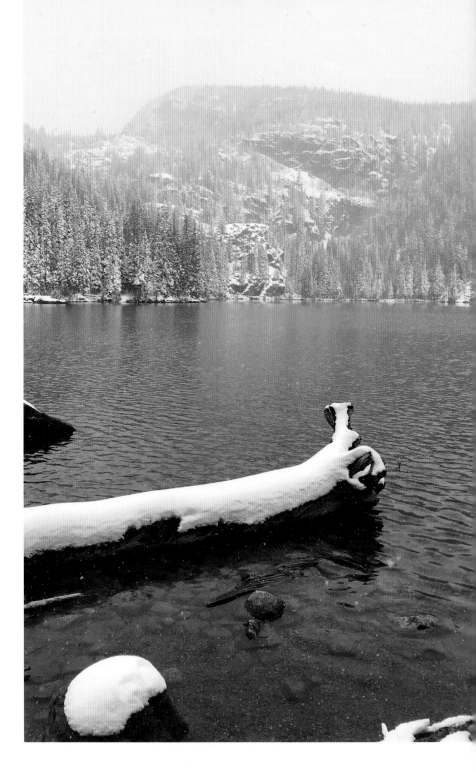

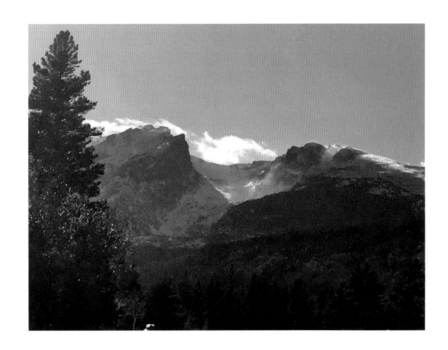

I ask you

Who was responsible
for the construction of the elk,
of the muscle and steam,
or the belling?

Who put the stone and ability to echo in place?
Who tucked the snow
into the trees, onto each numbered branch,
sheltering each shivering burrow?

Who waits to blow down the avalanche?
Who pierces the blue of blizzards in the night?

- AB

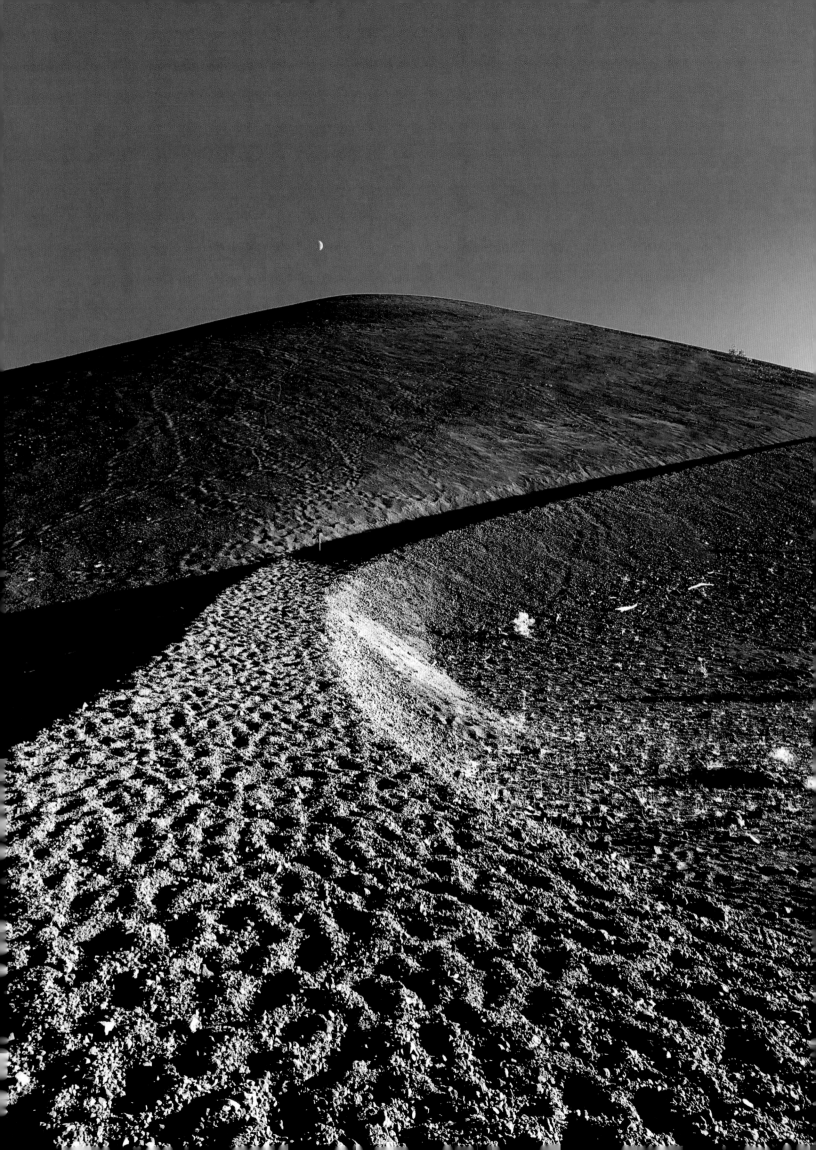

Lassen Volcanic National Park

CALIFORNIA

How often can you pick up a rock and know the exact day it was formed? You can do that at Lassen Volcanic National Park. On May 30, 1914, Lassen announced its reawakened state with steam. On May 19, 1915, it began more violent activity, and on May 22 the mountain exploded, creating a wave of boulders and ash a mile wide and three miles long. While the volcano is quiet now, it is still considered active. The rocks you touch in the Devastated Area were formed on May 22, 1915.

Just a short distance from the visitor center geothermal activity is generating an area of sulfurous boiling mud pots that are slowly but surely gnawing toward the asphalt. As of this writing, it was within twenty feet of the pavement. This experience is reminiscent of Yellowstone—except here nature's dangerous heat is much closer, and advancing.

A driving tour through the park is essential. If you get the opportunity, walk the Bumpass Hell trail. You will see unbelievable sights caused by the boiling earth. Definitely take the interpretive trail that guides you through the Devastated Area.

It will drastically reset your understanding of the park's geology. And from Butte Lake Campground take the Cinder Cone Nature Trail. The Cinder Cone is a dormant volcano that is the steepest an ash cone can be and still maintain its shape. (It is called the "angle of repose," approximately thirty to thirty-five degrees.) When you get to the volcano, a wide path that looks relatively easy winds its way up the cone, but do not be deceived. The volcano stands 750 feet tall, and the entire surface is cinder ash. You will go five steps forward—and three back. There are no handrails or staircases. Those who have the cardiac stamina will be rewarded with a spectacular view of the surrounding landscape. For even hardier folks the trail that climbs Lassen Peak is an all-day adventure. It is worth the effort. Take a Ranger-guided hike or, if possible, ask to speak to the local naturalist Dave Schlom. Lake Helen, Emerald Lake, Juniper Lake, strawberry snow, Edward Abbey—there is far more to the story of Lassen Volcanic than can be covered here. Read on your own. There is relatively new earth waiting for you to touch.

- AB

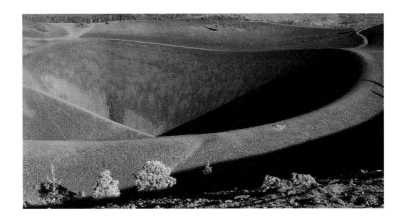

Angle of Repose

Climbing the cinder cone–
two steps forward, one step back
 two steps forward, one step back

we embraced Her slow dance,
each foot sinking above the ankles
as the sun-soaked ash
tried to claim us as its own;

suddenly aware of the awakening Earth,
Her distant scent of sulphur;
the upturned fingers of Her hemlock;
Her estranged beauty of childbirth
slowly slipping into our shoes.

- kk

Ishi

*Ishi was given his name by an anthropologist because
the traditions of his people dictated he could not say
his name until he was introduced by another member
of his tribe. But he was the last surviving member of
the Yahi People.*

*When he had finally stepped out from the forest, alone
and starving, he was taken in by a university and
given a job as a janitor. He lived his last few years in
the white man's world supplying as much informa-
tion as he could about his culture. No one ever knew
his real name.*

I would love to start with the word
Extremophiles because that is a word
rarely used in dinner conversation.

Or any type of conversation. Not usually uttered
over a petite syrah or a carmenere—
both of which are specific nouns that
are very delicious.

Back to Extremophiles, those entities
that can only exist under harsh conditions
yet seem to flourish here in Lassen

in the bubbling sulfur pots
whose expanding appetite
threatens to swallow the park road whole.

Here is another specific noun
(although technically it is a date):
May 22, 1915. I suspect most of you

were not alive then. Neither were
most models of cars like the Impala,
Explorer, and Skylark.

Such glorious names. And here,
in the park, even more: Juniper Lake,
Lake Helen, Bumpass Hell Trail,

fir trees,
hemlocks,
sugar pines,

There is not enough space
in a journal for all the specific
dates and names.

We could kick ash up in clouds
around our feet
in the Devastated Area

(you should use all capitals
when you say that).
Yet, even as the scientists

scrambled up the volcanic sides
and down into the burnt arroyos
Ishi manned a broom

down clinical hallways,
the swish of the working straw
maybe rhyming with his name.

Maybe the clang of the mop
reminded him assonically
of the name he vowed never to speak.

- AB

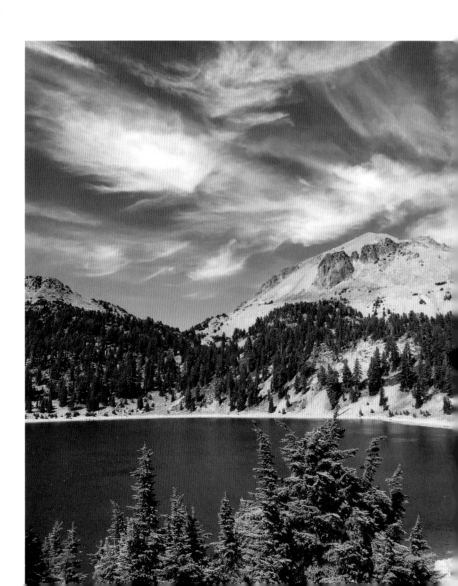

Hawai'i Volcanoes National Park

HAWAI'I

This park is an excellent example of how Nature always has the last word. Kilauea started erupting on May 3, 2018, and finally stopped (officially) in early August of that year, after hundreds of homes were destroyed and acres of new stone were brought up from the interior of the earth. The primary visitor center was closed, surrounding buildings were damaged, and many roads and trails were either badly damaged or completely destroyed. Crater Rim Drive, the easiest way to view the primary craters, was totally closed. A secondary visitor center was set up in the Kahuku unit, located in a non-volcanically active part of the park. There are multiple trails, some of which will take you into areas that were once active. Of particular interest here is the trail that takes you onto the fields from the 1868 eruption. Watch the cairns as you hike. The rolling waves of cool lava look alike. It is easy to become disoriented. When you get to Kilauea, if there is access, make sure you take the trail that leads to the petroglyphs. They are an essential way to learn about the indigenous peoples that occupied the islands.

Be aware these are active volcanoes. Mauna Loa, the other primary volcano within the park, last erupted in 1984. Kilauea has been in almost constant eruption. If you decide to hike, always talk to the Rangers first—and always stay on marked trails. Land may appear stable, but the thin crust can be deceiving. At the south visitor center you may notice that the trails, roads, and runways (an abandoned runway is part of one trail) appear green—not due to plants—and you may hear an unusual crunching beneath your boots. This is olivine, commonly known as peridot. Gem quality varies, and none can be taken from the park, but locally there are craftsmen who collect stones from outside the park and sell them as necklaces and bracelets.

Kilauea and Mauna Loa have the last word on Hawai'i. As of this writing, many areas around the volcanoes are still inaccessible or permanently closed, but some have been opened around the primary visitor center. Currently Kilauea is sleeping. Hurry. Visit before she wakes up!

- AB

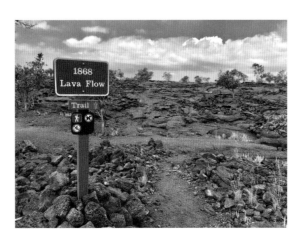

A Hand atop a Smoldering Tattoo

Pele sleeps.
Her long lava hair
fire red,
flowing halfway over
her outstretched arm
down into the ocean,

where it sizzles and smokes
in cool South Pacific Seas.

Locals leave clipped ginger,
anthurium,
orchid leis at her feet
along Kilauea's rim,

that she might wake,
and stir the gifts with steaming fingers.

We witness the youngest earth
on the planet–
a newborn ooze, fierce and bare,
black as her goddess mother.

In a million years
she will green and jungle into rainforest,

with no memory
of the way we looked upon her darkness;
the way we marveled in her sulphur breath,
the way we took her into our skin:
the hot blood and ink
of a boar's tusk tattoo.

- kk

Hawai'i Volcanoes: Crush

Walking in the olivine.
Brushing them with my boots.
Losing my way.
Following the cairns.

Crush.
Crush is a good word.
In the bathtub.
Crushing the small muscle of soap left.
I flex my fingers
Into the nature of it.

Like glass.
On the edge of the path.
It looks like green grass crushed.
On the edge of the lava flow.
History not so ancient.

I have to follow the cairns.
Once I topped a hill
And spun around. This rock
Flowed into another,
The edges of an unlit highway at night.

Later
When I was led from the flat barrenness
And to the next cairn
And to tall grass
There was even green
in the gravel clutter underfoot.

At the edges of the lava.
At the fringe of old disaster.

Crush.
There is still something brilliant.
After the heat and pressure and jarring.
And cleansing. And scouring.

And there you are, standing by the cairn,
Saying, "There are stars at your feet.
They are green. You can touch them."

She wears a necklace of olivine.
Rocks that were crushed and burnt and cooled.

I say it has all been crushed.
She says yes, isn't it glorious?

- AB

Haleakala National Park

HAWAI'I

If there was one word I could say about Haleakala, it would be *Ānuenue* **(pronounced "āh-noo-weh-noo-weh").** *Rainbow.* We saw rainbows every day. We even stood on top of one looking down from a cliff.

This is a land of rain and fire and mist. Of black beaches and newly cooled earth. Of Mo'olelo—ancient stories of why things are the way they are, such as Pele, the goddess of fire who makes the lava flow, and of Maui himself: Maui was a demigod. His mother, the moon goddess Hina, was upset because she did not have enough time during the day to dry her kapa (Hawaiian bark cloth). So her son, Maui, made a rope from coconut fibers to snare the sun from the top of Haleakala. The sun, captured, then agreed to move slower across the sky, making longer days.

Everywhere we went, the locals still refer to Maui as a benevolent, living being, with such common and repeated expressions as: "If Maui wants you to stay, you will find a way to stay" or simply "Maui provides."

Maui is everything you expect it to be—gorgeous, abundant, fertile, with thick rain forests and a summit that resembles the barrenness of the moon. The locals are tied to the earth here in ways we all wish for—a true love affair between human and land. It feels good, balanced; a land of poetry. Even one of the National Poets Laureate called this home: W. S. Merwin. He lived near the village of *Haiku*.

The sixty-eight-mile Road to Hana (Hana Highway) is a must do. It is a daylong adventure with six hundred hairpin turns and fifty-nine bridges. You will stop again and again to try to capture the beauty in your camera. But take a moment at these stops and turn-outs and just soak the beauty in. Let it flow over you. Let it make you vow to protect and preserve this incredible moment for your great-great-great-great-great-grandchildren to experience. Let it make you fall in love. That would make Maui *very* happy

- kk

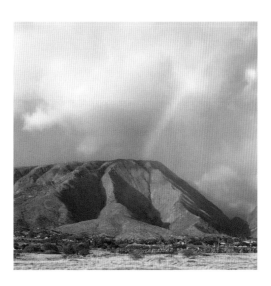

Maui

We come by wing and wind and wave–
hungry seeds desperate for earth.
I cannot sleep without dreaming
of these wilds–banyans that shade miles–
long bark in my palms; of black sands
and jungle so lush, they harvest
the sodden clouds. I run the hills
of Haleakala–sacred
summit below my feet, my mouth
open to mist; to a demi-
god of stingray and peregrine,
biceps thick with drum and muscle,
still holding on to summer's sun.

- kk

Biking Down Haleakala

Tomorrow I will spend more time
looking at the silversword.

Or I will maybe drive to the Hana rainforest,
setting my mind to the twisting, canopied road.

But this morning, I am busy on the bike ride
down from Haleakala.

My shirt flapping in the breeze,
looking forward to lunch in Paia

twenty-eight miles away.
There is a term

for when an experience
is so big that thoughts become simple.

Maybe it is just the feeling
of turning into a grade-schooler

when all you had to do on the weekend
was point the bicycle downhill

to escape school and homework
and chores and making beds,

and you let the wheels do all the work,
and all of today was just downhill.

Right then, I thought, my friends back home
were barely settling behind their desks.

I was gleefully pointing out pineapple fields
to no one in particular,

as my years trimmed away
in the buzz of the bicycle spokes.

- AB

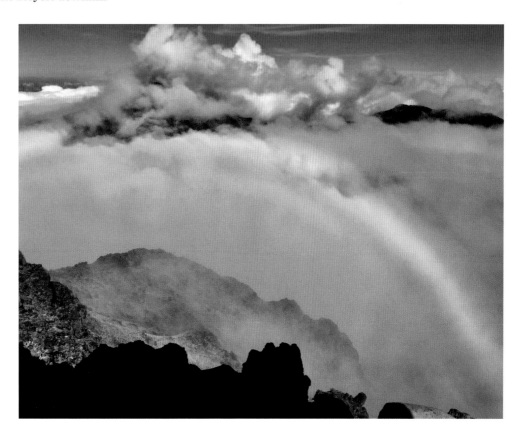

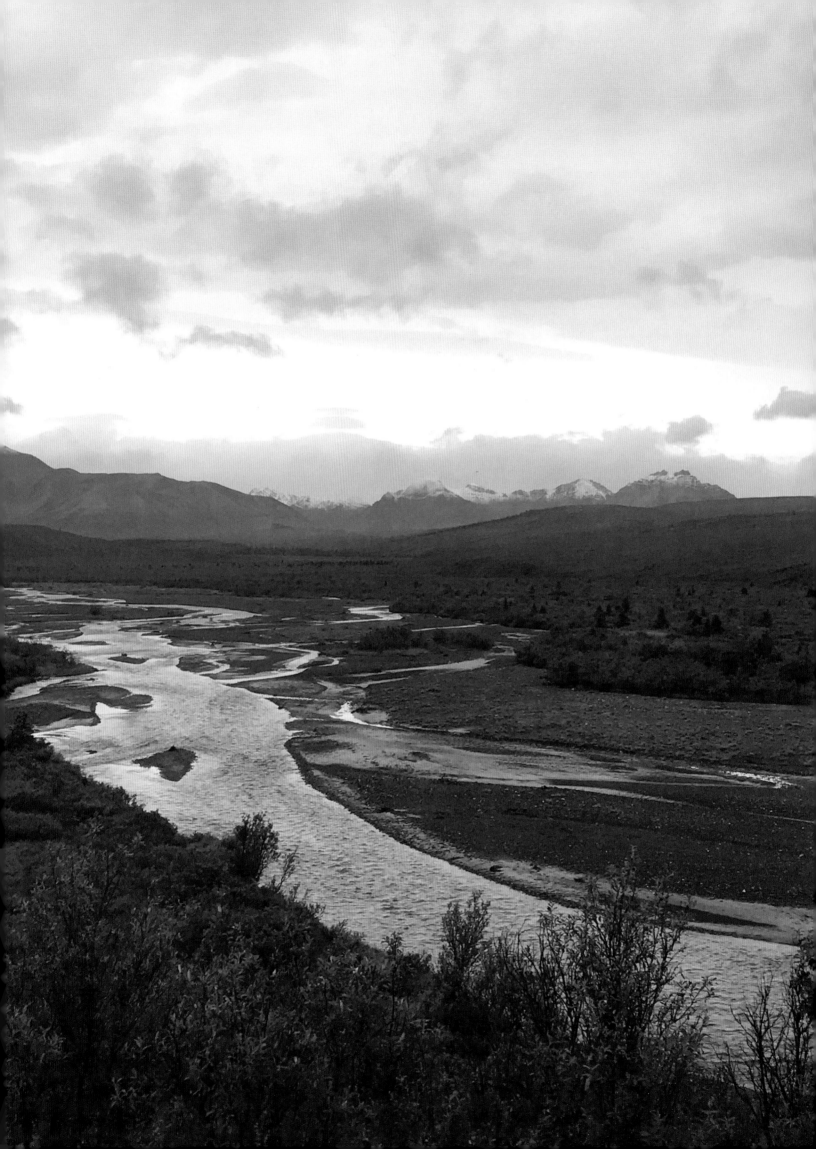

Denali National Park

ALASKA

The tundra, the fireweed, the unforgiving ruggedness, moose standing majestically primitive, gray clouds wrapping the mountaintops—and no evidence of man other than the road we were on. We were only soft and casual visitors in the far-off shadow of the Great One—Denali.

As we stood at the Eielson Visitor Center, at the end of the paved road, with Denali in clear (and rare) view, karla turned to me and said—"Alaska changes everything." And she was absolutely right.

Denali, at 20,310 feet, is the tallest mountain in North America. Denali National Park is one of the eight national parks in Alaska and the first named. Originally it was called Mount McKinley National Park, but after a decades-long political battle, the name of the mountain, and the name of the park, were both officially changed to Denali. This is the most well-known and one of the most visited national parks in Alaska. It covers over six million acres; most is wilderness. With increasing visitor count there is a constant struggle to preserve and protect the land against human interference.

It will seem very turista, but one of the best ways to get a sense of the majesty of Denali is to take one of the tour buses to the end of the paved road, ninety-two miles deep into the interior of the park. While the tours are not operated by the park there is an informative tour guide on board, several camera points along the way, and of course stops for wildlife as necessary. Moose, elk, and caribou are common sights.

You'll learn about terminal snow, a term that we had never heard in the lower forty-eight. Terminal snow is the first snow of winter, the snowfall that marks the end of summer and the warning to prepare for closure of roads and trails. Our bus ride was the last one of the season. Terminal snow was already sitting on the lower mountaintops.

The Alaska Railroad runs between Anchorage and the park. It is one of the most scenic railroad routes in the world. Enjoy the glass-top railroad cars. And don't forget to go all the way back to the open caboose!

- AB

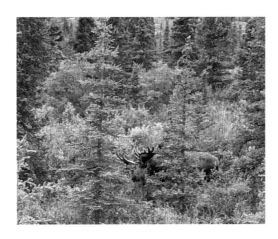

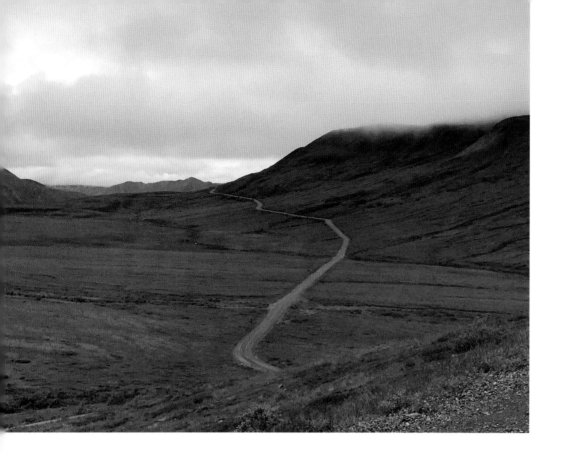

Alaskan Mnemonics

Far too old for tests, my mind
still goes there in stress–naming
the planets, musical chords,
the mountain peaks of Wrangell
National Park, five kinds of
Alaskan Salmon. I turn

my head away, focus on
my right hand–the pinky, yes,
that one's easy–pinky, pink,
Pink Salmon. No, don't go there,
don't think about pink parts or
the pain of pink wrought too hard.

Now ring finger, ring, silver,
Silver Salmon–good. My eyes
shift to the gold wedding ring
on my left hand, wondering
what does that finger look like
after 37 years
under the same wedding band.

Middle, tall, kingly, the king,
King Salmon. I curl the rest
of my fingers back to fist;
let the King do my bidding.

Pointer, point, put your eye out
with that thing, that strong finger,
sock it with Sockeye Salmon.

Then the thumb that rhymes with chum–
Chum Salmon–lowest story
on the totem pole. Ground up,
fed to the dogs and the fish;

defiant. The King may do
the talking, but Chum's the work–
horse, the pack mule, the sled dog–
yes, let one try to get through
glacier and grizzly to me.

Stick that Chum Dog up and out–
see how far it could take us,
bundled into the Yukon,

these excruciating nights
a class I no longer have
to pass, all gone like gold dreams,
like fish running five kinds of
frenzy through the midnight sun.

- kk

The Train to Denali

I've seen the bright face of Denali
and it showed me the soul of myself.
Once you have slept in Alaska
you cannot live anywhere else.

If there is a God I can telegraph,
and the wires are steady and true,
I'll humbly request one more ticket
where the eyes of the glaciers are blue.

Just put me there onto that railroad.
Let me go 'til the end of the rails
The moose, wolf, and aspen are calling.
I'll meet them like smoke on the trails.

I'll say Lord, I've traveled Alaska
from Bettles to Seward to Nome,
but just let me go back to Denali
before terminal snow calls me home.

- AB

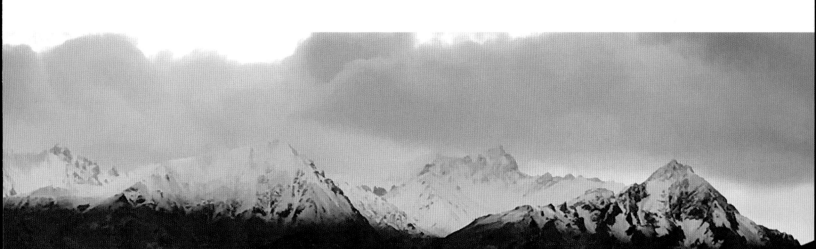

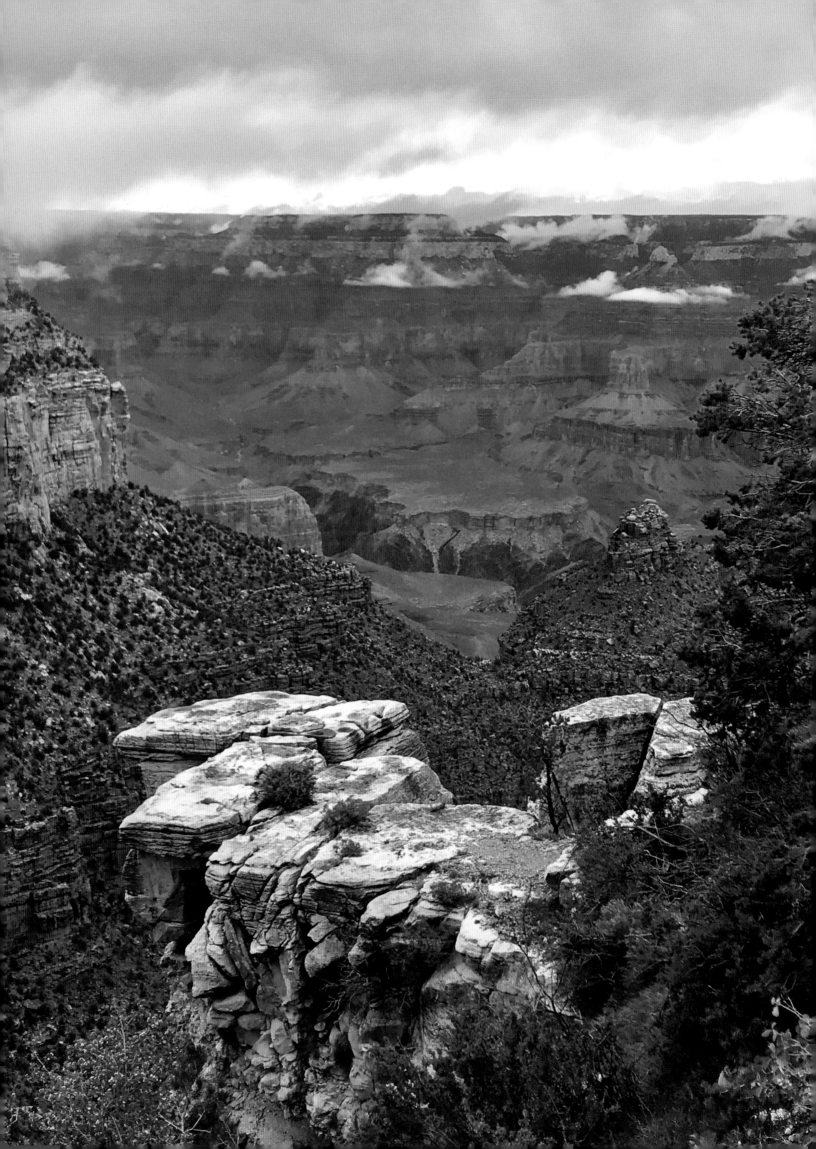

1919

Grand Canyon National Park

ARIZONA

The Grand Canyon. It is an instantly recognizable name. There is a reason this is one of the most visited of all the national parks. Actually, there are dozens of reasons and hundreds of stories. A mile deep in places and miles wide, there is no way for a camera, or the human eye, to encompass the full horizon. To describe the experience of this park without sounding like a travel brochure is a daunting task. This is one of the national parks that needs to be seen as part of the complete American experience.

There are some suggestions we can pass on; they will barely scratch the surface of what awaits. There is a north entrance and a south entrance. The north entrance is less visited and crowds are smaller, but in the winter it shuts down completely—the visitor center closed, local shops closed, and on many occasions, the road itself is closed. And more of the recognizable, although more crowded, facilities are on the south side. Spend some time looking into the history of the park. While many National Park Service sites owe a huge debt to individual people, very few have left such an impression as engineer Mary Colter.

In the early part of the twentieth century, a female engineer in a male-dominated field, Mary Colter was a unique visionary. Visit the Watchtower and study the fireplace at the Bright Angel Lodge to get a small idea of her strength and genius.

Speaking of lodging, for the south entrance the center of the universe is the El Tovar. The El Tovar retains old world elegance, combined with southwestern charm (and a gift shop and restaurant with exquisite food); you should visit even if you don't stay there. It is not the only lodging available in the park, but whatever lodging you choose you will need to make your reservations months, if not a year, in advance.

And don't forget the Skywalk at Grand Canyon West. Located on tribal land, technically this is not a part of the park, but it is part of the total park experience. A glass floor extending seventy feet over the canyon makes for great photographs. Make sure your camera can take landscape shots. The same vista changes by the hour. And each one will take your breath away.

- AB

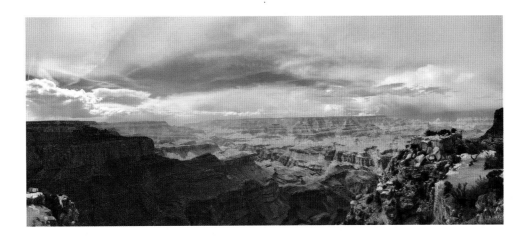

The Grand Canyon:
Completely Fogged In

When we reached the edge,
the white held us back
as if it were ghost hands pushing;
as if rain and snow could turn a being back
from where it needed to go.

And I thought of Edward Abbey,
buried somewhere out in that Arizona west,
seven feet beneath sage and lizards;
someplace just below the white sands.

The snow stopped first,
then fog shifted her skirts South
and eternity opened its red-cliffed body . . .

I could see the river.

I don't know where the endless waters flow.
I don't know what happens when we
step into that white
and the earth falls away
and the thunder echoes down the canyon
wall to wall to wall.

But I have stood on that distant ground
where that canyon began.
I have been in that river.

Don't tell me there is nothing beyond this cloud,
beyond these pale and layering sands.

The Canyon does not feel the haunt of hours,
just the petroglyph stars
and the restless sun.

There, deep runs the river.
There, deep, the river's run.

- kk

Antelope Canyon.

Grand Canyon: Imaginings

This park is four parts View-Master
and three parts preconceived notions—
with a tablespoon of mule ride to the bottom.

It seems almost impertinent to speak casually
about such a place. Like talking about fast food in church.
Well, maybe not exactly like that.

But this is what big places and big events can do to us.
They change us before we get there.
It's painting the nursery ahead of time. Wanting a new
sports car.

I've envisioned visiting the Grand Canyon many times.
My escort would be a lovely twenty-something
and I would be a rich sugar daddy, fifty-something.

I would have my arm around her two-decade-old waist.
My silver temples would be glistening in the sandstone sun
and we would stand like demigods on the south rim.

People would queue up to take our picture—and not theirs.
But that isn't this place or this moment.
I'll hold this woman's hand as she climbs down from
the minivan.

I'll admire the freckles on her upper arm
as I have for years, seeing new stories and constellations.
We'll pause briefly by the telescope.

Our breaths will sync up just as a layer of clouds
lifts from the mesas.
There is a river down there, eroding, yet still musical.

Later, on top of the mule, there will be tumbles and colors
and body-rockings past anything I had thought of.
I gladly reset my visions from small square windows.

Some women and some places I say to myself
are far more than what I thought.
I imagine the layers of limestone can sing.

- AB

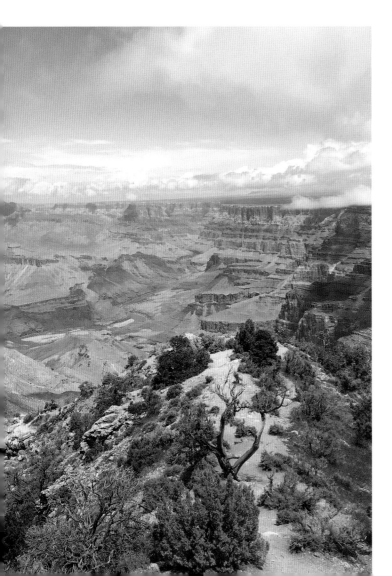

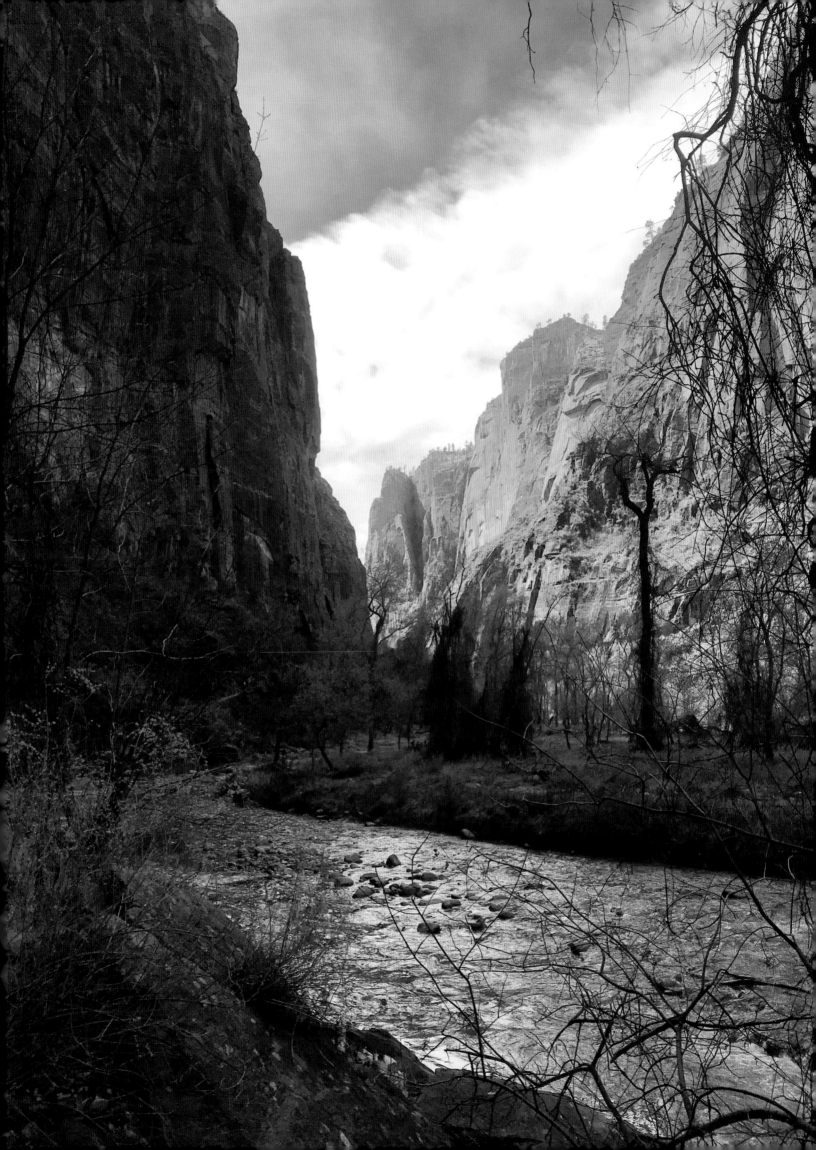

1919

Zion National Park

UTAH

Zion is one of five national parks in Utah—and one of the most dramatic. By the time you get to the visitor center you will have already discovered the sheer magnificence of Zion. The road curls and twists at the bottom of multicolored sandstone towers. Stay at the Zion National Park Lodge if you can (reservations fill up quickly, so book early). This lodge has been rebuilt but still retains much of its old-world splendor. The building sits in a valley with a breathtaking view of natural stone towers.

Whether you have the ambition and daring to attempt the strenuous Angels Landing Trail or you simply want to hike to the Narrows or Weeping Rock, Zion National Park can accommodate you. (There are many stories and videos about Angels Landing. When the Rangers say strenuous, they mean strenuous.)

The Narrows is at the end of a moderate and well-worn trail. Up to that point you will have been following the river. Then the canyon walls start to close in. If you wish to go farther, you will need to wade into the water. The water just off the trail is shallow but be aware: the Narrows are deceptive. If there is significant snowfall, or there have been spring or summer rains, the water level in the narrows can rise quickly. If the water is low and calm take your time—and look up. The red walls rise hundreds of feet, carved by time and nature.

The stone formations in Zion are mostly made up of different types of sedimentary rock. These layers gave the stone towers a multicolored appearance. Spend time studying the strata in The Patriarchs—then drive to the Kolob Canyon. When you get to the top of the road, turn around and look down the valley. You will forget you brought a camera.

There are petroglyphs and pictographs in the park. There was no parking lot for the trailhead to the pictographs we visited, and we were grateful for our walking stick and that our hiking boots had grip; some of the sandstone plates were slick and tilted. Magnificent views—but demanding caution.

Zion National Park: It is a cathedral waiting for you to enter.

- AB

Mukuntuweap:
Zion, the Place of the Gods

There was a name before Zion,
what Paiutes called those stone cathedrals;
the name before the white man.

An astrophysicist said 82 percent of kids from big cities
who sign up for his class
have never seen the moon,
nor stars like these:
bright wild horses
grazing the night sky.

Beneath the highway
roam the petroglyphs.
There is snake and sheep.
There is river.
There is the exact moment of solstice
etched on a turtle's back–

a language I feel I should know–
lost stories of a winter count;
a mountain meadow massacre;
things humans have done to one another
in the name of religion.

Maybe God is up there above that White Throne,
calling each horse by name as it slowly circles past.

Sometimes they wait a lifetime
for us to look up;

for us to dare walk into
the naked night
and fill our mouths with
the holy.

There are names we should speak.
There are names we should not speak.

There are languages begging to be known;
there's a moon climbing just over the cliffs
her arms outstretched
among a million
star-faced mares.

- kk

The Lilliputians Every Morning

As if to say the mountains weren't there all along;
we simply decided to slyly move in

and live in their shadow. We needed to compromise
our own significance, and we did, but there was always

worry and that sun-blotting fear.
Who were we, before, to think we were so grand,

with our bedecked horses and our insignificant machines?
We could shoot arrows into the air if we chose;

sometimes we did. We raised our voices in awe
and despair—and only heard echoes.

Waking up to see these behemoths
with sandstone sinews and lips of limestone

we had to reset all our beliefs
based on the relative faith of size.

We loved in plenty because of and in spite of,
every morning raising our eyes,

always aware of the sweet boulders of Heaven
that could crush us with an insouciant shrug.

- AB

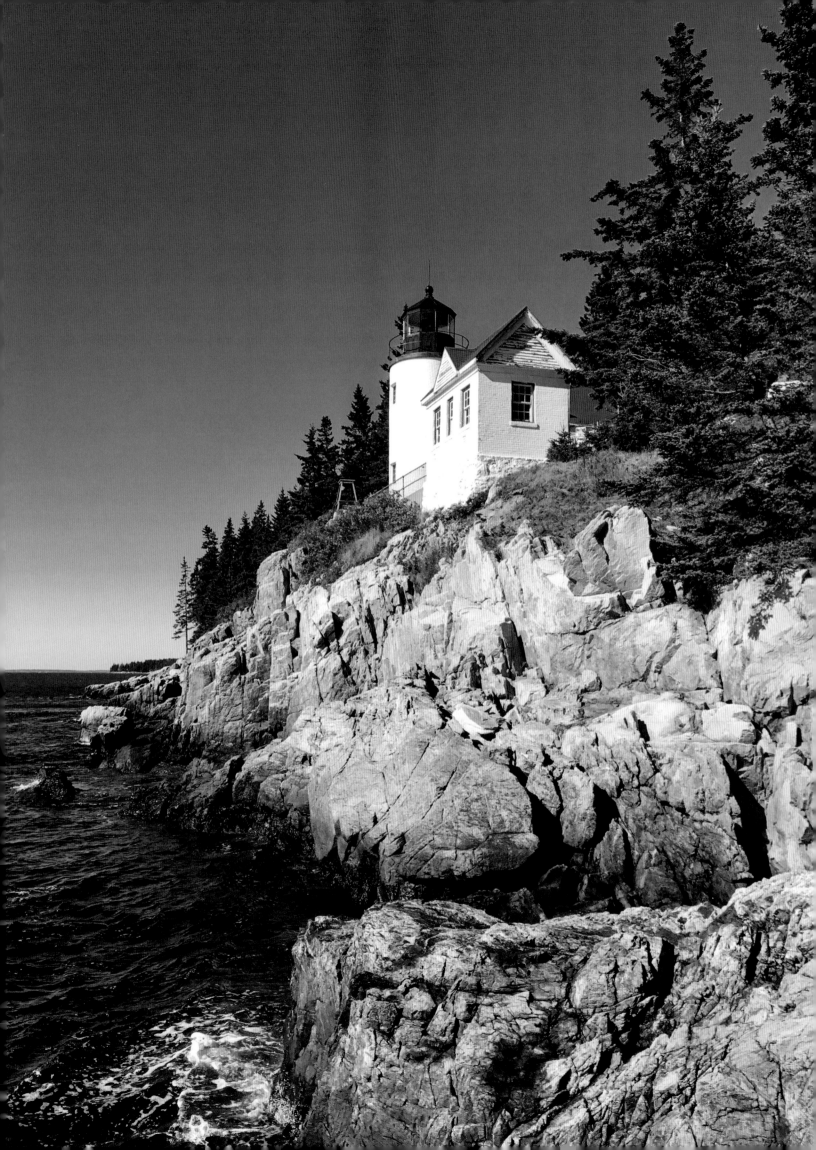

Acadia National Park

MAINE

There is no other park like Acadia.

It feels old world the moment you walk onto the 1913 broken-stone carriage roads lined with the simmering jeweled leaves of late October. John D. Rockefeller Jr. loved this area, donating almost eleven thousand acres to help create Acadia National Park, financing fifty miles of cobbled roads that forbade (and forbid still today) motor cars. He loved Mount Desert Island (pronounced dessert) and also funded sixteen of the seventeen stone bridges that give the park such a romantic feel.

Also impressive is the coastline. There are over forty miles of shoreline among Acadia National Park's fifty thousand acres. They are rocky and craggy with the constant pummel of the Atlantic Ocean. The waves are like wild animals; never turn your back on them. While their current is fierce, low tide exposes beautiful tidal pools, with hidden caves best seen from above.

We can't think of Maine without picturing the lighthouses along the coast. There are over seventy lighthouses along Maine's coast, each with their own special code of light, color, and number of flashes, that the seafaring may know their location. Inside the park, be sure and see the iconic 1858 Bass Harbor Head Lighthouse.

Get up before dawn one morning and drive to the top of Cadillac Mountain (the highest point along the North Atlantic seaboard). Spread a blanket. Wait for the spectacular sunrise—the first place (seasonally) in the continental United States to see the rising sun. Afterwards, walk the adorable town of Bar Harbor, shop for tourmalines, eat fresh blueberry pancakes at Jordan's. It's all a lovely adventure.

- kk

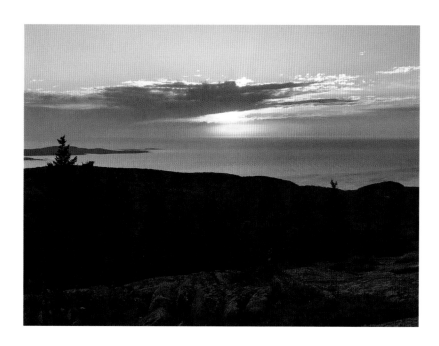

October Sunrise, Cadillac Mountain

We stirred.
We walked that mountain
like nocturnal beasts.

We nestled on the ground.
We wrapped ourselves in Pendletons
among the rocks,
and waited.

What is it like, earth,
to never grow old?
What is it like to know without doubt,
the warm hand of morning
will always touch your face?

There is life
and there is being alive.
There is ocean and mountain
beyond this darkness.

There is a dawn like no other
when we can raise our arms
bare-branched to the sky

and open our fists—
each burden turning to gold.

- kk

Acadia

Even after the perilously slick stones
around the mouth of the anemone cave,

and the demand of thunder hole
slapping the dark water into the stone,

and yes, even after leaping from boulder to boulder
to capture that lighthouse shot,

even after that.

Even after rationally knowing there would be an
end to the color,
the leaves that looked like palette oil paint,

a smeared easel, an impressionist dream of leaves.
And even after lying on the granite mountain

teeth chattering, watching the sun come up
to touch me first, me first, before my children,

before my nanna and grandpa
and all my friends still drowsy back home.

Even after all those things I can list,
things I should list, I will hold your shoulder

and tell you about these two things:
Across from the hotel there was a quilt shop.

Squares of texture, meant to be patched,
to be taken on the road, back home.

A big fuzzy memory of color. And then,
this one last thing:
At the cemetery, as old as the town

in the late afternoon sun
I took a picture of shadows from the tombstones.

The shadows said there was another person
beside me.
When there wasn't: some things demand to
be remembered.

Occupying a small space within us
along the perilously slick path of years.

- AB

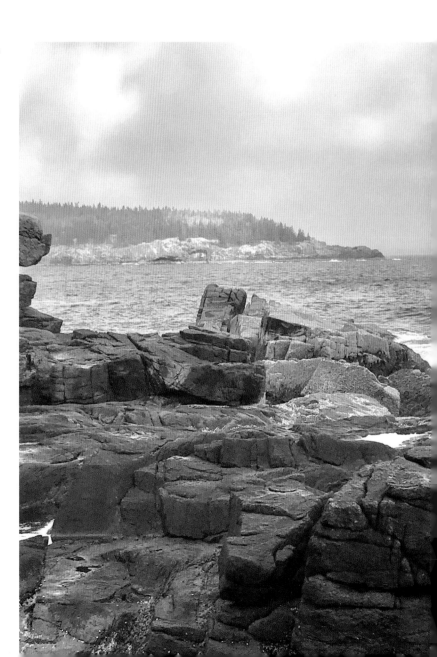

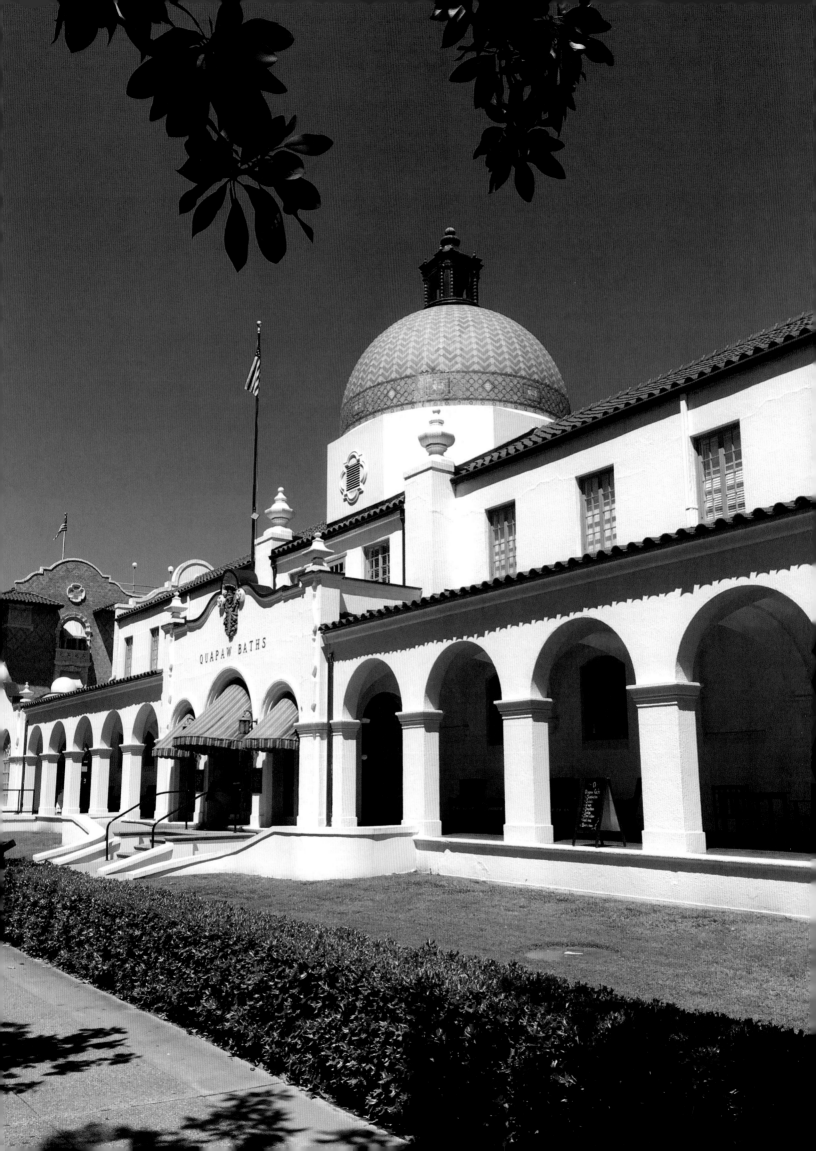

Hot Springs National Park

ARKANSAS

While Hot Springs was officially named the eighteenth national park March 4, 1921, many declare it was actually the very *first* park—named Hot Springs Reservation in 1832 to preserve the forty-seven hot springs coming up from Hot Spring Mountain.

While native peoples have been traveling to this area for centuries, it became US Territory in 1803 as part of the Louisiana Purchase, with the first European settlers arriving soon after to take the curing properties of the waters. Preservation and protection needed to happen quickly, as the town of Hot Springs soon sprang up around them (and became a favorite hideout for gangsters in the century that followed). Because of this, Hot Springs National Park is a completely urban park, right in the middle of town.

While there are twenty-six miles of trail to hike in this 5,500 acre park, the thing to do here is soak and quaff the waters in old-world glamour—

with two bath houses—the Buckstaff and Quapaw—still in operation. The other bath houses are repurposed into such establishments as Visitor Centers and bookstores, but the Superior Bath House is the cool one—the first micro-brewery in a US national park, *and* the first micro-brewery to use thermal spring water as their main ingredient.

Still today, Hot Springs is the only national park mandated to give away its natural resources, and there are cooled water fountains available to fill up water jugs across town.

This national park is exciting, historical, and restorative, with a spicy past, making it a *perfect destination*. However, once visited, it will become your favorite overnight stop on your travel route no matter where your journey is taking you.

- kk

Let the People Go

We stormed the trails
up and down Goat Rock—
trying to find the goat in the rock
through lush hikes of Sweet Gum and Mountain
Daisy,
till finally the waters.

Forty-seven springs bursting through the earth
at 143 degrees;
rain that fell five thousand years ago
as the pyramids were being built—
rock chiseled and chained and heaved.

Down went the rain
as forests greened,
as Egypt's dirt
rose up toward the sun.

Around town, spigots of cooled waters
fill jugs and cups as we go—
the Park saying:
Go: *take the Cure.*
Go: *quaff the waters.*

What could this biblical rain teach us
in its journey of centuries;
a liquid Odysseus traveling to the core and back,
gleaning the heartbeat of the mountain;
the secrets to every human ailment.

What Sirens' tails did it roil across?
What passion turned rain into tonic
and fell across the fevered foreheads
of the Pharaohs;

Moses desperate to heal the world–
the bolt of his staff
zigzagging into serpent;
his voice thundering
Let them;
Let them go.

- *kk*

Rejuvenation

It is going to happen. I am sure of it.
One day when I feel as if I am getting too old

I will drive into Hot Springs,
and park right there by the bath houses.

There will be a crowd coming and going
at one of the open fountains, holding tin cups and
glasses, dipping in.

They will be waving their arms, smoking cigarettes,
brushing dust off their dated clothes,

silk and burlap,
and all manners of thin cloth.

I'd like to think Yeats and Keats will be there.
But certainly Heaney and Whitman

and Merwin. Robert Service might be standing
out to the side

tapping out a rhythm on his fingers;
Wilfred Owen and John McCrae, complete
with accents.

Someone will lean into me, Akmahtova I think,
and whisper, "None of us know why we are here,

but the water is gloriously old.
and there is so much to say."

Given minutes like wisps, I will try to listen,
but as I finally accept that I need to leave

William Stafford will touch me on the arm and say,
"It is truly required that we give it away."

He'll smile then turn back to Ovid
to further discuss what is static and what is meant
to change.

- AB

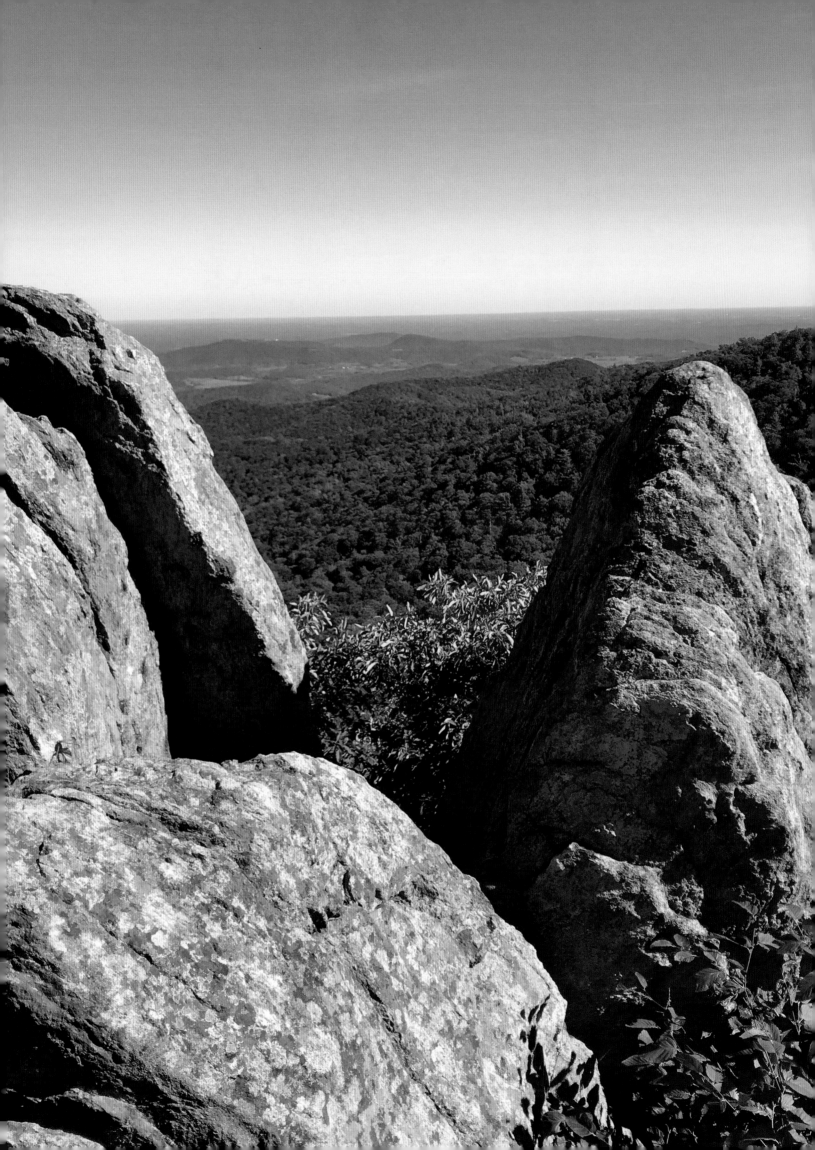

1926

Shenandoah National Park

VIRGINIA

The primary story of this park is the Appalachian Trail. This park, in the Blue Ridge Mountains, is most easily reached by the highway known as the Skyline Drive, one hundred and five miles long. Scenery and speed limit dictate that you allow yourself at least three hours to drive the complete length. Plus there are many access points to the Appalachian trail itself. For the most part Skyline Drive was built right on top of the trail—but there is some variance due to the number of hikers. Get a trail map from the Rangers, or order one yourself.

The full trail runs from Maine to Georgia and is about 2,200 miles long; Shenandoah only incorporates a small portion. The idea for the trail came into being in 1921, but the actual building of the trail was not completed until 1937. Its maintenance is under the guidance of several organizations working hand-in-hand with the National Park Service.

You need to understand: this is a "made park," as opposed to a naturally occurring one. Yes, there are mountains, trees, and waterfalls—and volumes of apparent (and not so apparent) Civil War history—but there is also the internal, heartbreaking governmental and civic history of settler displacement that had to happen to actually create the park. It was created under three mandates: 1. It needed to be close to the nation's capital (it is seventy-five miles away); 2. It had to be accessible by car; and 3. the US government did not have to pay for any of it. Several Civil War encounters and battles took place in the area that is now within the park's boundaries. There is historic and geographic significance to the area, and it should be visited in order to gain a full understanding not only of the growth of the eastern United States but also of the park system itself.

There is both a north and south entrance. The park is open year-round, but some of the lodges do close during the winter. Red oak, pine, maple, laurel, hawthorn—and a much longer list of plants will cushion and shade your footsteps. Walk a part of the Appalachian Trail. You will feel like you are walking into part of history.

- AB

Blue Ridge:
The Shenandoah

In the midday,
the long glisten of spider webs
spread the sun
like curved, thin swords
along the Appalachian Trail;

all the world wielded together
on one stem of light–
branch to sky to earth
in infinitesimal time.

Forever there was this life
throbbing, swaying
the whirligig beetles
the rough-leafed aster
the leathery grapefern;

the two-legged arriving in swells
to the land–
learning to walk
trampling, devouring, piercing.

Forgive us world–
our fondling reach,
our extravagant affections,
our crushing love,
our need to taste and feel and burn;

we fat-footed children
loosed upon a perfect,
porcelain world.

- kk

Shenandoah:
The Expiration of Anguish

It's only a question
of which ghosts you
decide to pursue.

There are more than
enough wraiths of
war in formation.

And there are the bones
of cabins where
generations flourished,

those settlers hoed with handles
made of oak and hawthorn.
They canned fruits and hunted

and sang and, well, left echoes.
You may never be fortunate enough
to live their complete life,

to have that kind of wood
in your hands,
to swing an axe,

to build your own home,
to die in the trees for what you believe.
But you can buy a walking stick.

Invest in a compass.
Take a few steps into
the shade of the trail.

Look—but mostly listen.
There are more than enough stories
to fill your unfledged heart.

- *AB*

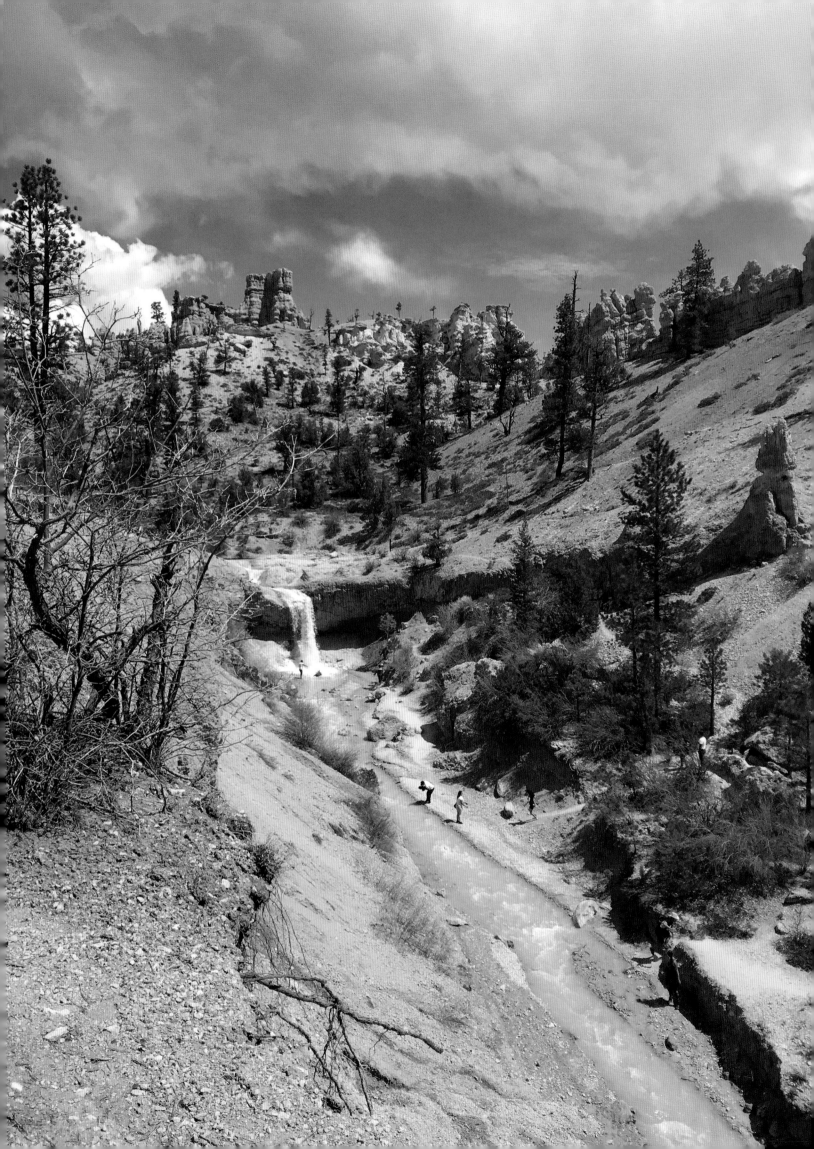

Bryce Canyon National Park

UTAH

I don't know how the African word *hoodoo* became part of the Southern Paiute Indian culture, but that is what they call these tall stone columns that punctuate Bryce Canyon, believing they hold the faces of their ancestors.

We rode mules down and back up. Equine is definitely the way to hike Bryce Canyon, their steps so sure you can spend your time looking up and out, instead of down at your feet worrying about the immediate drop-off.

Bryce Canyon was named a national park September 15, 1928. These 35,835 acres of Utah protect and preserve these amazing rock formations of hoodoos along with other geologic phenomenon such as sandstone spires and fins. The canyon is actually part of a larger picture called the Escalante Staircase—a series of cliff levels and canyons that descend eventually down into the Grand Canyon. Here, you are able to see the big picture—no matter what it is. When you come and witness the earth staring back at you, when you can see into eternity, you begin to understand something about your own life, your own soul, your own purpose.

And the night—*oh the night*—with its multitude of stars shining so strong and vivid, your outstretched hand makes a shadow on the ground on a moonless night.

We spent days in the perfect May sun riding through the hoodoos. It was the Bryce Canyon Mule Days celebration. I fell in love with a mule named Wallapie. We stayed at the Lower 40 Ranch. We chopped our own wood. We tried to count the stars. There is nothing about Bryce Canyon that isn't pure magic.

- kk

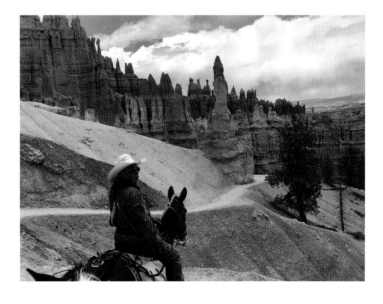

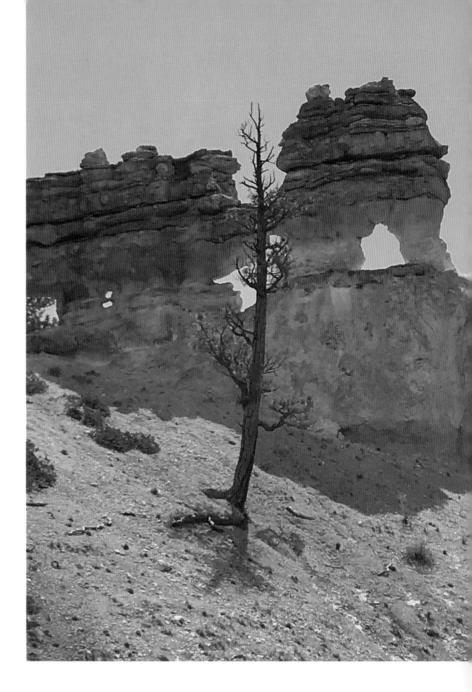

**Mule-Backed on Wallapie
among the Hoodoos**

First it was Venus.
One, I said. The long gap to two,
then *three . . . four . . .*
At *thirteen*, I was rendered silent–
a multitude of stars no longer countable;
our own *Lower 40 Ranch* kitchen lamp,
the only beacon for miles.

A day among the hoodoos, mule-backed,
shifting shoulders sideways along skimpy
paths
Wallapie knows by heart–
his steps, plucked and counted
until the next hairpin,
rabbit ears alert for rattlers.

My eyes, high among
those castle spires,
those cathedral bones.

Every night hoodoos fall,
rocks echoing across the canyon–
stone blind, wind weary.

I closed my eyes, heard their cracked voices,
their sandstone inflections;
their heat beginning to freeze.
This must be what the stars sound like.

In the morning, we will find the grand puddles
of their sudden shifts and spills along the trail.
Wallapie will stop, and rear–

two paws against the sky
from whence they fell;
the silver glint of his hooves
like the last morning stars.

- kk

Thor's Hammer

It stands
over the landscape

like it should be made
of copper

or some other ancient metal
covered in rust.

It appears as if it
were raised like a flagpole

or a medieval
engine of war,

dust covered slaves
tangled in ropes at its feet,

the air filled
with scarred foreman exhorta-
tions,

far off enemies already gauging
their level of fear.

- AB

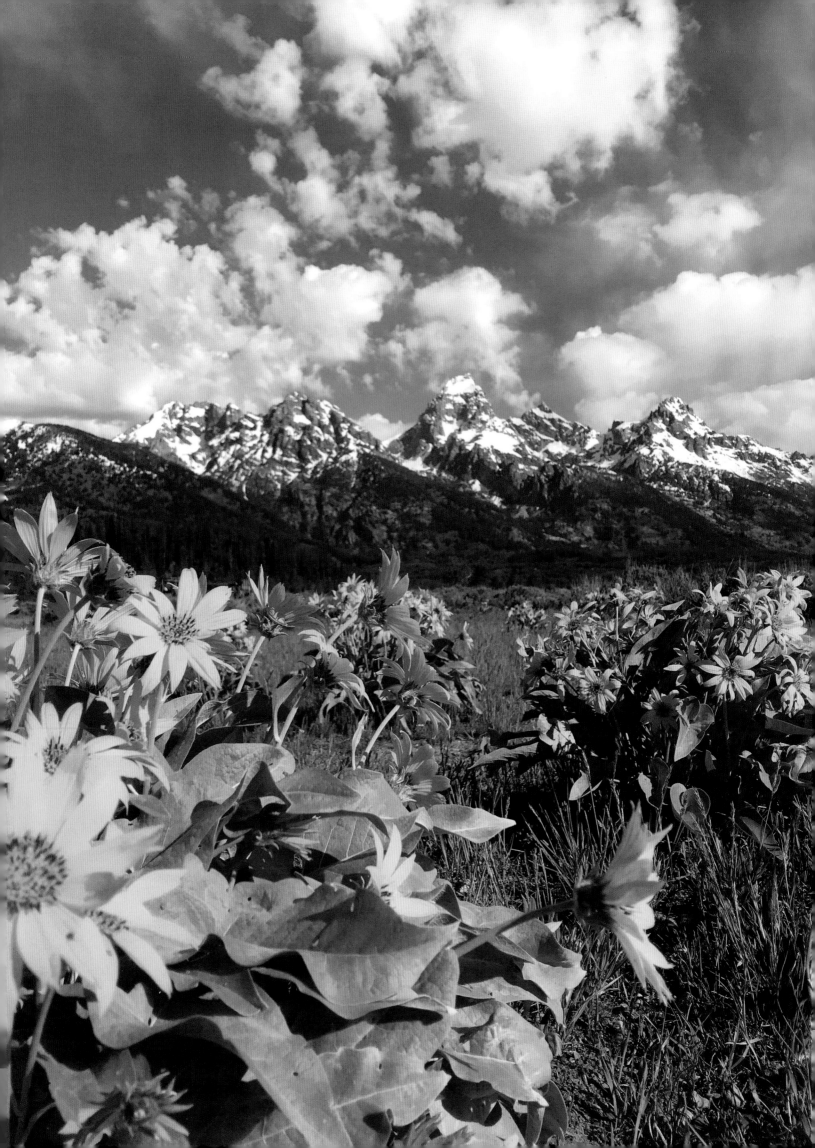

Grand Teton National Park

WYOMING

Grand Teton National Park, established in 1929 right next to Yellowstone, covers over 300,000 acres. Geologically, the mountains are young, still sharp. Erosion has not given them round shoulders. Jackson Hole is here and a myriad of snow- and glacier-fed lakes. Go not only to see the Teton Range but to explore, actually put your boots on the ground. Available hikes will take you through old growth of spruce, fir, and lodgepole pines. If you visit in the fall you will be able to witness the bursting color of aspens and cottonwoods. For those less active there are at least four excellent short drives within the park, all offering spectacular and unique scenery. Fishing trips and horseback riding are also available.

Jenny Lake and Jackson Lake Lodges, among several others, offer well-equipped and comfortable central points for exploring the parks. Plan ahead. As in so many of the grand western parks the lodges fill up quickly, even during the winter. This land is rugged and wild. Always be prepared for bears, rough terrain, and fickle weather conditions. Check with the Rangers before you choose any outdoor activity, any season. But once you are prepared, your eyes and mind will be filled with magnificence that only the Tetons can give you.

- AB

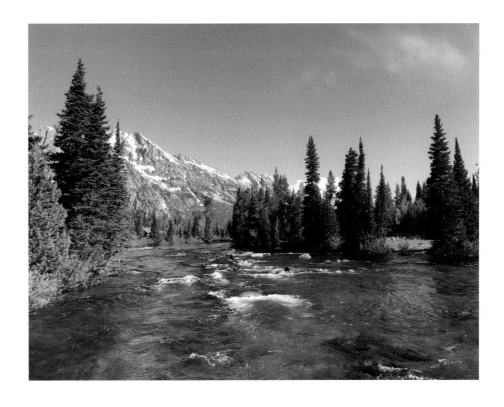

Song of the Tetons

Who are we now, we resident visitors,
miniscule among massive peaks,
these mountains, some of the youngest
of the planet;
tall and lanky,
sharp-shouldered teenage indifference.

Do they know we stand and stare;
how we dream of their permanence—
ours, the frail bodies of milk and blood
and hollow bone?

Had they voices, would they sing?
Would they dream of becoming the
weightless sparrow?
The mere homo sapiens?

Perhaps that's why they tremble and shimmy,
shaking boulders loose
like dogs rising from a pond
in a violent whip of water.

One morning, early,
the bed began to quiver,
and I swear I heard a tune—
a single humming note—

the same sound the ravens' wings make
when they fly—
low and closed-beaked
over my head,

even their bodies
unable to contain the song
of who they were meant to be.

- kk

Grand Teton

The glaciers will show elephant-skin gray,
but snow on the crust of Jackson Lake
will be white.

Back home there will be no spa or pool
that is anything like Jenny Lake.
There, in concrete security, any backyard splash,
you would be able to see down to the bottom.
But not here. Not there in the icy, secretive waters
of Jenny Lake.

Surely, your mind will say, there is a middle ground.
Perhaps a stationary girl with a sickle listening to
a thrush, or a man, a worn-down man, leaning on a plow.
Perhaps there will be two roads emerging from a
well-manicured wood and one will look less traveled.

But the Tetons do not compromise.
You may park your car at a turnout,
stand by the open door, and wait.
Your mind has been set for asphalt but not elk or canyon,
nothing as connotative as Snake River.
The washed concrete driveways your eyes are used to
are nothing like hot rows of mica or feldspar,
or any stone newly born a millennium ago.

Finally, you will climb back into your car
and drive away, letting your mind imagine, maybe,
a ship, an ancient thing
with a mythical creature for a prow,
there on the waters of a frigid lake,
carrying just a handful of people.

And the water, the icy, secretive water, will splash
as it has always splashed, the timbers will creak as
they have always creaked,
and the sharp teeth of the mountains
will threaten, in the bravado youth of their aeons,
to gnaw all sails, all snow-kissed oars.

- AB

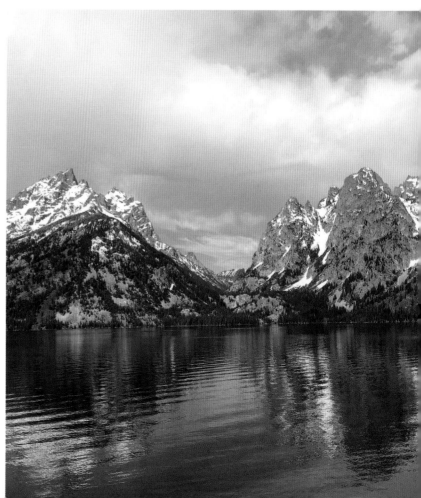

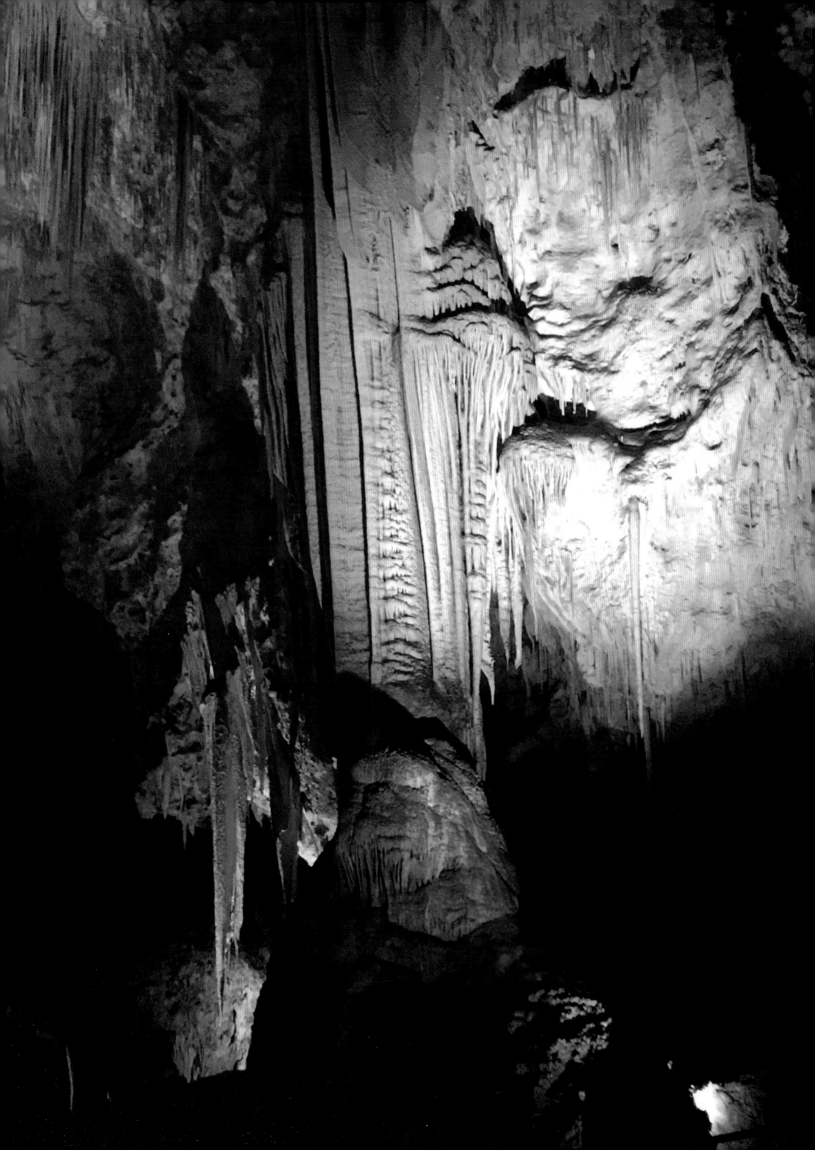

Carlsbad Caverns National Park

NEW MEXICO

These are some of the most famous caverns in the world, achieving Monument status in 1923 and National Park status in 1930. While the park preserves and protects 46,766 acres, below ground there are at least 118 caves with over 180 miles of known passageways.

Take the elevator seventy-five stories (one and a half times the height of the Washington Monument!) down to our favorite—the Big Room, 8.2 acres, longer than six football fields.

It could house the Notre Dame Cathedral. Take the self-guided audio tour. You will not be disappointed.

In the spring and summer, up to 400,000 Brazilian free-tailed bats come to roost and birth their pups here, creating a spectacular bat show, spiraling counterclockwise at dusk as they emerge. These beneficial creatures eat up to half their weight in insects every night.

Carlsbad Caverns actually sit underneath a part of the Guadalupe Mountains, making it a perfect destination after your visit to Guadalupe Mountains National Park. Put them both on your must-see list. You will be glad you did.

- kk

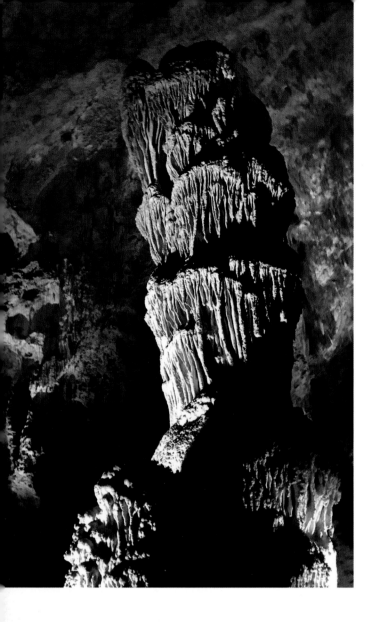

I saw saints down there.
I saw magic and delicate wonders formed
one drop at a time—
rain that took eight months to seep down into the
cave.
A patience only God and the earth can know.

Nights, still, I dream of its dark beauty,
hounded by the thoughts
that the devil was once an angel
who named his beloved dog Spot,

and who, maybe, as he was falling,
had one great momentary change of heart—

reaching wide to slow his descent,
creating the Caverns
while plunging through the belly of the earth,
before finally choosing brimstone.

Or perhaps this exquisite, sunless Pantheon is proof
that the Sufi's have it right:

we all go to the same place,
but some
bring their own hell
with them.

- kk

Mapping the Underworld

*from Wikipedia: Cerberus, the guard dog of the
Underworld, comes from the Indo-European word
Kerberos, which became the Greek word kerberos,
which was changed to cerberus when it went from
Greek to Latin. Kerberos means "spotted."
Hades, lord of the dead, literally named his
pet dog Spot.*

Remembering Persephone,
I refused the snack bar
seventy-five stories below the ground;
755 feet into the planet's black entrails;

unwilling to debate the borderline
between the Underworld
and this one;

the three-headed Chihuahuan Desert
unchained at the cave entrance.

Rule of 3

This cave will sniff
at your three sources of light.

Tell three friends where you
are going. Yes. Go ahead.

Seven hundred and fifty feet down
the wind that forms the stone draperies

will eat your candles
like a lost bobcat eats bones.

The flowstones do not believe
in the rumor of stars nor sun.

They are absolute in their belief
that the bats lie.

The stalagmites inexorably proclaim
with a limestone certainty

that three sources of light,
or the thought of three friends,

mean nothing to rocks
that remember Pangea.

They will show you their trilobites,
head-side showing ancient conquerors.

The expired Permian currency
of an absolute mineral truth.

- AB

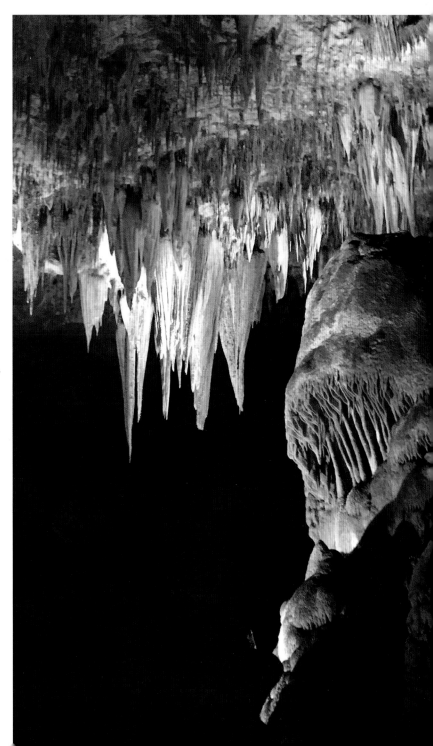

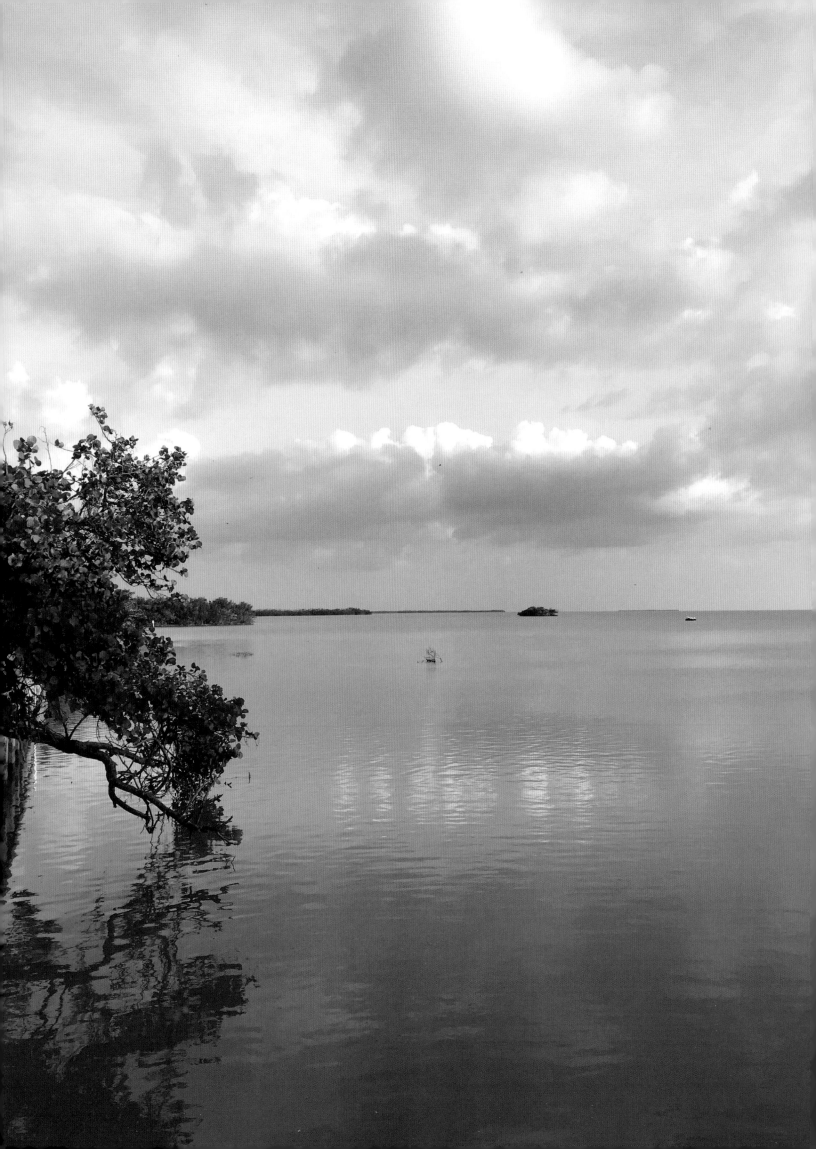

Everglades National Park

FLORIDA

This national park was one of the great surprises of our national parks tour. We, like so many, did not expect gorgeous freshwater so clear you can see the marine life swimming the sandy bottom.

Once upon a time, the Everglades stretched from Lake Okeechobee (near Orlando) all the way down the state of Florida. In their ignorance, our predecessors decided to "drain the swamp." The waters were indeed drained and built up with cities, and today, the delicate ecosystem of the Everglades now encompasses only 1,500,000 acres of far south Florida—saved by the naming of Everglades National Park. What they did not understand was that the Everglades are not swamps, but slow-current, fresh-water sloughs (pronounced slews). Sadly, Florida depleted their massive supply of fresh water and endangered hundreds of its flora and fauna. Many of these endangered species now take refuge in the Everglades, like the Florida panther, American crocodile, and the manatee, and this fresh water source and flow that slowly makes its way into the salty ocean is under total human control.

The Calusa Indians were here centuries before the first Europeans arrived from Spain, and the Miccosukee and Seminole arrived in the 1800s, their beautiful culture still a strong influence in the region.

Up the Fibonacci-like Lookout Tower is a great place to see the vast "Forever Glades"—how the park got its name. It feels like the open plains after the first spring rains—the earth unable to soak in the glistening waters. The winds are sweet. The grasses rustle, and walking along boardwalks lined with sunning alligators, you cannot help but whisper.

The airboat tours are big fun, and an unexpected treat was the nighttime, Ranger-led Starry Walk. It is not often we get to experience nature in complete darkness. The other senses kick in, and in the scents and sounds and feel of this wetland wilderness, you will soon realize there is no other place on earth quite like it.

- kk

Unexpected Beauty:
The Everglades

I did not expect forever Glades of sawgrass
like prairie,

or currents of fresh Water so clear
Fish glisten in the sunlight,

or thousands of Spatterdocks boasting one round,
lemon-like Flower.

I did not expect red
Gumbo-Limbo trees–
used to carve Merry-go-rounds,
thick with Pink birds,
or high Hammock Islands with tracks of Panther.

I did not expect to cradle Alligator
in my hands,
nor delight in his vulnerable Belly just under
his thunderous Heart.

I did not expect to look into
the pale-yellow compass
of his Eyes
and feel, in my own,
the slow-welling slough
of Beauty.

- *kk*

The Shore from Flamingo

How does this land break off so abruptly?
This is not the map of my youth.

I had already driven through
the Miccosukee land of tussock grief,

and strolled within a leg's length
of indolent alligators.

I'd seen the clear water of the slough,
and been scolded by anhinga.

But it's the reality of the torn-edge shore
that did not square with a six-year-old cartographer.

This terrain was not like Rainier or Denali
where even the most myopic eyeballs

will tell you that gravity, altitude, and
granite points are an obvious line

of painful demarcation.
The palms here give you no indication.

The breeze just waves you on
as your brain says there should be more land.

But you are grown now so you watch your feet
and unsuccessfully attempt to emotionally codify

this new geographic information.
As you stand there, still yearning for sand.

You decide it would be best
not to form a new religion here today

that includes a baby Moses.
He might end up drifting through the sawgrass,

reaching his saline destination
much too soon to fulfill a prediction.

- AB

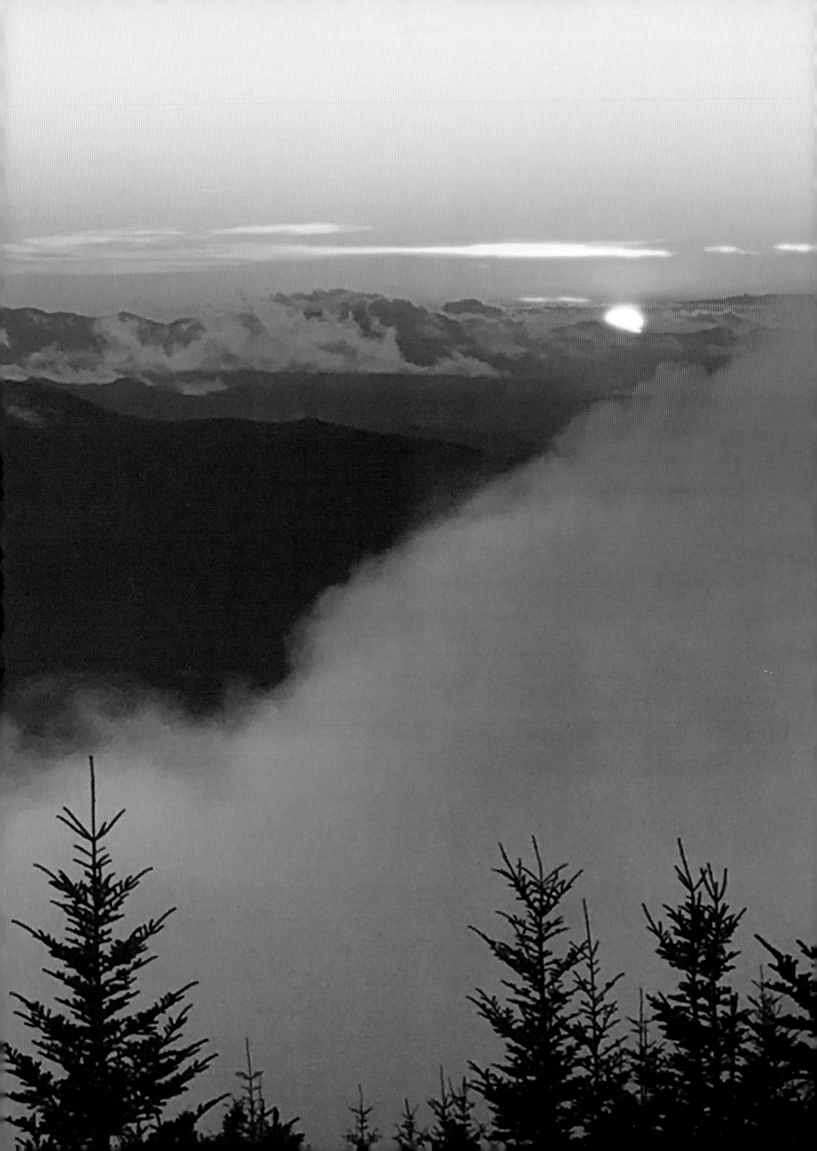

1934

Great Smoky Mountains National Park

NORTH CAROLINA AND TENNESSEE

Pigeon Forge was not the sleepy little town we imagined. We should have expected the crowds, since The Great Smoky Mountain (dedicated June 15, 1934) is the most visited national park—one-third of the US population can drive here in a day!

Visitors seeking solace must work a bit harder here and try not to be put off by the multiple hour, bumper to bumper eleven-mile one-way Cades Cave Loop Road.

Indeed, the Smokies are afflicted with the great dilemma of how to offer the beauty of the wilds to millions of people, and still keep it wild. Our world is experiencing a nature-deficit disorder and desperately needs these spaces—needs access to the very wilds we try to preserve and protect. It is a problem our Rangers struggle with every day.

It is a much-needed space, but holds a sordid history of displaced indigenous peoples, such as the Cherokee, who had permanent homes, farms, and culture here, yet were forced upon the Trail of Tears to Oklahoma in the 1830s. Another sore spot close by is the Road to No-Where, from when the war effort called for more aluminum, and villages and towns and heritage sites were lost to the Fontana Dam. To this day, the people are still owed over forty million dollars from the original settlement promised in 1943. It is a deep, open, sensitive wound.

But there is great beauty here, in the 522,000 acres beyond the traffic. There are black bears and deer and elk. There are waterfalls hidden among these old mountains, and sacred spaces that need to be saved for the next seven generations.

- kk

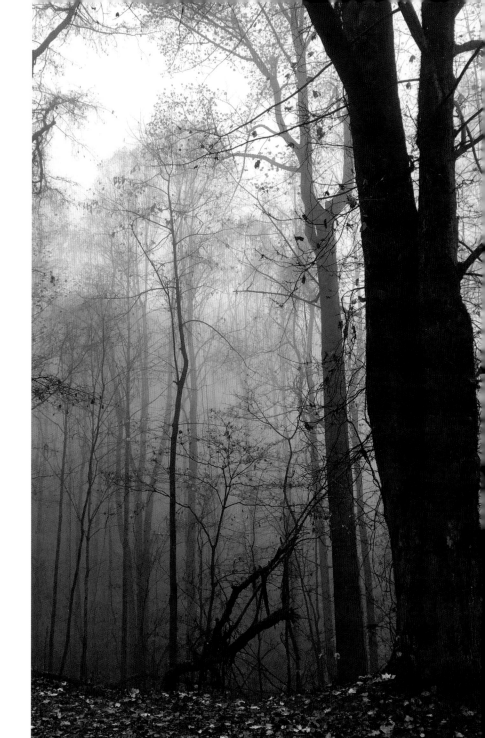

White Bear

Somewhere in these Smoky Mountains,
White Bear reigns over
the lake Cherokees believe
heals all wounded bears.

How forward to think bears
experience sanctuary–
that they know where to go
to save themselves.

I can imagine them there,
crippled, bleeding,
hobbling on all fours
into those waters,
the succumbing faith of submersion;

then lifting up, paws first
on two feet,
water spilling off thick fur,
renewed with the blessing
of second life.

Maybe that's why she let us go
on that trail,
when we quick-stumbled upon her feast
of sweet berries -

the reason she let us move slowly backwards
down the mountain,
hands up
in full surrender.

- kk

Obscured Truth

It would mostly be
an after-the-fact
Untruth but not much

if I said
that as we drove
the twisting roads

through the park as a detour
because there had been an accident
on the main highway

that we thought about
these three things
in the following order:

How can we pass anyone
when this road is one-lane,
the oak leaves falling

like purposeful orange
and brown handkerchiefs?
Should we roll down the window

and shout out a warning
to the woman in sandals,
carrying the paper cup of coffee,

who was climbing through
a mound of poison ivy
in pursuit of a photo

of a mama bear and cubs?
Or should we just be patient
and drive until we clear

this green and misty tangle.
And, then, this evening, stand
at the state line and watch

as the trees call the smoke in,
wrapping it into the valleys,
and crevices, the hidden rivers and dens,

sharing it into the folds of our coats,
our pockets,
the sharpness of our eyes,

letting us only imagine
what is forever hidden
beneath the antiquity of spruce.

- AB

Becoming Bear.

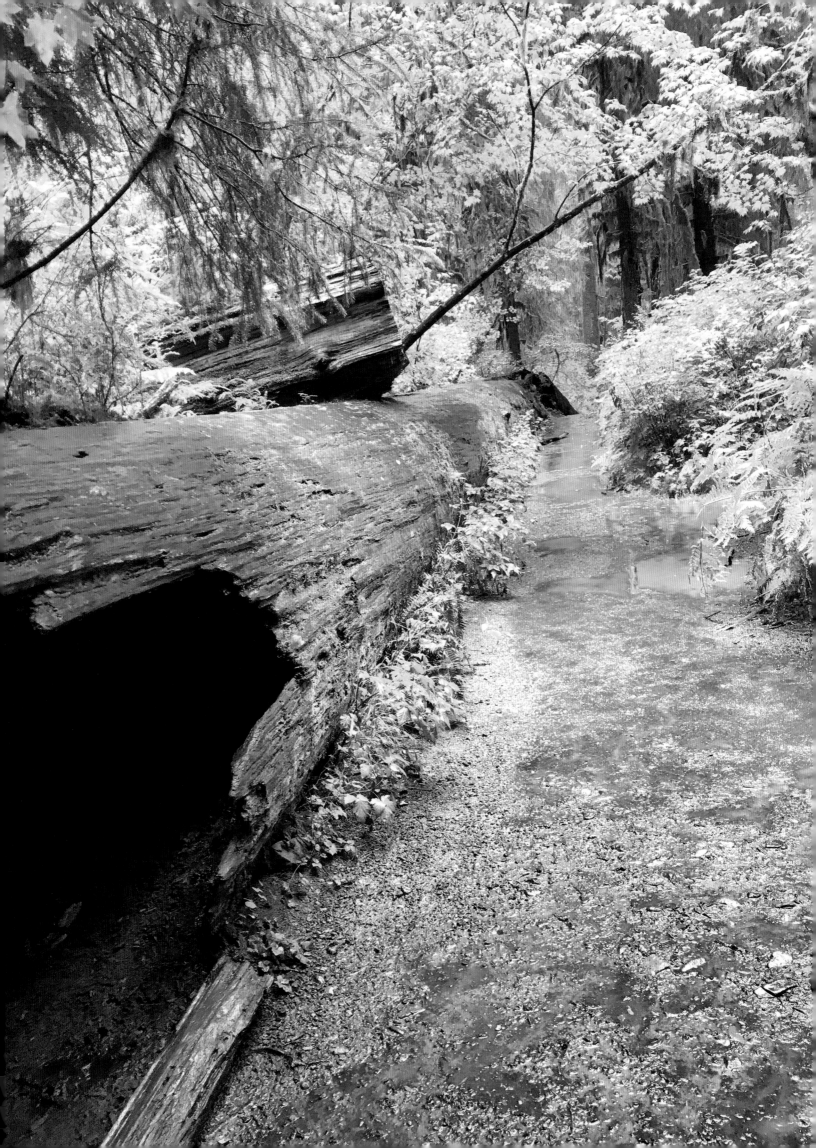

Olympic National Park

WASHINGTON

There is so much to do here, so much to see. Imagine the grandeur of Redwood National Park in California. Now, move north to Washington state and add awesome three hundred-foot Sitka Spruce, Douglas Fir, and Western Hemlock trees, seventy miles of wild coastline, primeval forests, rainforests, and glaciers. The Hoh Rainforest alone will make you stop so still, you can feel your own heartbeat.

Green. Green Green Green. How many layers of green can you imagine? Well, multiply *that* times a hundred, the wet side of the park receiving 138 inches of rain each year. It was raining, of course, when we visited the rainforest. Luckily we packed our raincoats and Xtratuf boots. It felt good and rich and clean and abundant.

There are more organisms in a given area in rainforests than anywhere else on the earth, and the Hoh Rainforest is a magnificent must-see, with its clubmoss and licorice ferns and lichens covering everything in the most gorgeous green gilding.

This park, which Theodore Roosevelt named a monument in 1909, and his distant cousin Franklin D. Roosevelt named a national park in 1938, also protects the Roosevelt Elk that live in these 922,651 acres. FDR was too late, however, to save the wolf, which was hunted to extinction on the Olympic Peninsula in the 1920s. We have made so many mistakes as humans against Mother Earth, but that is exactly why these national parks are here—and why we do what we do—to save what we can save, and protect these sacred lands, their flora and fauna, and preserve them for eternity. Join us in our quest. Our earth desperately needs it, our humanity depends upon it, and as Chief Seattle said, we are all connected: "If all the beasts were gone, man would die from a great loneliness of spirit. For whatever happens to the beasts, soon happens to man."

- kk

A Fallen Nurse Log:
A Douglas Fir 87 Steps Long: Hoh Rainforest

It's as if we've opened
the long door
to grandmother's attic;

the world doused
in thick green dust.

Hundreds of years
throbbing below
the cluttered floor.

Here, our past, our DNA–
all of us
tied somehow to this one space.

We don't know
how long we get to stand—
our face, our arms
lifted to a single strand
of sunlight.

Yet still we do,
as day turns to night;
as the stars whirl,
and the Pacific
pours out her heavy heart.

This world
both harsh and tender,
casket and cradle
in the same
moment of time.

- kk

Walking the Beach at Kalaloch

We all need driftwood
but nobody ever tells you this.
They will tell you
that you need a good quilt

or wrench or lawnmower.
A good job of course.
Friends. Maybe an ox.
Some goats. A purpose—

like maybe a quest to Mecca.
When you are in the first grade
you only need pencils
and a colored thermos for status.

But no one ever mentions driftwood.
For us there was the carcass
of a redwood, beached, resolute today,
just above high tide.

A coffin from the forest we slowly paraded around.
Pacific waters were fingered in,
like the last of the non-family,
making the body sink a little deeper.

We wanted to carry it home, this big holy body,
or even one of the smaller pieces,
from a wall of salt-bleached bones,
that dared us to touch it,

to touch its forehead, its exposed arms.
After the procession, we wanted to take pictures
of living cousins, birds skimming,
shaded roads people told us to see.

When we got back home
we didn't know how to talk.
People gave advice on what we needed,
some rest and a good wine to maybe loosen our
tongues.

- AB

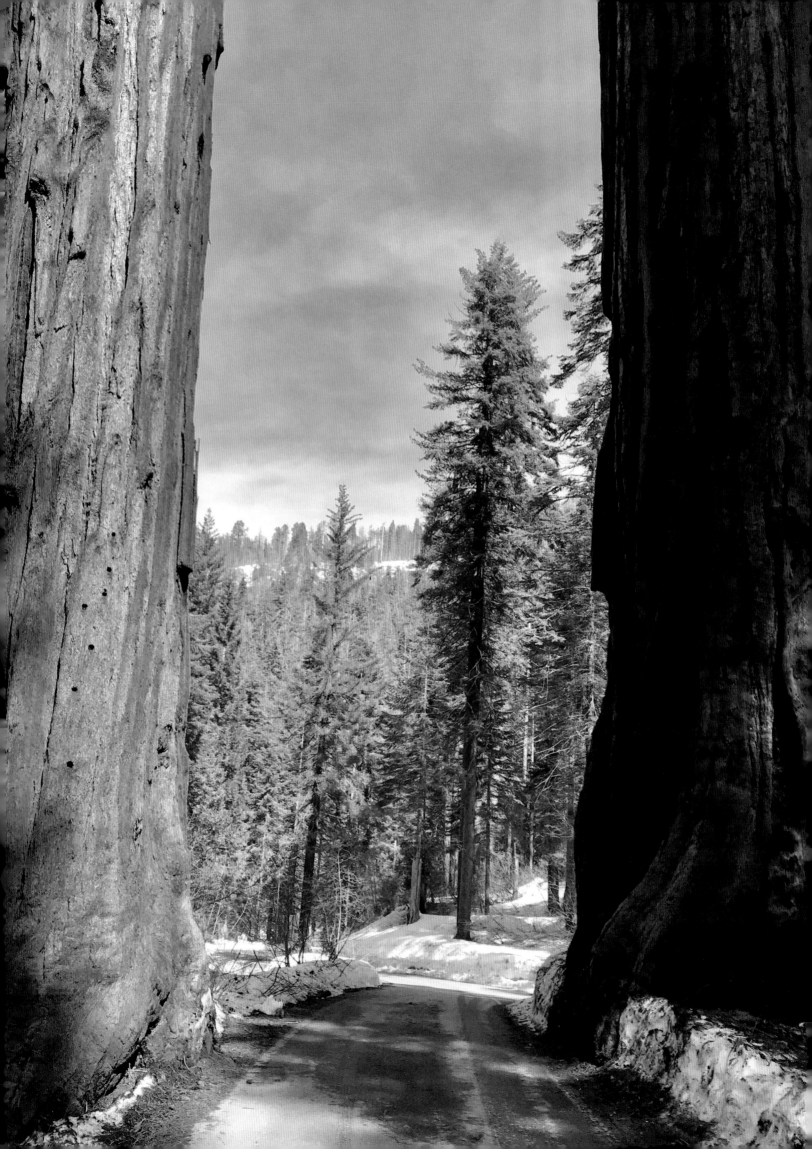

Kings Canyon National Park

CALIFORNIA

These are the trees of your dreams. While the redwoods are the tallest trees on earth, the sequoias are the largest on earth. The General Grant tree in Kings Canyon National Park is the widest tree on the planet, at forty feet wide. It takes twenty people holding hands in a circle to measure around that tree, and it is very young for a sequoia, only 1,700 years old. Imagine what has happened in this world in 1,700 years. And what is heartbreaking is the number of giant sequoias cut down before the National Park status could be designated. A tree similar to the General Grant was cut down in 1891. Over three hundred feet tall, it was named the Mark Twain Tree. It will take another 1,700 years to replace that tree. I wonder if loggers ever took the time to consider that before they took to the axe.

It was March when we visited the two parks, a March with record snowfall. The visitors center had snow higher than its roof. They had to cut out roads, not just clear them. We learned how to put snow chains on tires, did snow-shoe hiking, warmed ourselves by the hearth at the John Muir Lodge.

The National Parks of Sequoia (named in 1890) and Kings Canyon (named in 1940) are really one great big park, the border of one leading into the other, with the General's Highway connecting the two. Kings Canyon is a big tree mecca. Go. Stay. Wander. You will leave refreshed from the breath of these giant beauties. Tell your tales over and over again. Remind the next generation why we need to preserve; why we need to protect.

- kk

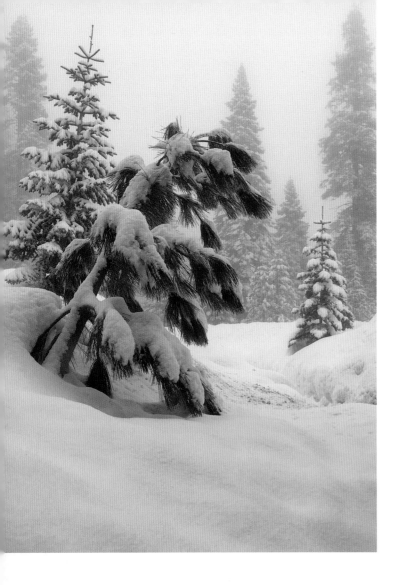

The Sequoia

These places,
and what I mean by these places
is this land - two parks French kissing
Jaws, lips, river tongue

A cold tongue
Something you step in after the hike
Twisting the blue bandanna–
The cool mop of face

Realizing seeds sasquatch into this
And what I mean by *this* is hard to describe–

Though standing here
I can tell you nothing else matters in the world
at this moment,
The brain absorbed in some kind of stunned
witness

And you reach out and feel these trees breathing
in their tough cinnamon-coconut-bark way

And you rope your eyes up 20, 100, 300 feet

Your body
Your body knows
Your neck at its zenith–
its maximum ability to see, *oh my God,*
this living thing that has watched
what we do to each other

and to *its* each other,
chewing without consciousness or taste

But your body knows. Head back, it knows,
it trusts the thin muscles of the neck to hold,
to hold taut
the jaw open–

Wonder,
the rise and fall of it,
finding, finally,
its dark wild way
inside

- *kk*

Travel Plans

According to my zodiac sign
I am supposed to travel this month
to Chilean Patagonia.

I am told there will be glaciers, hiking,
and horseback riding at the end of that continent.
The main tongue there is Spanish,
something I am not skilled in.

Distances, according to the travel guide,
are vast. I should be prepared to travel many hours.
And I must have my paperwork in order
to cross between countries.

But it is March here in Grant Grove.
The snow is deeper than the roof of my house.
I see the wandering tracks of deer,
the stories of foxes following rabbits,
the strange Sanskrit of the march of crows.

Only vertical distances here are vast.
My horoscope does not mention
sequoias in my future yet here they are.
I can touch them. I am sure they can feel my heart-
beat.

As I walk over the snow
I leave my own footprints, sixteen feet closer
to the crest of branches. I did not need
another language.
I did not need to travel hours
to imagine myself at the top of the trees,
looking out, looking out.

- AB

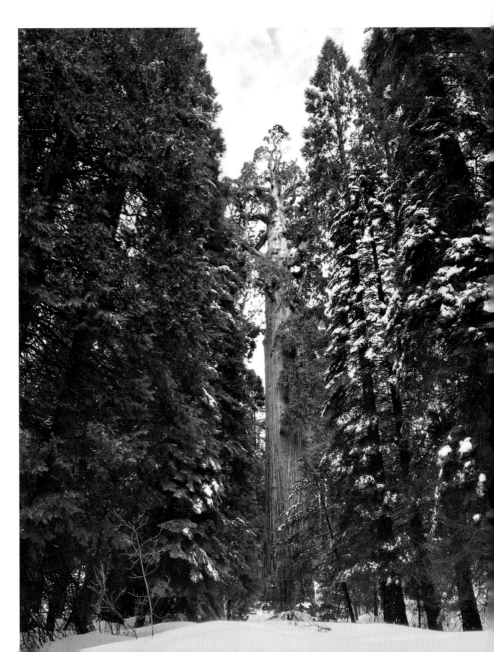

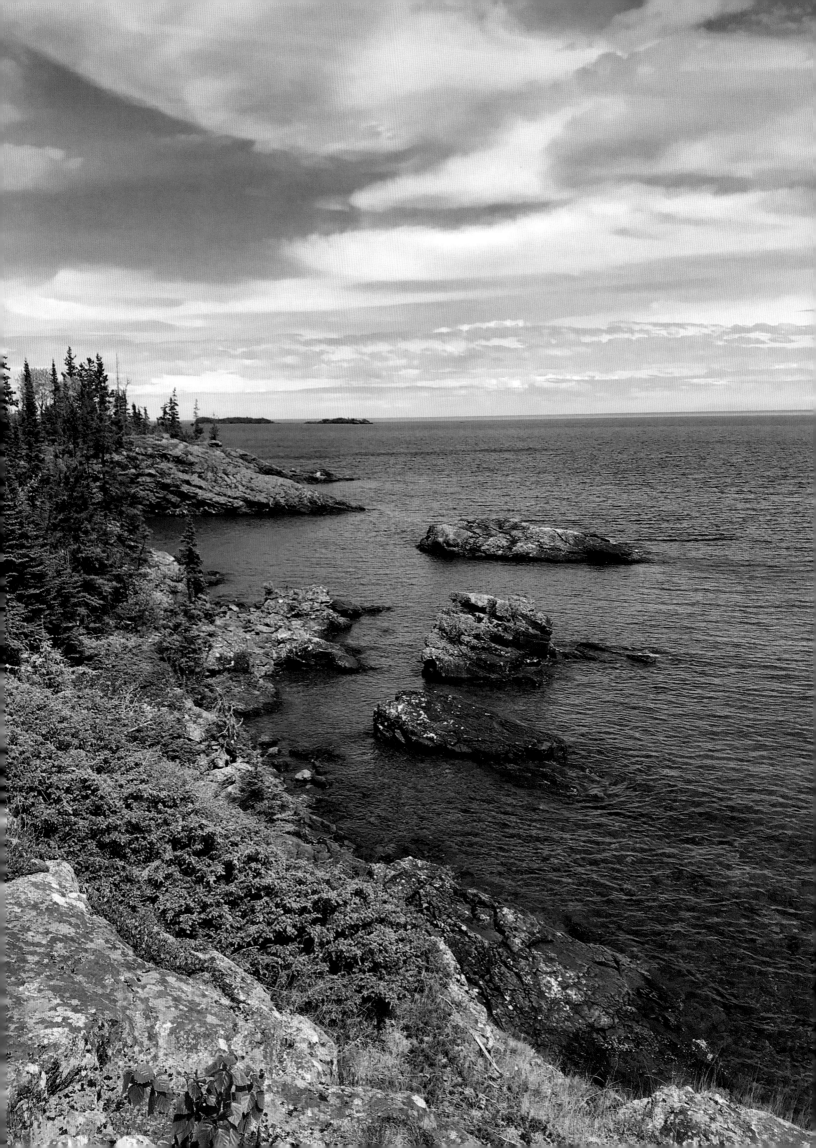

Isle Royale National Park

MICHIGAN

Isle Royale is a park few people even know about—and you have to work to get here. In 2018 this was the fourth least visited of all the national parks. This is not a drive-through park and does not align with the vast monumentalism of the western parks like Glacier, Yosemite, and Yellowstone. Isle Royale is the only national park to shut down entirely in the winter. (This park-shutdown count includes the parks in Alaska and other lower forty-eight northern parks.) The weather conditions can get extreme. Yet, for those willing to make the effort, this is one of the most rewarding of all the national parks.

The main island is forty-five miles long. The isolation here is almost complete. No cars are allowed. The park is actually an archipelago, with the main island holding the visitor center and lodge. The purpose of the park is to protect and preserve wild nature, including wildlife such as moose and wolves.

It takes a three-hour-plus ferry ride to get to the lodge and visitor center. The ferry boat holds one hundred-plus passengers. There is more than one place to catch a ferry, and multiple scheduled times of departure. One of the most popular departure points is from Copper Harbor. Plan to stay at least one, if not two nights in Copper Harbor for both the shopping and the restaurants.

Planning for this park involves coordinating how many days you wish to spend on the island, if there is room on the ferry, what the weather is like, and what you plan to do while you are there. Be aware that while the park itself may be closed during the winter, the ferries may still run; always check with the park service first to determine their operating calendar. Then call the ferry service. A one-day trip from the mainland is tight but doable. You'll enjoy the park more if you stay a few days. The park Rangers offer informative talks. You can rent kayaks or canoes, and concessionaires offer mini-cruises. Take the Sunset Cruise. The captain will take you around the islands and point out places of interest (we especially liked the post office box). There is lodging on the island (different tiers and pricing) and a dining room. Make reservations weeks, if not months, in advance.

- AB

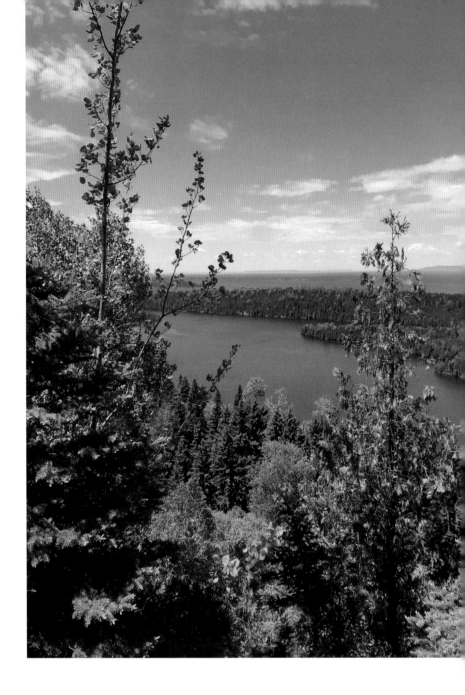

In the Beginning:
Isle Royale National Park

I like the way my boots thrum the bass drum
of this earth,
as if stretched taught with hide,
and centuries of fallen fodder.

The lichen coming first:
the Crustose, the Foliose, the Fruticose—

their open-jawed bodies
leaching boulders
dropped from the belly of glaciers;

slowly turning rock
into dirt,
dirt into cowslip and juniper.

And in the bogs,
the carnivorous Pitcher Plant and Sundew,
throats wide,

waiting with the patience of stars
for the naming of all tiny bog-bound crawlers—
the spider, the moth,
the black ant slick with moonlight.

- kk

The Day after the Hike

I made us late this morning.
Last night the lodge had no hot water.
My pillow was going to dismay the maid:
It smelled of pine sap and marsh marigold.

Yesterday I had hiked to the lookout;
As I ascended those old, gray boulders;
they accepted my boots as if they
were newly-recovered relatives.

Libraries of birch bark
fell to the ground like curls of papyrus,
telling copper-stained stories
to the bog.

Late, later in the morning than we agreed,
I heard her concerned knocking on my door.
How could I unapologetically greet her,
my eyes dreamy with thousand-foot deep waters,
my shoes stained with butterwort?

- AB

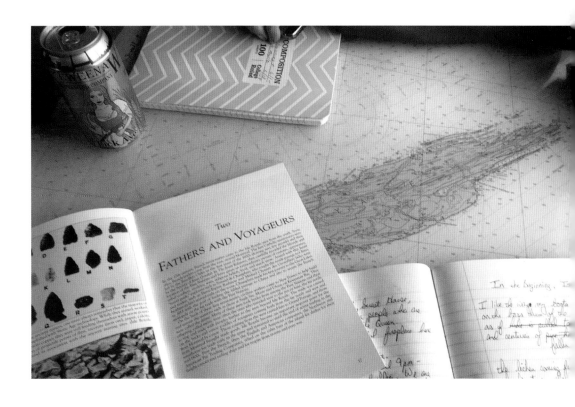

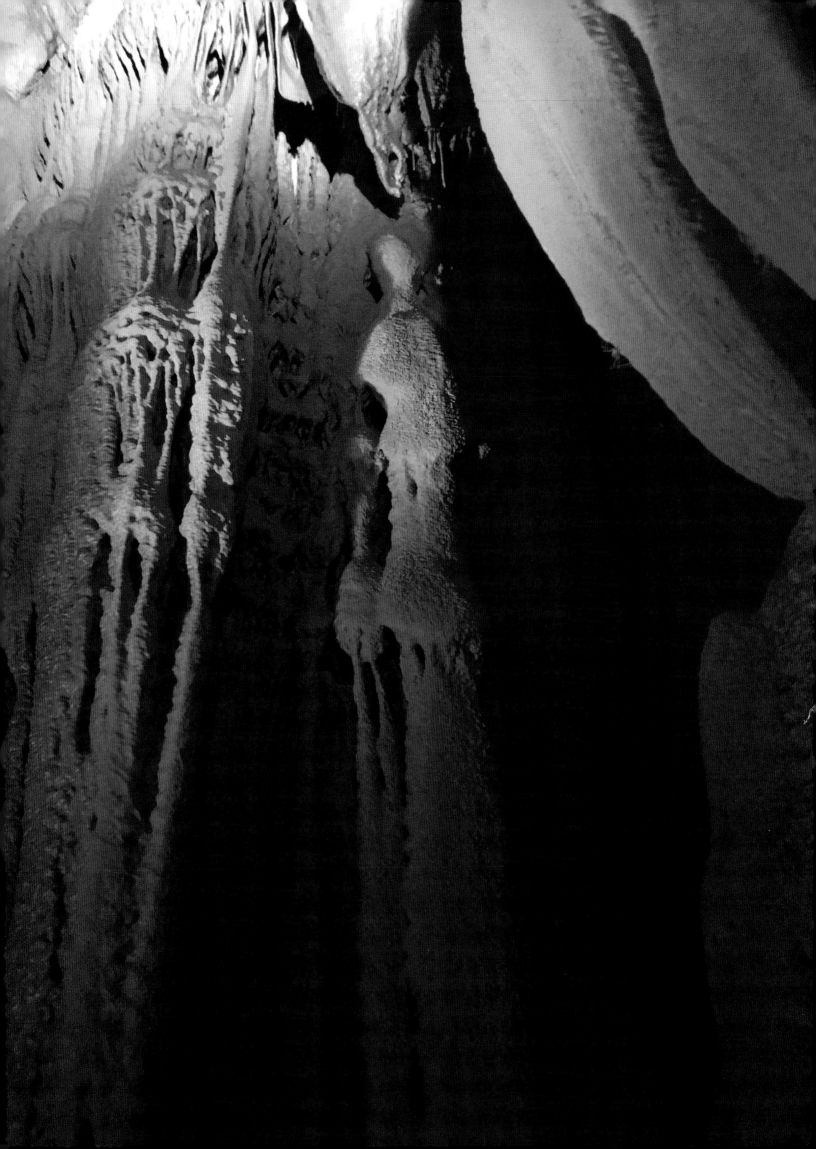

Mammoth Cave National Park

KENTUCKY

Kentucky used to be a tropical sea about three hundred million years ago. Limestone formed hundreds of feet thick on the floor of that sea from all its organic material. As the earth's water levels dropped, the remaining underground rivers carved out passages through this limestone, leaving the grand caverns of Mammoth Cave. It is the world's longest cave, with over four hundred miles of mapped passages so far. It was named a national park July 1, 1941. The human history leading up to the naming of this eastern park is both fascinating and harsh (read the book *The Kentucky Cave Wars*), but indigenous people used the cave three thousand years ago to mine salt and gypsum. It was also mined for calcium nitrate in the early 1800s for gunpowder—vital in the War of 1812.

Take a couple of Cave Tours—there is everything from easy upright to crawling, and the Rangers are, of course, experts down there. There are thirteen species of bats here and an eyeless cavefish that can live up to sixty years in complete darkness—even able to go two years without eating! Another great visit is to Echo Springs to watch the underground river bubble up to the surface, eventually joining the Green River. This world is so big and so full of things yet to discover. What are you waiting for?

- kk

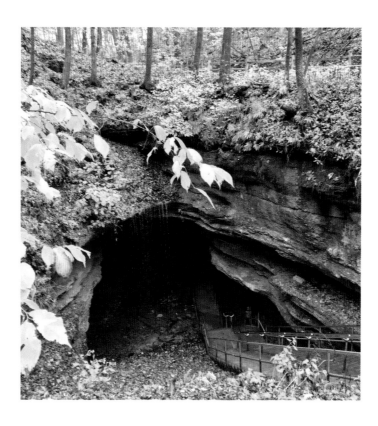

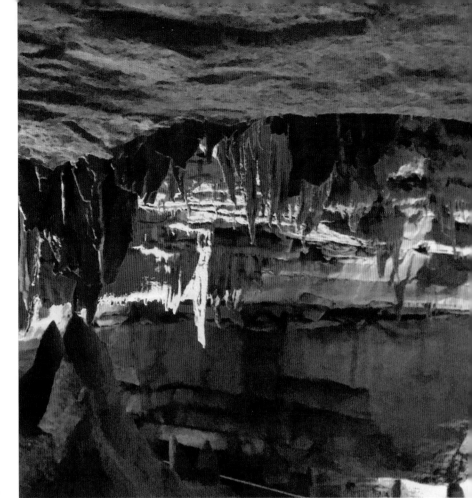

Spelunking

We stepped from the light
down beneath a ceiling silent and dry
as a West Texas riverbed,
where limestone kicks up fossils and points;
niches for cooling rattlers.

The river sleeps
in late summer droughts,
sound whistling through junctions
of ravine and cave,
then downward,
its wide mouth opening.

Among us, Cavemen still–
those thrilled to wrestle tight rock grips
and shimmy stuck torsos;

headlamps like a midnight eye
to share;
to see in the dark;
searching for some unknown answer
down among blind crawfish

and colossal stalagmites
that will never know
the feel of light upon their beauty;
the hot weep of sunshine.

- kk

November Diary at Echo Springs

Here in the cold on the outdoor bench
she shivers just a little in her blanket
but she still maneuvers her arms free enough
to write,
little furry gloved hands showing,
one to hold down the pages,
the other to urgently push the pen
across each line of the journal.
She always urgently pushes the pen.

She writes in her perfect handwriting
the events of her day,
yesterday, maybe the drive the day before.
The wind, sifting through the sycamores,
convinces the leaves to fall, to fall together,
clusters, spiraling in clouds the eye cannot count.

Echo Spring bubbles right there in front of her.
It makes ripples and currents in the water.
It traps leaves against the bank,
not allowing them to escape downstream to the river.

That water is coming up, on its own compulsion,
from the cave beneath us,
from some chamber, some cool place,
in the dark, filtered by soil and stone.

And here, by the spring, by the river,
there might have been houses once,
someone who needed this place,
someone who knew generations
of Novembers and sycamores
and springs from hidden places.

Oh, the voices in the cool dark.
Oh, the voices that still echo in the stones of the
river banks.
Oh, how greedy we are for things.
Oh, how we need and need.

Here in the cold on the outdoor bench
she shivers just a little in her blanket
but she still maneuvers her arms free enough to
write.

Her little furry gloved hands are showing
to urgently push her pen
across each line of the journal.
She always urgently pushes the pen.

- AB

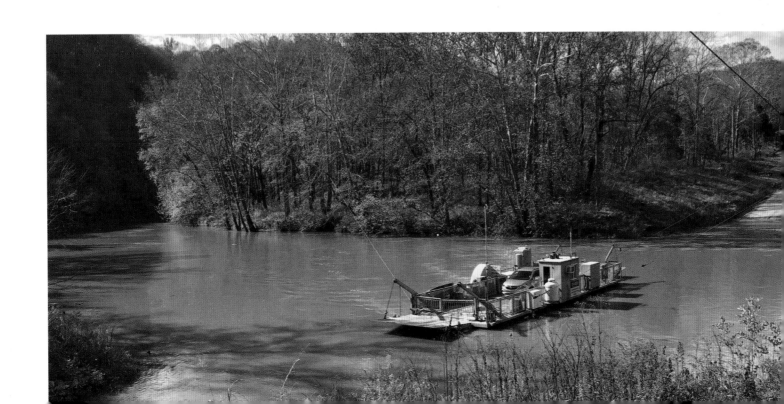

Big Bend National Park

TEXAS

In the great map of Texas, the Rio Grande River makes a big bend right here, southward, then turns north again to form the iconic elbow that hangs down into Mexico— where the park gets its name. The river runs the border between Texas/US and Mexico for 118 miles. There is even a Mexico crossover area for those who have planned and prepared with passports at Boquillas Crossing . . . except for Tuesdays. Don't go on Tuesdays. Mexico is closed on Tuesdays.

But *do* go to the Chisos Mountains for the famous Window View Trail, or the much more strenuous Window Trail (to see where rainwaters flow out of the basin).

One thing we have learned from Big Bend, and especially its sister Guadalupe Mountains National Park, is when Rangers say a trail is strenuous, they (without expletives) mean *strenuous.*

Do take the Ross Maxwell thirty-mile Scenic Drive to Santa Elena Canyon, and most definitely *do* hike down to the Langford Hot Springs, where, in years before being named a national park, people made the big pilgrimage to soak in these healing waters.

It is smack-dab on the Rio Grande River. Soak, climb the rocks to cool in the cold Rio Grande, then quickly climb back into the cozy hot water.

Give yourself time to explore the surrounding areas of Lajitas, the fascinating cemeteries of Terlingua, the Marfa lights, and as a special treat, give yourself a night or two at the Texas-elegant Gage Hotel in Marathon.

- kk

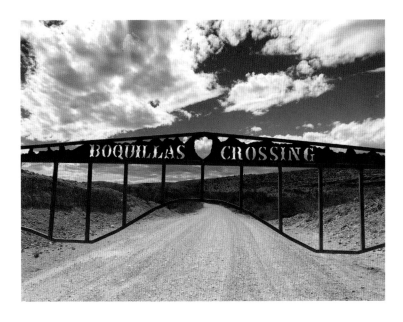

The Hunger to Know

I want to learn about the fields and muds
from the fields and muds.

I want the burst of flowers
to champagne through my blood.

I want to sit so sharp and silent,
Rattlesnake rises from her nest,

and sifts the sand from her paper bells,
and passes me by in a slow

muscle of lightning;
the desert floor seared pink into glass.

- kk

**The Rio Grande and the
Langford Hot Springs**

The bravest of us
climbed over
the remnant of the bath-house walls
and slipped into the chilly Rio Grande.
The current was swift but not dangerous.

A few sure strokes would have put us
shivering in another country.
No one but us two tried to decipher
the pictographs we passed on the high stone walls.

No one but us two tried to calculate
how long it would take
the adobe of the abandoned post office
to crumble into the river.

We scrambled back over the mossy rocks
into the hundred and five degree water.

Sitting next to us
the young hiker with the unintelligible tattoos
thought he would live forever.

- AB

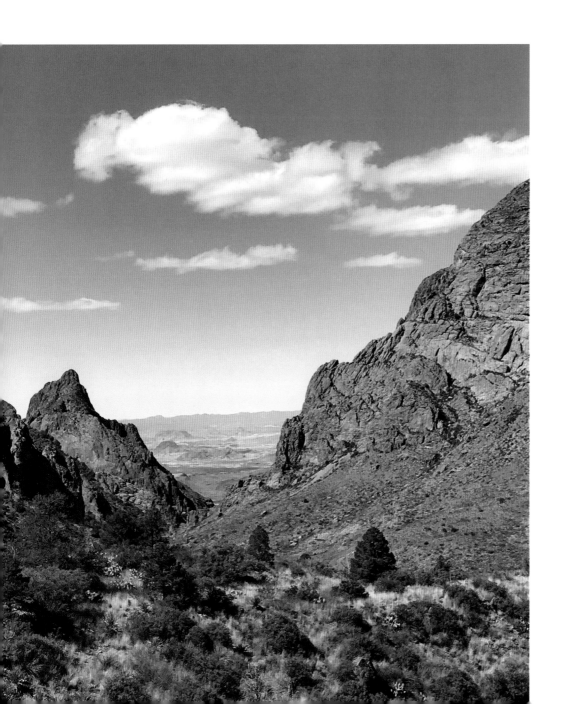

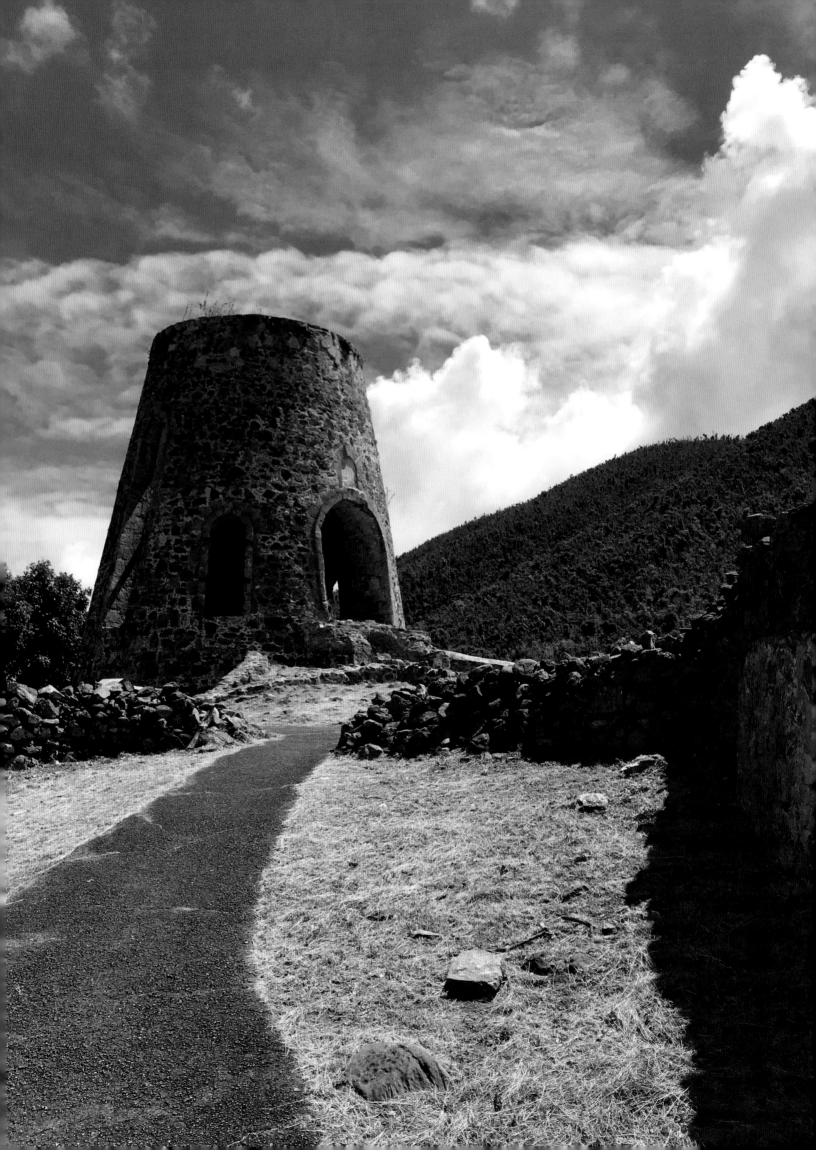

Virgin Islands National Park

US VIRGIN ISLANDS

This is one of the newer national parks. It has a history that is tied inextricably to slavery and sugar cane. Disputed for years by various nations, the islands were finally fully secured by the United States in 1917 and made into a park in 1956.

St. John is the heart of the park, all nineteen square miles, but the park itself actually covers scores of smaller islands. The national park only owns slightly over half of St. Johns. The visitor center is in Cruz Bay, a short distance from the ferry that brings you over from St. Thomas. (To get to your lodging you will probably need a car. Rent it in St. Thomas and take the car ferry over.) This is a rugged island with few roads. Narrow streets. These are mostly volcanic black rock islands—and many of the plants on the side of the road are not friendly to skin or shoes. There is some limestone, some flint—and lots and lots of coral at all elevations.

The beaches are smooth and beautiful. Snorkeling is rewarding. The visitor center is right across the street from one of the best shopping and restaurant areas. Other than the beaches, there are some parts of the park that absolutely should be visited: the Annaberg Ruins and the Petroglyphs. These are adventures you should read about, and take, on your own. I can only say that after sixty-two national parks I have never seen petroglyphs that looked anything like the ones on the Virgin Islands.

When we traveled here, the park, and the island, were still recovering from two hurricanes in 2017. Much of the tourist-friendly commerce has bounced back, but there are still infrastructure issues. Do not let that distract you. This is a beautiful, tropical national park. You can easily make work feel like fun.

- AB

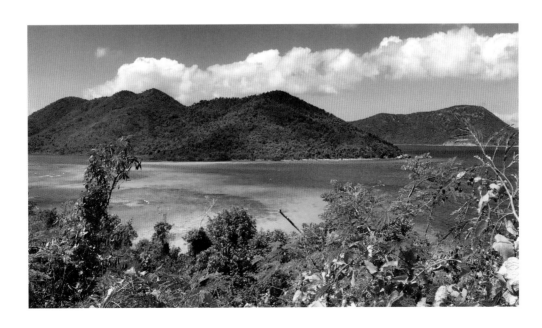

Manzanilla de la Muerte:
Little Apple of Death

It's a *people* park:
murmuring voices in Danish, Creole,
Jamaican, British, French;

fishhook bracelets on each wrist
like wedding rings.

A thorny island,
everything pierces, stings,
the Manchineel–
the deadliest tree on earth–
tempting in tiny apples among the iguana.

Life here is short, intense, brilliant;
each day between storms
a beautiful battle for survival–
guppies of minutes devoured
in the jaws of hours.

Locals share secrets
of ancient heartbeats in petroglyphs;
watch the wide eyes
of the tourist few

who become part of this place;
who give in
to the little death of love–
its mortal, fleeting beauty;
who turn fishhooks heart-ward.

There is always forbidden fruit
and a whispering reptile
in every Eden;

always a beauty that will break your heart,
for the hurricane comes.
The hurricane always comes.

- *kk*

Virgin Islands—Annaberg Ruins

Somehow it is comforting
to have another person beside you
when you are driving
on the wrong side of the road
and the jeep is constantly teetering.

And you are watching for iguanas.
And your brain is still trying to sort out
the monkey-eyed petroglyphs
that reflected oddly in the green pool.

This place wasn't the mountains
we were used to seeing.
And then there was the moment
there at Mako Beach
and the lady with the silver hair.

Maybe it might not have mattered,
the color of her hair
but it was silver. And of course it did matter.
At least here, for this brief, volcanic moment, it did.

The younger man with her
was knee deep in the water
walking up beach.
She was older.
She had deeper lines in her smile
than he did.

And suddenly, there we were
at the dungeon at Annaberg.
Looking over the key.
There is still sugar cane growing on the island
but you have to know where to look.
Looking. This place demands you always look.
You'll think things are brief here,
but they aren't.

Coral was embedded in the stone plantation walls.
Here was evidence.
And then we were at the dungeon.
Whoever was imprisoned there could see
through the narrow, unbarred window,

the big house up on the hill,
and the main pier for loading and unloading
sugar, rum, slaves, frilly things.

And there on the wall of the dungeon,
someone had drawn the house.
And they had drawn a boat,
sails and rigging intact and perfect.

But there were no women with silver hair.
No younger men with them walking up beach.
They drew what they saw,
like images in a cave.

The air was full of rum and sugar.
There was the dust of stones
kneaded with embedded coral.
There were the washed bones
of hurricanes littering the shore.

It was good to have someone beside us
as things temporarily teetered.
Maybe your hair was silver.
Maybe I was knee-deep in the water.

And maybe there would be nights
holding me captive,
filled with dreams of ancient monkey-eyed
petroglyphs
reflecting oddly in green, shallow pools.

- *AB*

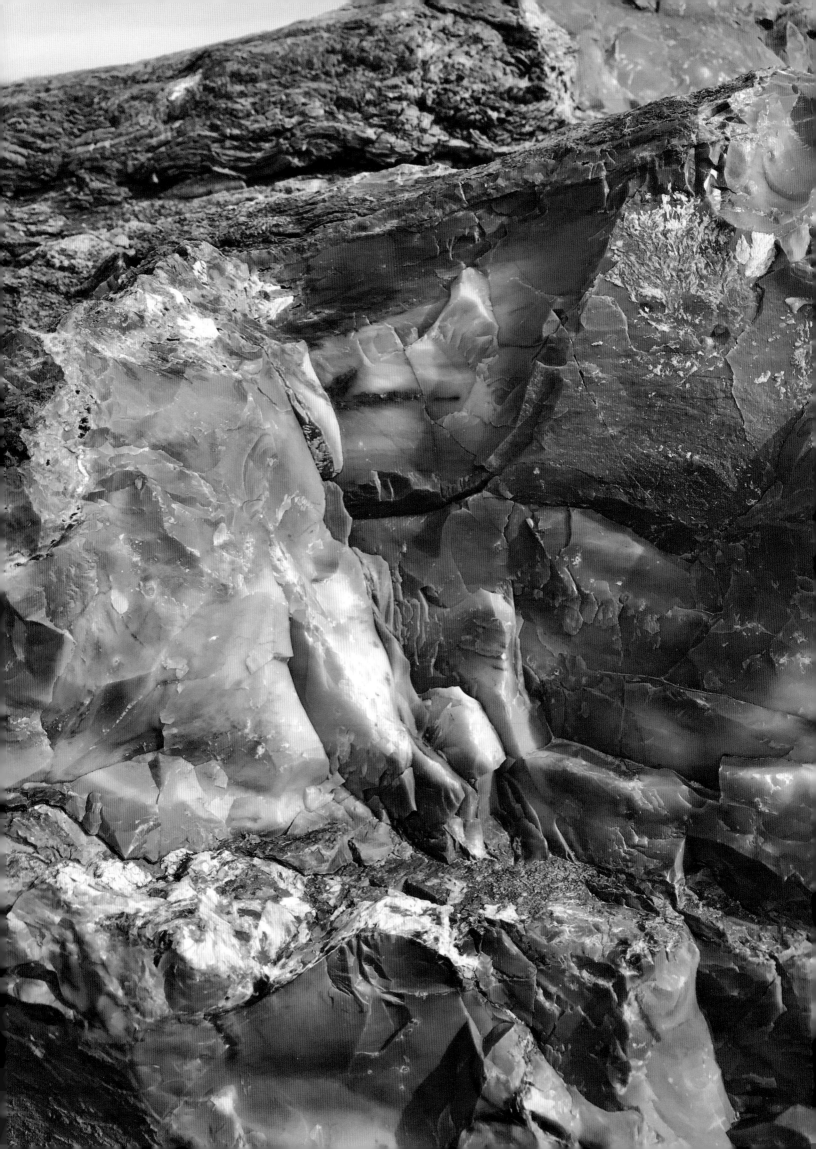

Petrified Forest National Park

ARIZONA

This park was a beautiful surprise. With only one main north/south road running through it, most people believe that everything can be seen in just a quick drive through, but there is so much more.

The Painted Desert area is an excellent place to begin, these Arizona badlands in their pink skirts are easily accessible right off of I-40, (around the old Route 66) and stretch for almost 150 miles–nearly reaching the Grand Canyon! But the iconic treasures are the petrified logs themselves. This entire desert area was a forest and swamp some 217 million years ago. Trees grew large and died, soon covered in the murky mud. Then the magic happened, turning the wood into stunning minerals and crystals.

In the 1880s, people came with the newly built roads and railroads, pilfering these gems, so the Territory of Arizona first protected the area in 1895, and it was named a national park in 1962. You walk among these glistening giants strewn about, marveling at the transformative abilities of Mother Earth. The colors are amazing.

What we also didn't expect was discovering there are more than a thousand archaeological sites in the park, and a huge number of petroglyphs still being discovered and documented. The two massive boulders of Newspaper Rock alone host over six hundred petroglyphs. Fascinating.

This is an area full of literal gems–one of the greatest concentrations of petrified logs on this earth. Give yourself this visit, this instant connection to the past. You will never think of the desert in the same way again.

- kk

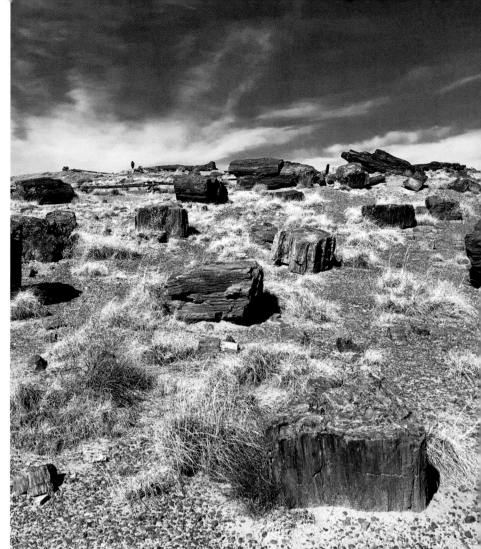

**Discovering Arrowheads
in the Petrified Forest**

I like the feel of it–
the way my eyes reach out
in all six directions,

rolling over Navajo prairie
and through the always wind;
the power in being underestimated.

Some see only wasteland,
but 220 million years ago, this land
was rainforest,
trees falling into quicksand and swamp,
minerals and time turning them into jewels.

I run my fingers over stone forests,
colors chipped and knapped into arrowheads
since the beginning of mankind;

the labyrinth of their journey from
sun to seed to wood to stone.

I think of them flying through this always wind,
the pierce of each beastly heart;

the way they sleep deep in the soil,
only rising
when their story
is ready to be told.

- kk

Petrified Forest: Petroglyphs

If you think there's not a language here—
you're wrong. A heron beaks a startled frog,
a panther snarls as it curls its toes,
paneled lines suggest a vast out there.
One sleepless concrete night you'll moan and
finally extrapolate that yes, a gospel
can be chipped in stone. Get up then. Go.
Scratch a picture of yourself pointing up,
or running, or leaning on a stick,
or holding someone's hand. Make a picture
of a path, of a sun that might burn forever.
Chip out the best symbol for wonder you can imagine.

- AB

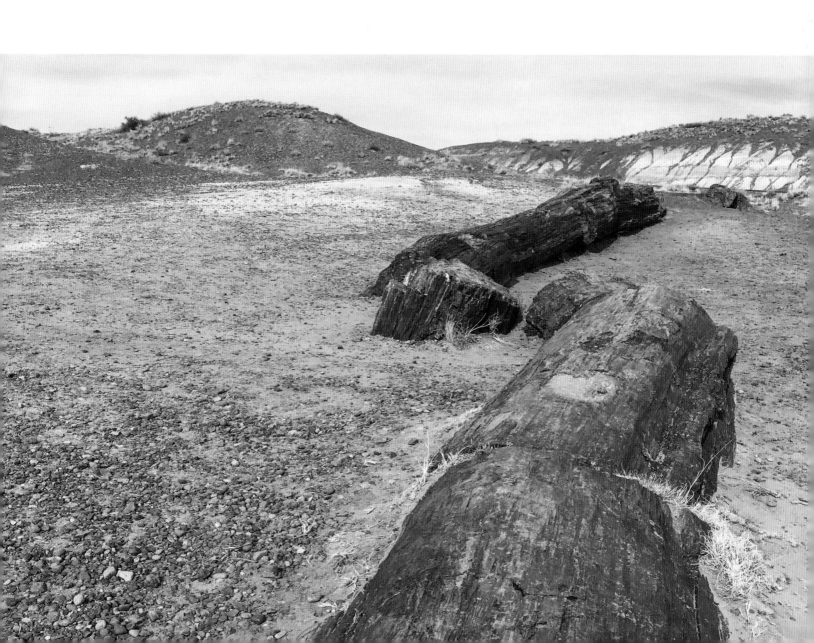

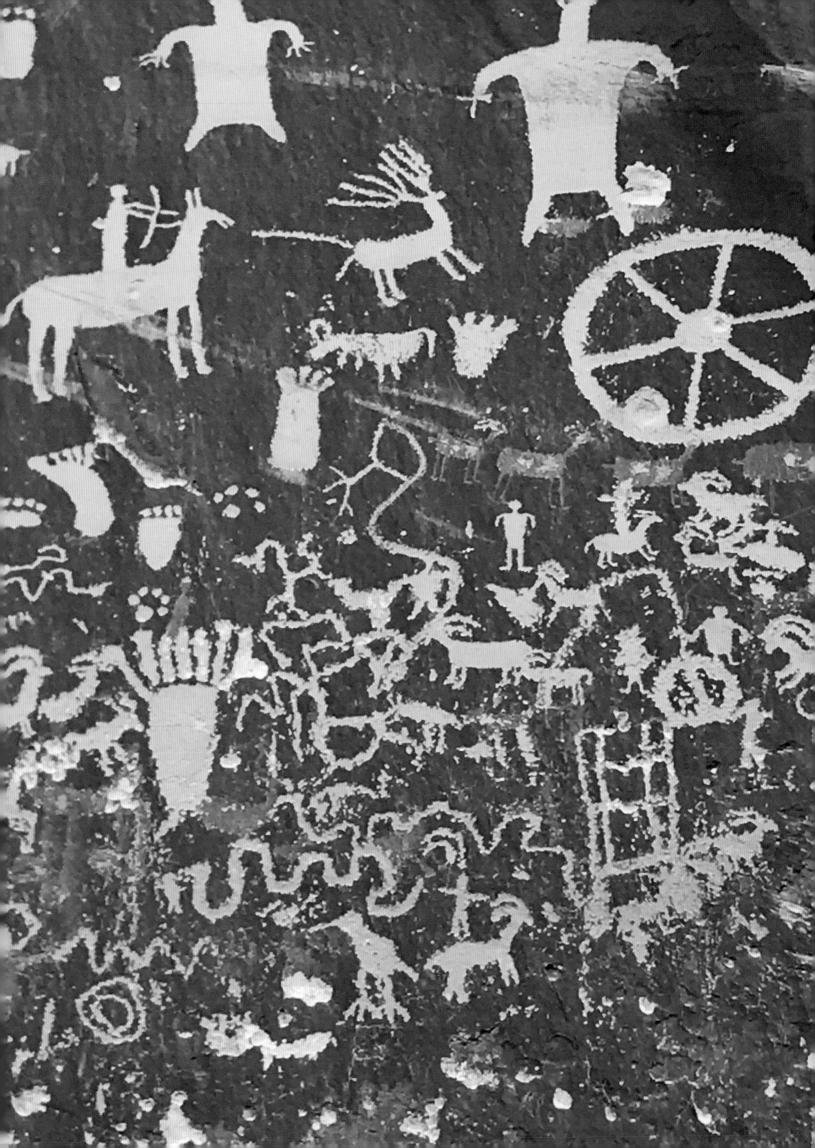

1964

Canyonlands National Park

UTAH

There are certain places your mind drifts back to now and then—certain events or interactions; certain moments that seem to become part of your being. Canyonlands National Park is one of those places. The 337,598 acres were dedicated as a national park September 12, 1964, and is one of the five national parks of Utah—truly America's playground. The city of Moab is itself a wonderful destination and a perfect place to stay when visiting Canyonlands and close-by Arches National Park. There are thousands of petroglyphs for those like us who are fascinated with the lives of the ancient, indigenous peoples—including our favorite huge, red-ochre Fremont images painted throughout the area. Canyonlands National Park is full of great red canyons etched from years of wind and water, with the Colorado River and Green River coming to a glorious whitewater confluence inside the park. There are hikes big and little, but everywhere a vista that knocks you to your knees.

One of the most remarkable places inside Canyonlands was beyond the Cave Spring Trail—after we climbed wooden ladders to the top of a mesa. We sat in the inspiration of the view of canyons and mountains when it began to rain (a phenomenon itself in this land of less than nine inches of rain per year), and the potholes across the top of the mesa filled with water. Suddenly those desert-dry potholes began moving—tiny tadpoles that had been dormant sprang to life at the tiniest drop of rain.

There is no experience that can compare to witnessing this genesis of life, those potholes becoming something more than science and biology can explain; some kind of holy experience we come back to again and again.

Life began, in an instant, before our eyes.

- kk

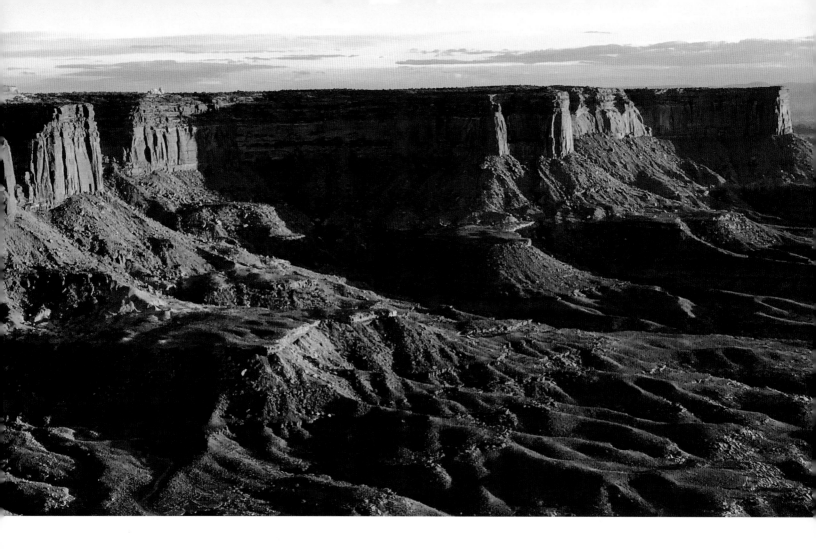

Fonts of Canyonlands

Only a little rain filled the potholes–
those sandstone saviors of the Colorado Plateau.

Coyotes, cats, humans, even butterflies
survive by those watery miracles.

I've been told I use the word *miracle*
too lightly.

But you tell me
what other word is the tool of description

for sitting in the high desert
and witnessing the sudden genesis

of tiny tadpoles
in a shallow bowl of rock

that was dry just the day before?
Tell me what to call the genetic makeup

of a creature designed to come to life
at the first touch of rain?

And what then
would you name that holy moment

when Nature dissolves
the hard crust of *your* world,

and your Soul spills forth
in glittering fins of rapture?

- kk

Walking Away from Words

You might think so—but if you want to be lost and forgotten
this is not the place.

You'll think that sand abrasion will be
adequate and final, that stone is a good pillow,

but you'll be lying on bones, who, jealous
of the interrupted queue, will tattle on your location.

Yes, it might be millennia before even
your phalanges feel sun again.

Your empty sockets will finally be scoured
of whatever led them there.

Your grandchildren's descendants will gently
brush dust away from your red cheek.

The wraiths of dry oceans will bring back
your voice they stole,

so that someone, even then, will tilt his head and say,
"Listen, oh listen, to how he sings."

- AB

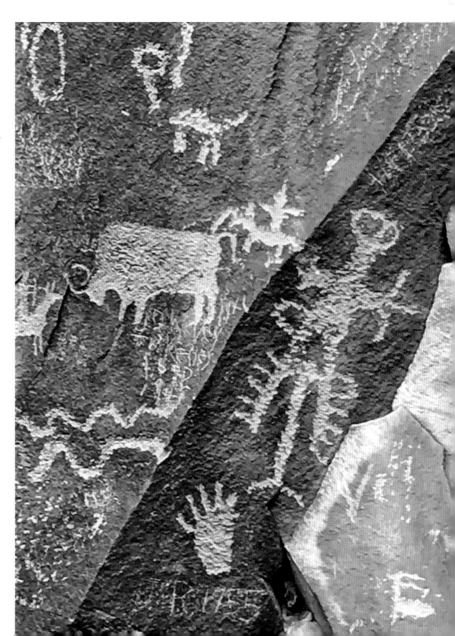

1966

Guadalupe Mountains National Park

TEXAS

It should be a rite of passage that every natural-born Texan climb to the top of the highest point in Texas: Guadalupe Peak—8,749 feet. The hike is moderate to strenuous, 8.4 miles round trip. Take plenty of water, sunscreen, a hat, a walking stick, snacks, and a flashlight for every person in your party. Leave early in the day to avoid the direct afternoon sun. At a minimum the hike will take six hours—and possibly considerably longer. (In our case, it took us fifteen hours. Did I mention the flashlights?)

This is the world's most extensive Permian Fossil Reef. Roughly about twelve million years ago the bottom of a shallow sea was lifted and exposed. Some parts were eroded away and others stood in stark defiance to the flat surrounding landscape. The most obvious landmark from the highway is El Capitan, 8,085 feet, a towering landmark of the Guadalupe Mountains. Water and wind, working in concert through the centuries, helped carve out McKittrick Canyon, another excellent, albeit less adventurous hike.

This park is managed as wilderness. Be ready to be self-sufficient on the trail. Also be aware that the line between Central Standard Time and Mountain Standard Time occurs in this area. If you drive to Carlsbad, New Mexico (the closest location for large quantities of supplies), you will feel like you are traveling north and east to step into a "western" time zone.

During the winter the cold can be humbling. Snow is less of a concern than whipping winds. The road going east and west is wide open and susceptible to freezing with little provocation. When you hike the landscape you will quickly' learn that the land changes from sparse desert to areas of thick brush and trees. Be aware of wildlife. Rattlesnakes are more active in the summer.

This is Texas. It'll test you. It's worth it.

- AB

Guadalupe Mountain

What words are grand enough to speak of light—
the itch of orange, the streaking winks of pink.
Sun-shone hours turn, belly-up, into night
Good Day, Good Day is all that we can think.

Our legs a' tremble, muscles beastly sore;
a quest to know each vista, scene and swell.
Our soul's now been imprinted evermore
and become something greater than ourselves.

These moments groom the core of who we are.
How could we come and not be wholly changed?
We're Mountain, Wolf, and now, the evening Star—
every atom of our hearts rearranged.

We came here knowing not what this might bring.
We leave in awe; we leave with everything.

- kk

Guadalupe: Up in the Light,
Down in the Dark

If you're a native
you have to do it.

It's a secret thing,
past bragging.

Like a handshake.
Far more essential

than your first pickup
or even the baptism

of diving into Balmorhea.
You load up the canteen

and a couple of brisket sandwiches
wrapped in newspaper.

Grab that aluminum flashlight
your grandpa used

and test it by shining it
in your face.

Curl your expectant hand
around a staff,

something with lots of knots,
scars, and stories.

Tighten the boots,
prepare to be scoured

by eight hours of guardian
honey mesquite and juniper.

At the top sign the book.
Bow down like another worshipper.

Unwrap those sandwiches
and look out over

that fossilized flat sea
that is safe and perfect

for those with lesser pedigree.
Remember: Dark runs faster here.

A weaker man would be willing
to negotiate with any devil

that would get him
safely down

those CCC steps,
cannonball rocks

rolling away beneath
his feet. You'll simply

be willing to stare down
eyes of every shade

slavering at you
from the dark.

- *AB*

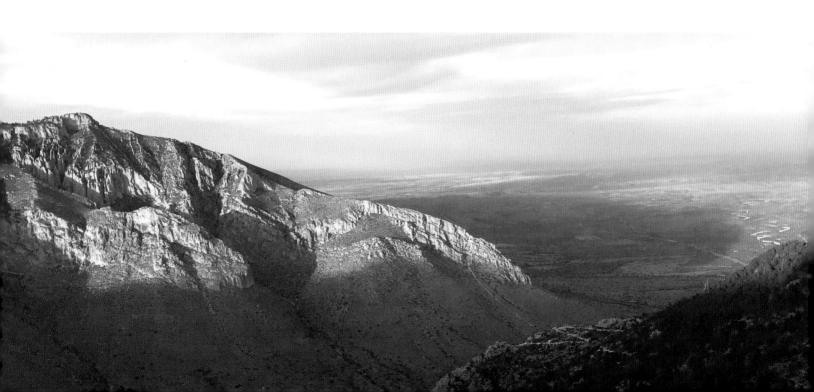

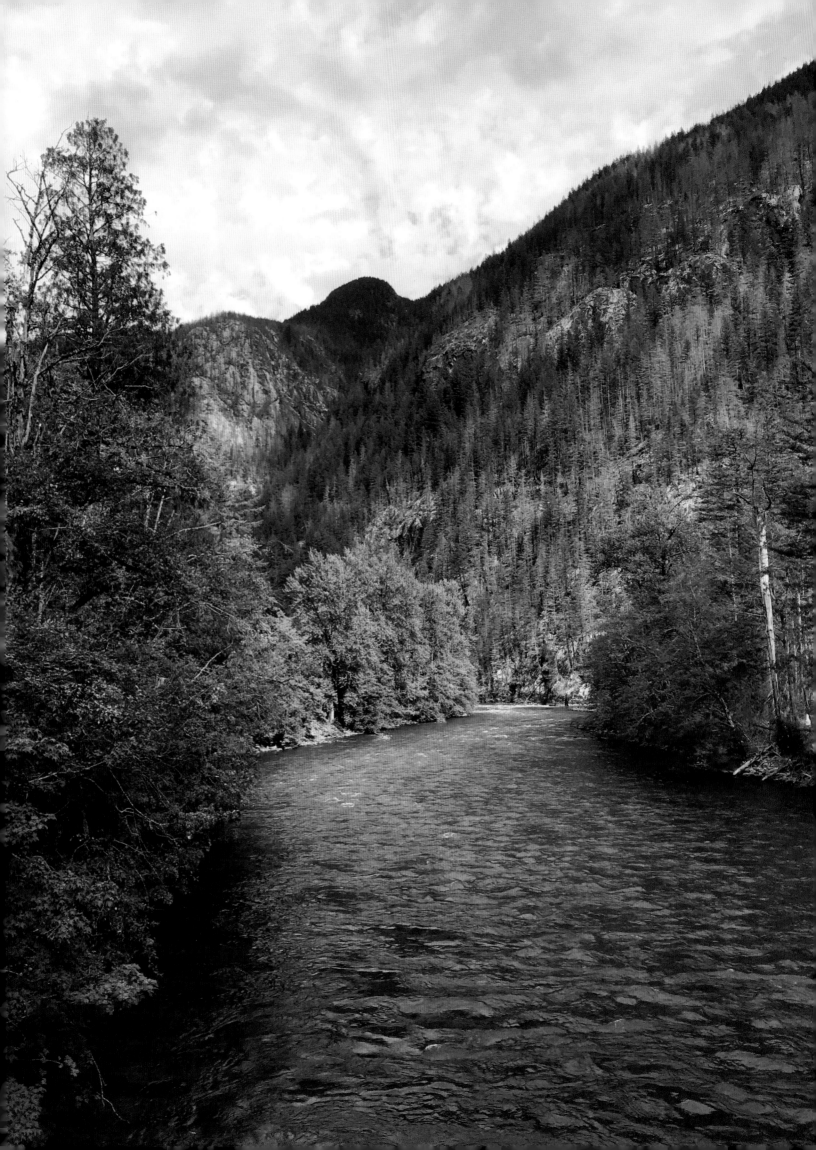

North Cascades National Park

WASHINGTON

From a sign within the park: next to Mount St. Helens and Mount Ranier, Mount Baker is the most active of the Cascade Volcanoes.

Maybe there is a reason this is not a driving park. It is called the United States Alps. Some of the most scenic areas of the park can only be reached by hiking or boating. But what is visible is absolutely stunning. The North Cascades is second only to Alaska in number of glaciers. The sharp mountain tops stand as snow-topped guardians for thousands of acres of unexplored wilderness. The outer perimeters of the park are easy to get to; the interior—not so much.

There is both a north unit and a south unit. The north unit center is only accessible by trail. The south unit is close to a paved highway and provides the main tourist experience of the park.

There is a vast network of trails running through the park. Always, always check at the Ranger Station (close to the South Unit Visitor Center). The Rangers will counsel you on weather conditions, trail conditions, and sightings of the apex predators: bears and cougars.

This park is also in the area of the Sauk Mountain Range, close to Concrete, Washington. The Sauk Mountains are not as tall, but are certainly more accessible. Go past the Sauk Mountains heading north and you will still not have reached the end of the North Cascades. As you explore the area visit the towns of Concrete and Marblemount. Spend some time hiking in Rockport State Park and get a strawberry shake at Cascadian Farms. And hike along the Skagit River. It is cold and rapid, snow and glacier fed.

Winter comes early to this park. While the park itself does not close, the roads might. Even in the spring and summer there is remnant snow on the top of the mountains. During the winter the roads near Rockport State Park are tricky at best. Explore as much of this area, and this park, as you are equipped—and can handle. Forests of fir, pine, and massive red cedar will surround you. It is raw and mighty—and will reward your efforts.

- AB

The Wild Cascades: Still They Climb

There are those who double-boot,
who strap on crampons;

who bind themselves
to the fates of fellow climbers
in mere eight-mm nylon faith.

These are the fire spirits
I want circling my camp–
hot ashes in their palms;
scratching an itch with ice picks

amid tales of Denali, Mount Whitney,
Mount Kenya, Mount Terror, Mount Fury;

tenting in glacial crevasses for days
until the storms ebb,
and the ascent continues;

passing the pemmican;
breathing the sweet ice ether;

green-eyed mountain jacks who know
there's nothing they can see up there
in that cloud-shroud;

blind as they'll be
from lingering so long
beneath the veiled gaze of God.

- kk

Desolation Pottery

Is there enough cedar
to load up this firebox?

There is dread here, steaming snow,
ice melting on the kiln.

You'll question what hands are large
enough to handle the clay.

How long to let the flames burn?
How patient the chimney?

There is a splashing in the Skagit river.
The salmon are spawning. Let's go!

They know of a heat upstream.
They can only show you by their leaping

what that heat is like,
what thermal compass guides them.

Climb Forbidden Peak. Come back.
Something inside you will have ignited.

Now you will be Desolation Pottery,
able to withstand all cold and heat.

The hands that load the kiln
are the same ones that tempered you.

The slow cold of coming back downstream,
The starting over, the building, the deep fire.

- AB

1968

Redwood National Park

CALIFORNIA

Most people have heard about the Redwood forest. It was named a national park October 2, 1968. The surprise here is the coast, as the 131,983 acres also preserve and protect thirty-seven miles of coastline. Here we experienced a "negative tide"—hitting the beach at 6:30 a.m. to experience a low tide that would normally make us run for cover if we didn't know it existed!

And there, in the magic—orange and purple starfish, blue anemones; all thoughts of adulthood lost as the beach pulled back, and the wonder of the ocean floor is at your fingertips. But we couldn't wait to experience the trees—*oh, the trees* . . . Imagine trees taller than the Statue of Liberty!

One late afternoon, we lay down to nap amongst these beauties, and in those slow wake-up moments, when you hesitate to get your bearings, we felt as if we were fairies among the stunning giants.

If, I dare say, there is ever a chance you can get to just one national park, let it be Redwood National Park.

- kk

Enchanted

I walked among them,
sheltered and shadowed;
wild child gone full mountain;
a tiny sasquatch in fairyland.

I breathe their out-breath;
a pantheon of redwoods
standing guard as I sleep
like massive grandparents:

wise, vulnerable,
whispering in their ancient knell:
when we save what is holy,
we save ourselves.

- kk

Redwood: Cathedral

You'll walk through timbered halls
three hundred feet high.

The sunlight glistening
in oblique shafts

will be full of motes of gold
like torches from angels.

Your undeserving feet will walk
on forested carpet so thick

that no one can hear the sounds
of your prior sins.

And when you have exited,
you will be allowed to pluck

fresh berries still clinging to the vines.
A delicious bursting and sudden awareness

just like the Bible
you grew up with

that had the voice of Jesus
printed in red.

- AB

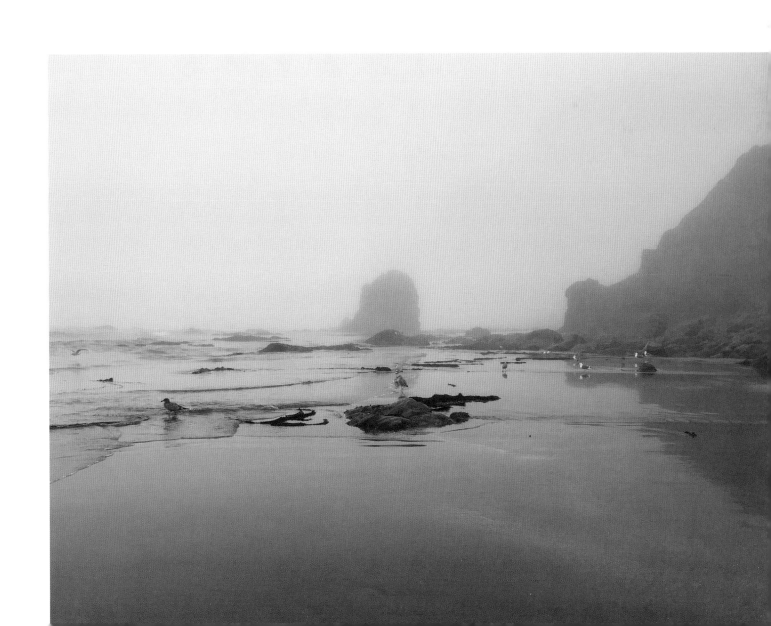

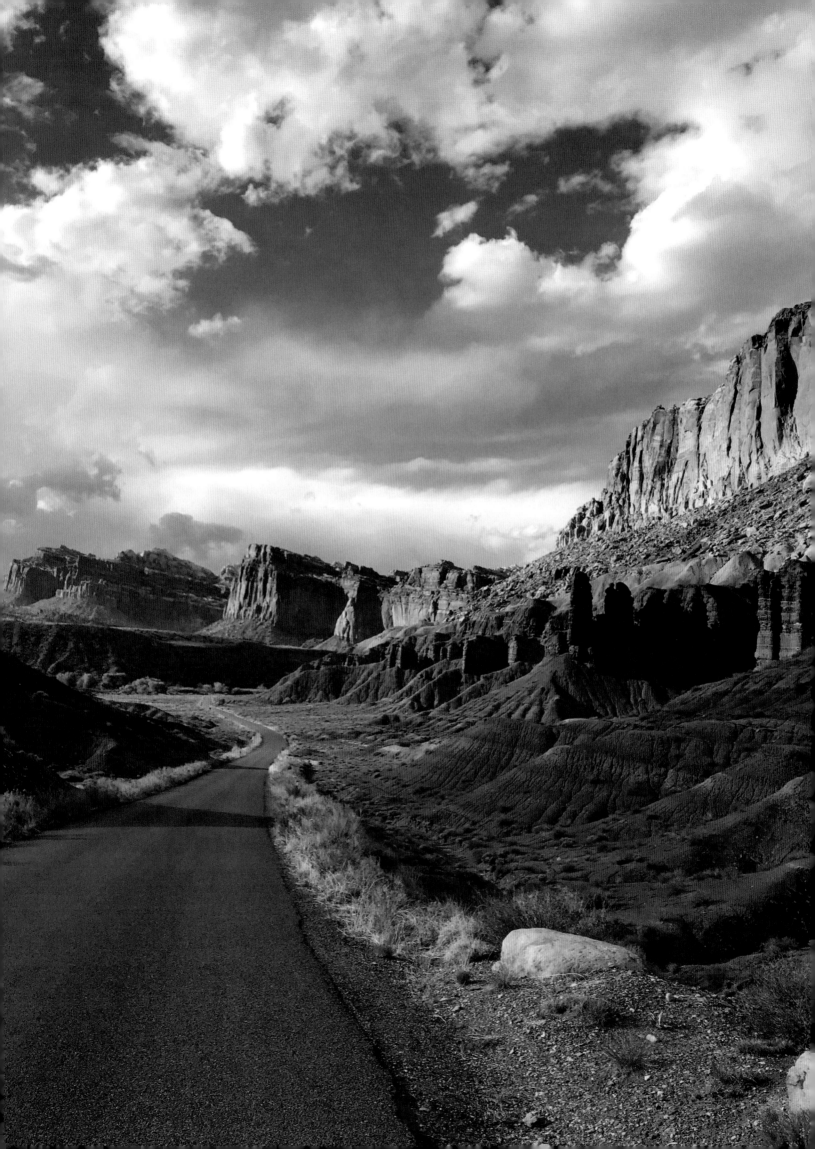

Capitol Reef National Park

UTAH

The sun in this park seems different. The rocks almost seem to glow from within. The Navajo sandstone, random lava rocks, and shale. There is almost no way to take a bad photograph in this park. This, along with Bryce Canyon, is one of the overlooked Utah parks. But so worth the time and attention. And since it is also one of the least visited you will not be fighting crowds on the road or trails.

The "Capitol" in the park's title refers to the sandstone formations that look like domes on Capitol buildings. (There is one just off the main road through the park.) The reef does not refer to an ocean but instead to rock formations that form natural barriers. The main geologic feature of the park is the Waterpocket fold. Best viewed from above, it is essentially a wrinkle in the earth's crust, kind of a zipper look, that is even now in a state of constant erosion. Petroglyphs are just north of the main road going into the gateway community of Torrey. Locate on a map, and talk to the Rangers, and drive through what is left of the town of Fruita. The orchards there are remnants of the former Mormon orchards. When fruit is in season, for a small fee, you can pick a more than reasonable amount. Surrounded by colorful mountains, quiet, bounty in your hands—what's not to like?

On the road through Fruita is another section called Capitol Gorge. This was the main road until 1962. Now it is a walking trail with tall, narrowing walls. The names of many of the early Mormon settlers have been scratched into the tufa on one of the walls. On the other side of the narrows, just slightly up-trail, are more petroglyphs. The quiet, and the etched burden of the memories of history, fill the stone canyon. You will feel the presence of prior souls as they walked the canyon ahead of you. Take your time. This is one of the highlights of the park.

We can recommend staying in Torrey. It is a short east-bound drive to the park. Breakfast is excellent at the B&B Torrey Schoolhouse and dinner at Café Diablo is amazing. Both excellent ways to begin and end days of exploring at Capitol Reef.

- AB

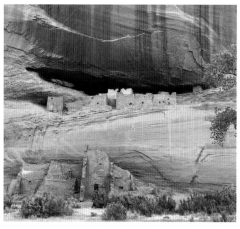

Canyon de Chelly.

Small-Leafed Globemallow
Capitol Gorge Trail

There upon the desert floor, a flower,
though it's hard to call this desert in April,
or even May,
as the sun milks the cliffs in pinks and purple–
cliffs shaped by palette knife and water and wind.

All night long we talked about the petroglyphs.
The wind howled.
A boulder fell across the road.

We walk the only trail once across
this Waterpocket Fold,
a wash of animal prints,
and Paleo-Indian,
and Mormon pioneer.

It is true-love here in the high desert,
the kind only the heart can answer,
the cliffs leaning in–
intimate above our heads.

I draw it upon your palm as we rest,
as we sip the canteen's metallic wash;
our bodies stretching, reaching
for these quick orange blossoms of spring.

- kk

Two Sets of Letters

1. Coming into Fruita

Imagination can
doom a man, make him see
no access in these red
sandstone, tufa walls.

It's February, maybe March,
and your cold knees will feel older
than the rest of you—but all's
well and steady ahead.

There's a path in, perfumed up
with cherry and peach blossoms
if you are open to believing
even stones can provide.

For warmth en route hold onto this letter.
Miles and moons won't bury you.
Forget dark clouds.
And unbelieving neighbors.

When you reach the gorge
and see the names high up
on the wall on your left,
and even older scratchings

and blessings on your right,
both varnished with the visions of ages;
you'll be bathed in tumult
resplendent with your faithful entrance
into sweet syllables and sun.

2. At the B and B—On the Bookcase

On the bookcase, next to the lute,
Dante was pulled out.

He was about four books down
from Plutarch and the Sabine Women.

I was thinking how this was
May 1st and words leading me

through damnation
were in my hands.

I wondered how you always
walked in front of me,
reaching back.

The fickle permanence
of obstacles and stone.

All the perjurers, idolaters,
and insufficient concubines,
left behind, their joints creaking,
shivering in the non-believing cold.

- *AB*

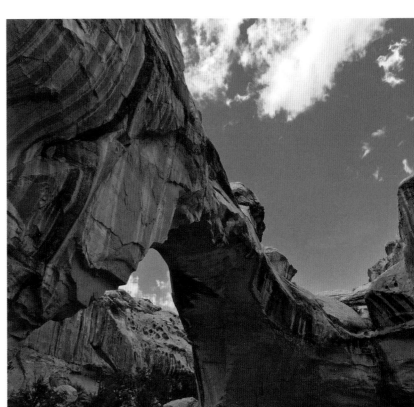

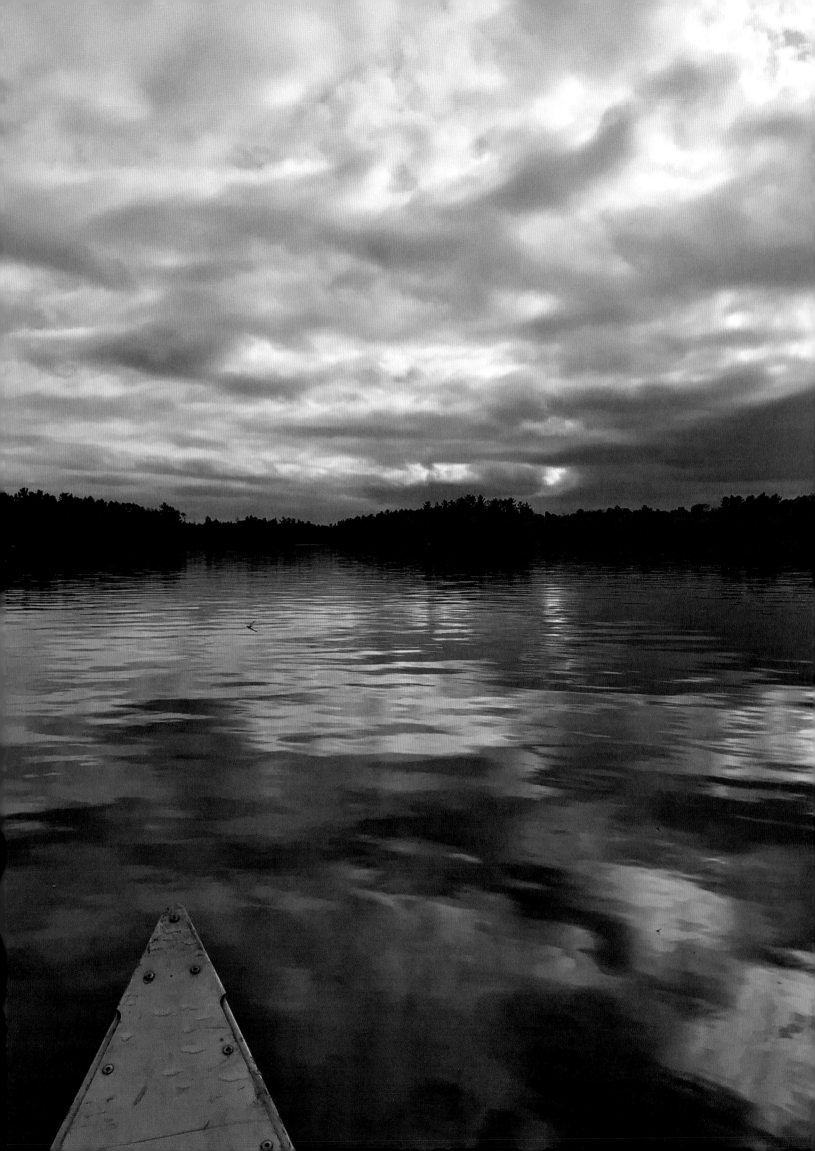

1971

Voyageurs National Park

MINNESOTA

This is one of those places where, on the day you leave, you begin to make plans to return. It is one of our favorite places—especially the 1910 Kettle Falls Hotel. To get there, you have to take a boat from the mainland. There are no cars.

When you get to the hotel, and you walk in past the long white screened-in porch, the bustle of the city falls from your shoulders. Here, even the ghosts are happy. You will step back in time. White wicker and a view. Have a drink on the veranda from the bar nicknamed the *Tiltin' Hilton*— its warped floors leaning several feet. Just walking through it is a true sobriety test.

It is a fisherman's mecca, spending each day out on a boat fishing for walleye. This national park is 40 percent water with four major lakes (Rainy, Kabetogama, Namakan, and Sand Point, with dozens of smaller ones).

Catch your walleye and bring it cleaned to the restaurant. They will fry it up for you complete with all the fixings. You will swear you've never eaten anything better in your life. Sleep in.

Hike to see, not to race. This is a place to rest, a place to fish, to throw horseshoes; a place to take a slow canoe out into the lakes, careful not to stray into Canadian waters.

Here is where the Voyageurs, those amazing French Canadians from two hundred years ago who created the river trade routes between the US and Canada, traversed. They started out their four-thousand-mile waterway journey with trade goods and returned with furs, always singing to keep up a swift canoe oaring pace.

On breaks they smoked their pipes (pronounced peeps), and would dress in their iconic red sashes and hats.

It was said you could hear their singing before you could see them, and it was in their honor that this national park was named. It is a step back in time here, that slow summer you've always wished for; a step so needed in this immediate digital world. We cannot wait to return.

- kk

Lake Namakan

A few metal scrapes of aluminum canoe
and we shoved off
the birds wild with song

Then beyond
careful not to break the silence
of billion-year-old rock

pines and birch rising like
well-schooled children
anchored tight against the permafrost

At once, lost in the escort
of hundreds of mayflies
in their one day of existence

the frogs serenading
oars hapless, still and long
across our laps

lily pads face-up from dark water
gently brushing their purple cheeks
across the bow

- kk

Voyageurs

This is what I say when people ask:
The bones of winter vines still twisted in the window screens.

On Namakan Lake, outside the current,
the water was buffed with gray and satin.

The floor back at the lodge, back at the bar,
tilted like a metaphor; I adjusted my steps like
a drunken fisherman.

Sarge gives good canoeing advice.
The girl drawing beers arm-wrestles the barflies.
Buddy turns good bacon.

You'll need to touch the rocks on the shore;
they are older than the moon.
Second growth pines tunneled us up
from the water's edge.

At the end of the day we watched Jupiter like it was Polaris,
the compass point all wrong,
but that wasn't important.

The floor of the bar made us happy,
like drunk fishermen.

We sat on the porch, looking to the water.
I took off my watch,
used my poetry book as a fan.

- AB

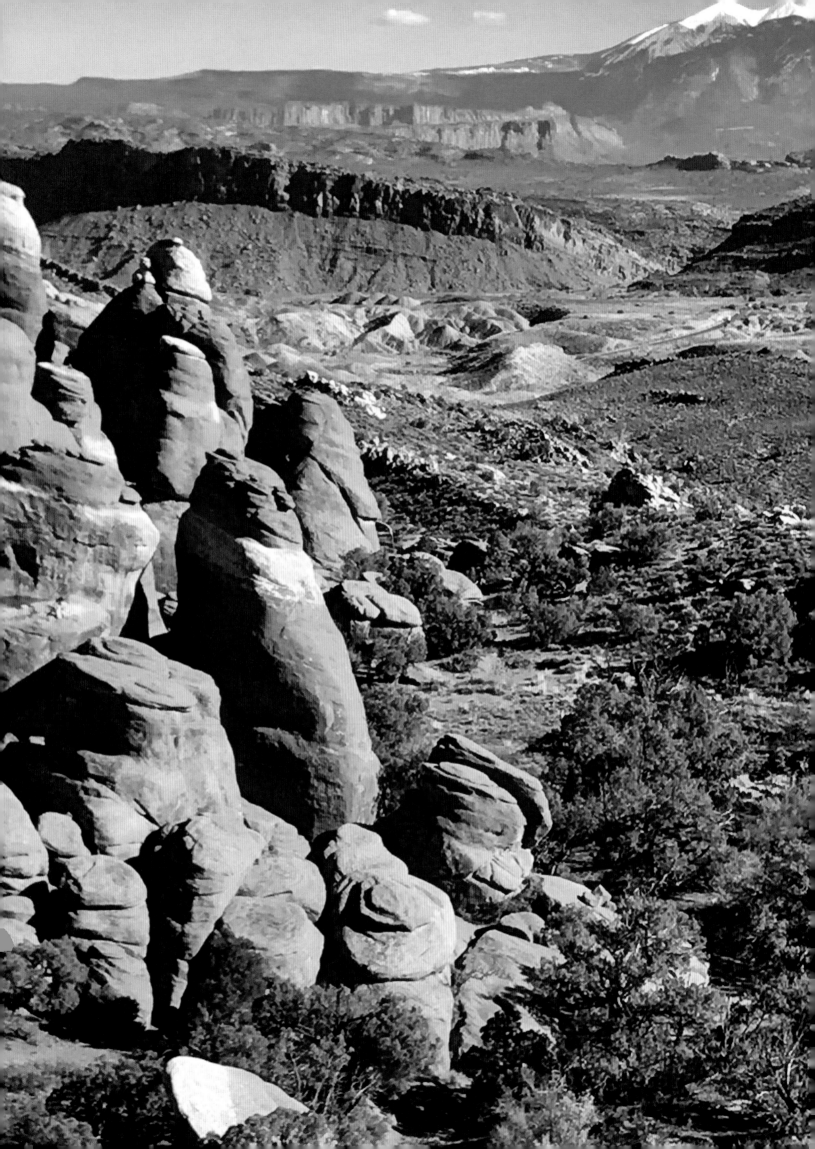

Arches National Park

UTAH

Arches is one of the most spectacular and most visited of all the Utah parks. Situated just outside Moab, it is a perfect example of how many of the parks and their gateway cities seem to have seamless and symbiotic relationships. There is a lot of scenery outside the park boundaries and miles of hiking trails. Shopping in downtown Moab will cover you from new artisan works to antiques. Secure a brochure about trails leading to petroglyphs and pictographs.

Arches is almost a perfect summer driving park. The roads are good and well-marked—and will show you many of the arches you want to visit (or at least put you at the trailheads). Most of the arches are made of red sandstone. Originally part of an inland sea, the park you see now is a product of erosion over thousands of years. As the sandstone eroded, and underlying salt layers sank, giant stone fins dominated the landscape. As those fins were subjected to wind and rain, arches slowly formed. While Delicate Arch and Landscape Arch are the two most visited arches in the park they are certainly not the only sights to see. The Fiery Furnace, while a strenuous hike, is well worth the sore muscles. (Take a Ranger-guided tour. It is safer and more informative.)

Wear shoes with good grip when you visit Delicate Arch. After approximately a one-mile hike one way over constantly changing terrain there is a long section, uphill, up a sandstone mountain. For the less adventurous there is a viewing platform a good distance away from the base of the arch. The pictures are good—but nothing compares to making the complete hike yourself. The Delicate Arch stands at the top of a funnel. There is always a line to have your picture taken standing under the arch. Be courteous. Be careful. And always carry water. During the summer the heat bounces off the sandstone; you will dehydrate quickly.

Arches National Park is not the only place in the world where stone arches occur. It is simply one of the most concentrated areas—and one of the most awe-inspiring. Set your camera to landscape. It will be easy to take amazing photographs.

-AB

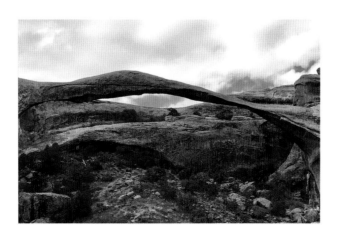

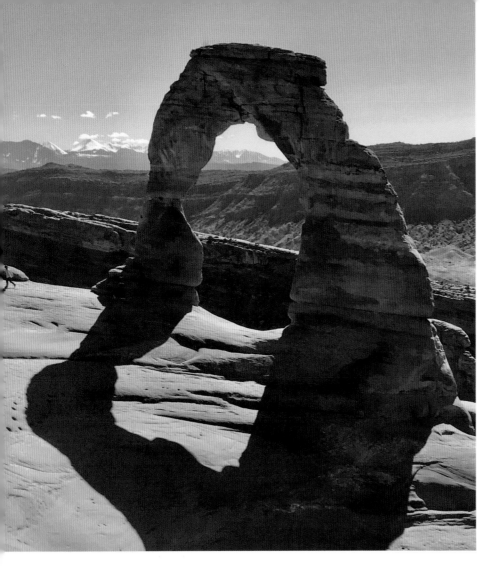

Arches

They wait in their silent language,
patient as an hourglass,
the wind marking millennia
one grain of sand at a time.

The pessimist will tell you
we begin to die the moment
we are born–

the wind, the rain, the heartaches
constantly shaping us.

We traversed Delicate Arch Trail
up across steep slick slopes,
down small inclines,
around thin, blasted edges,

then rounded the corner
and stopped . . .
sixty feet of glory before us–
the blue of sky: above, inside, around.

It's all a two-toed balance;
all about the number of grains
whittled through thin necks
on their way to ease the
heavy desire of gravity;

all of us rainbows–
our delicate beats of heart,
the ethereal keystones of existence.
Look how thin the curve.

We have *this much* time to be alive;
this many hours,
this many breaths that we take,
then give.
Take, then give.

How is it we were led here?
With what purpose we shall go?

- *kk*

Song While Hiking to Delicate Arch

Don't get me wrong.
I have written more than a few poems
about the sounds my boots make
on all types of surfaces.

Actually, I have three pairs of hiking boots
and they all have their own sound.
One of them has a particular high pitch,
like a tenor who is constantly clearing his throat.

The second pair, with one broken eyelet,
is never really in tune with much of anything.
He complains about any uneven surface
with a litany of incomplete and off-color lyrics.

But the third pair, with the thick rubber soles,
has a bass note that is dependable.
I could almost sing along wherever I was,
concrete, marsh, tundra.

At least, I thought it dependable
until I reached the funnel at Delicate Arch.
Don't get me wrong. My boots did not fail.
But with my first steps on the tilting surface

they gently reminded me
of the limits of their singing range,
how they much preferred a steady andante
as opposed to a sandstone accelerando.

- AB

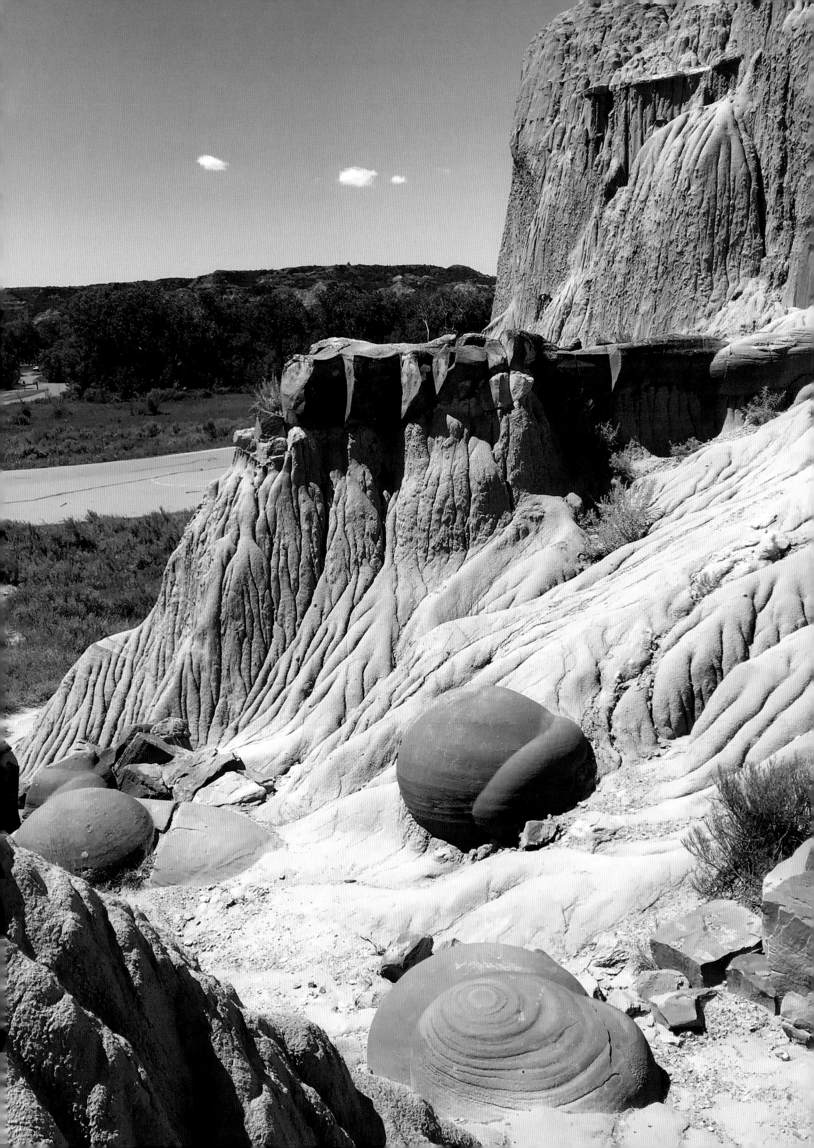

Theodore Roosevelt National Park

NORTH DAKOTA

Theodore Roosevelt is the most romantic of all national parks. The first thing I noticed here was the smell—we drove with the windows down, infusing our truck and our bodies with the scents of the wildflowers and tall grasses.

Here, there are buffalo and wild horses.

There is the Elkhorn cabin where Theodore Roosevelt lived at times between 1885 and 1892. He fled there after the February 14, 1884 deaths of both his wife Alice and his mother Mittie. This wilderness soothed him. It healed him. So many of us know this healing, as we are drawn to these places in times of crises.

These 70,467 acres were designated a national park in 1978, to preserve the legacy of one of our greatest conservationist presidents, but also the delicate ecosystem of the prairie. The prairie is underestimated, but it is the second most diverse ecosystem in the world. Only the rainforests have a greater variety of animal and plant life. This is the only national park named for a person, but how fitting. As president of the United States, Theodore Roosevelt designated five national parks, eighteen national monuments, many national forests and wildlife reserves—over 230 million acres set aside as public lands that we all may come here for healing.

There is true beauty here in the prairies, in land that has never known the pull of the plow. We gaze upon the wild horses. We roll in the wild bergamot. We too are healed.

- kk

**Elkhorn Ranch, in the Floodplain,
beneath the Cottonwood Trees**

*—for Theodore Roosevelt, who lost his wife and mother
the very same day, and fled to Elkhorn Ranch to heal.
It was here he knew he had to preserve and protect
these unspoiled lands that healed him.*

I speak for July
for Yellow Sweet Clover;
six kinds of sage;
for three-hundred-year-old cottonwoods.

I speak for July,
the way sorrow floods everything downstream,
that wispy seeds may land and root
in the soft, wet Earth.

I speak for July
which knows
the greater the love,
the greater its grief,

and were it not for love,
there would be no need
to yearn beneath these heart shaped leaves
as the Little Missouri
watermarks its own life–

the purple bergamot,
sudden as wild horses
in the deep ravines
left behind.

- kk

Feast

We owe the grass an apology.

Most of the tourists took the other hill
but we chose the hill to the right.
The view was just as good,
but the trail was less marked.

She wanted to bury herself in sage,
roll in the cornflowers,
be bathed in pollen.

I was dealing with the ghost of Roosevelt.
We sat down on a floorstone each;
We could feel the cool through our jeans.

Buffalo horns, barking prairie dogs,
warning on the edges of the pool of our bodies,
stood at alert.

We could have written
a sparse note back home.
"What impressed us most
is the certainty
that the Little Missouri
will carve its way,
eventually joining the channels
of its own oxbows."

Those words would have been
a lie to say how much we recognized
how old we were.

The shades of the long grass reminded me of a
lover's hair,
an evening long ago, before the scars and cataracts.
It was an unconnected memory I had of the wind
lifting and stroking.
She crossed the street in front of the restaurant
where I was sitting. That is what I remember.

I will tell you you'll need to take a walking stick
into this prayer of a place.
You won't know that you are praying but the scent
of lupine will be both before and after you. Even
those of you who have forgotten how to pray will be
nudged into whispering.

In the layers of the badlands, sitting on the cold
foundation stones,trying to understand the round
concretions slowly pouring from the mountains,
you will wish you were a man half your age.

You will wish to be fresh and unanchored. You will
wish to consume scents, gnaw on the moments, eat
a meal with spirits along the Little Missouri river.

We owe the grass an apology.
For a few minutes we felt young.
We wanted to feast on something new.

- AB

Badlands National Park

SOUTH DAKOTA

Established in 1978, Badlands National Park at first appears to be a combination of stone turrets and cliff faces scarred with erosive rivulets. As you venture deeper you will realize why it is called the Badlands. It is a dry maze that goes on for miles, valley after valley of confusing paths and undependable and constantly changing hills made of sandstone and clay. And then there is the Badlands Wall, a dramatic sedimentary barrier that seems like something out of a movie. In some ways this is a driving park (Highway 240 within the park allows you to see many of the fascinating formations)—and in some ways the park encourages you to climb out of your car and hike. If you do decide to hike, stay on the trail. After several turns the towers, minarets, and valleys will start to look alike. Avoid stepping too close to edges, which can crumble easily. Much of the top soil here is a delicate crust that may have taken decades to begin to take root. Erosion is one of the biggest destructive factors in the badlands.

Be aware that bison and bighorn sheep may wander onto the road and be slow to move. While it is dangerous, and illegal, to stop traffic to take a picture—or to climb out of your vehicle and approach the wildlife for a better photograph—there is little that can be done if a bison decides to unconcernedly occupy your lane.

This is one of the only, if not *the* only, national park with a working fossil paleontology lab onsite at the Ben Reifel Visitor Center. Millennia ago prehistoric beasts roamed here. Bones can still be found sticking out of the sides of the dirt walls. It is one of the richest fossil sites in all of the United States. Spend some time at the White River Visitor Center studying the Winter Count, a calendar of sorts, drawn on hide, that marks significant events in a tribe's cultural history.

This park is an excellent location for a jump-off into other adventures. Wind Cave National Park is down the road. Mount Rushmore, Crazy Horse Memorial, and Wounded Knee are all within a day's trip.

- AB

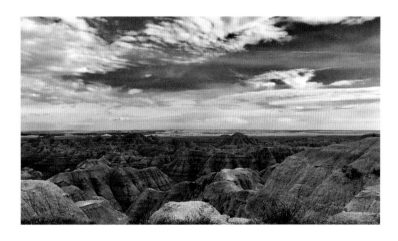

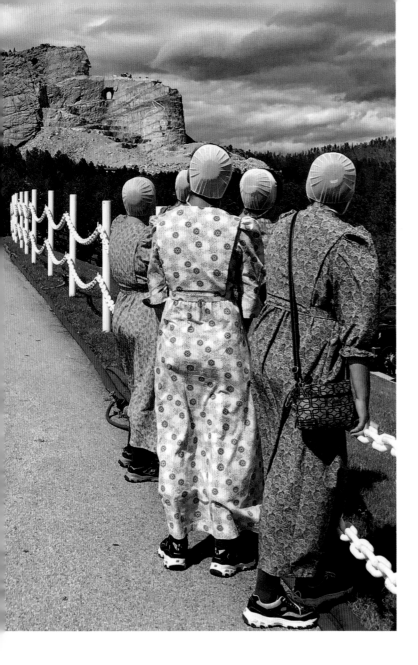

**Horseback through the Badlands:
the Borealis**

He said he rode out to this spot two days before,
this cowboy named Marshall
on a horse named Cowboy,

said he saddled up at midnight
though he was tired and sore
from the day of ranching.

And there it was:
those Northern Lights
dancing
all the way down South Dakota.

Imagine, he'd said, gifted such a sight.
Something like that
you carry with you

like a love note folded tight against your chest;
something you bring out
when no one's around;

desert hoof-steps
the only noise;
those Badlands crowned
in emerald joy.

- kk

The Bering Land Bridge and the Badlands

I do not consider it coincidence:
on the bush plane to the Bering Land Bridge
the co-pilot, sitting up front, was a dog.

The pilot pointed out to us
the shallow water and the curving finger
of land that once connected this to that.

It was hard to reset the mind to millennia
when we were soaking in the Serpentine Hot Springs,
the ancient water sizzling on the tub boards.

But later, we thought about the Dakotas, the first bony evidence
of dog
jutting out of the towers of sandstone,
something still vibrating, something that walked here.

The canine feet with us, alongside us.
The cold wind, the steaming waters.
The days of ocean and dust.

What we could see from our vantage point.
What we depended on, a snout that led us.
Something older than us, an echoing howl.

- AB

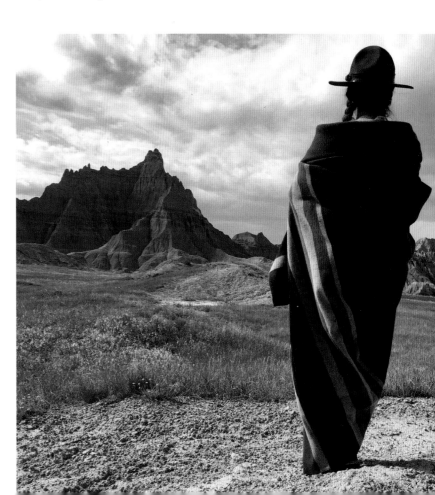

Channel Islands National Park

CALIFORNIA

This gorgeous archipelago of five islands is located off the coast of California, between Santa Barbara and Los Angeles, and was designated a national park on March 5, 1980. It takes some definite planning to get to. Located so close to Los Angeles, the Channel Islands are literally an oasis to the chaos of the big city, and once there, visitors are on their own. No lodging is available. There are no services of any kind, so be sure and bring your own food and water.

People such as the Chumash Indians have inhabited these lands for over thirteen thousand years, and, in fact, the oldest human remains in North America have been discovered here on the Channel Islands. The trip by water is full of opportunities to see migrating whales or dolphin, or, as in our case, the great white shark. He was belly up and in the last moments of his life. It was a great honor to be able to share such a moment with such an amazing creature—to know he lived and died in the wild, where he belongs.

There is a particular sound the waves make as they pull back across the big rocks on shore. Sit and listen for a while. Perhaps its power is just the fact that we are able to sit and listen, but then that is what these parks are meant to do—to help us slow down and learn the great wisdom nature has to teach us.

- kk

Channel Islands

What were we to do,
but come to his side,
a great shark
floating upside down.

No signs of injury or distress
as we rolled him over,
his marble eye proclaiming his hold still
to this world.

There was calm in him;
a long shark life;

that eye gently moving across our faces
in what could only be felt
as a caress—
from one animal to another;

both of us peers,
the top of our food chains,
both of us full of fish and squid,
and slow-moving brethren.

It seems insulting to say
he looked human;
perhaps I became shark,

both of us understanding
It was his time.

There was no fight,
no aggression;
just the turn of his great eye
back toward the ocean,

then one last
thrust of thick tail
to turn himself
upside-down again.

At this, we let him go . . .

So this is how we die—
one day, the teeth fall out,
and the gills turn up,

and the bright white belly
becomes one with the sky and the stars
and the waning moon.

We all become sea foam.

I often think of him out there
among the rain and whales.

What must they think
of our once-fierce brother,
his tender ascension
to the top of his world.

- kk

Channel Islands:
Spirit of the Dead Watching

This wasn't
Sunday Afternoon on the Island by Seurat.

This was more Gauguin living in Tahiti:
the boat tour let five people off at Prisoner's Cove,
and three of them were Rangers
who quickly disappeared into the brush
on trails only they knew.
Then it was only us.
Given enough courage and time
we might have felt a yearning to search
for a paradise
that might, or might not, have been there.

It was only two hours away from
orchards and tilled rows
that were honeyed with oranges,
emerald fields of broccoli and lettuce.

Two hours by boat,
escorted by whales and dolphins,
we only looked forward, hesitantly,
to landing at Prisoner's Cove.

We could have called it Papeete.
The critic crows dug through our bags.
Boat-orphaned,
we could have thrown all the words we wanted
to the stones on the shore,
letting them be pulled out, clack clack,
scoured and empty,
with the tide.

We climbed halfway up a hill, sat, let our
feet dangle, looked at each other, and asked
"Where do we come from? What are we?
Where are we going?"

We saw the returning boat pulling up to the pier.
If we had known the answers to our questions
in each other's faces
we would not have been heading back.

- AB

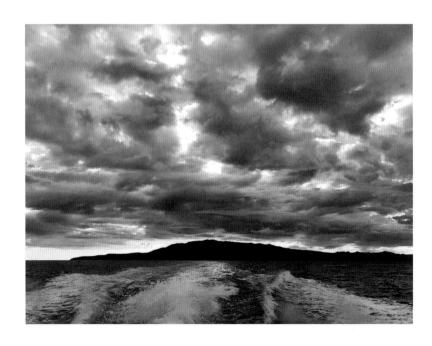

Biscayne National Park

FLORIDA

Biscayne National Park covers over 170,000 acres, most of which are water. While there are trails that start around the visitor center, by far the best way to enjoy this park is in the water, whether it is snorkeling, scuba diving, swimming, or kayaking. The diversity of fish, birds, and plants (especially the reaching mangrove) will keep your camera and inquisitive mind occupied for hours.

The park is south of Miami. The beautiful and informative visitor center sits on a small peninsula of land. Within easy walking distance of the visitor center are several picnic tables (about fifty yards from the water), and piers for park and concessionaire boats. (You will almost certainly see a wide range of wildlife right around the picnic area, including crocodiles, raccoons, gulls, and eagles—just to name a few). There is no backcountry camping, but there is camping available on some of the islands. Boca Chita Key and Elliott Key are accessible. Of special interest is Adams Key, about a two-hour sailboat ride out—and the previous location of the Cocolobo Club. At least four former US presidents used to escape here. The island now is an open-use area with a large picnic pavilion and restrooms. Both the Rangers and outside concessionaires know how to get there. It is an excellent place for quiet paddling through secluded lagoons. It's easy to see why presidents would spend time at this park: it is isolated, peaceful, and the ocean scenery is spectacular. Pick your season for Biscayne. Spring and summer are the worst for mosquitos. And remember: this is Florida. Bring your reef-safe sunscreen and enjoy what Biscayne has to offer. Get in the water!

- AB

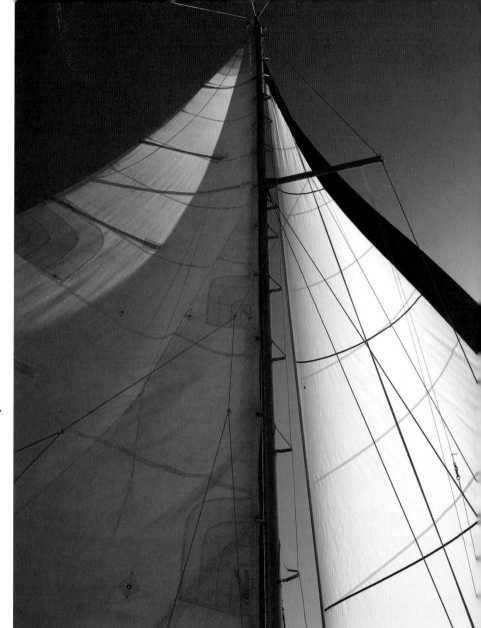

Vatic
— from the Latin "to be spiritually aroused"

Back to front
in that blow-up kayak,
we paddled in among the mangrove trails
then stilled the oars,
and gave ourselves to the current

that we might hear
the tiny shanty of descending snakes
and lapping water;

red roots arched
like a thousand gothic windows
in a church so opaque
no saint would dare stare within.

Even in darkness whirls the holy–
the unseen
the unnamed.
Even in darkness we are found–
the great white heron plucking us,
breathless
into the sun.

- kk

Kayaking at Adams Key

Back on the boat
I'd left my watch
and last week's shoes.

Twelve strokes along
the saltwort and the seagrass
stroked my hull,
my husk,
a fading yet new thing.

I pulled up my oar
and heard
a mangrove dialect.

How could I have brought
this back to you?
I touched my salty fingers
to my lips.

What new awakening
seasoning was this,
what unanchored measurement
of time?

How could I bring you back
this briny particulate
of truth?

- AB

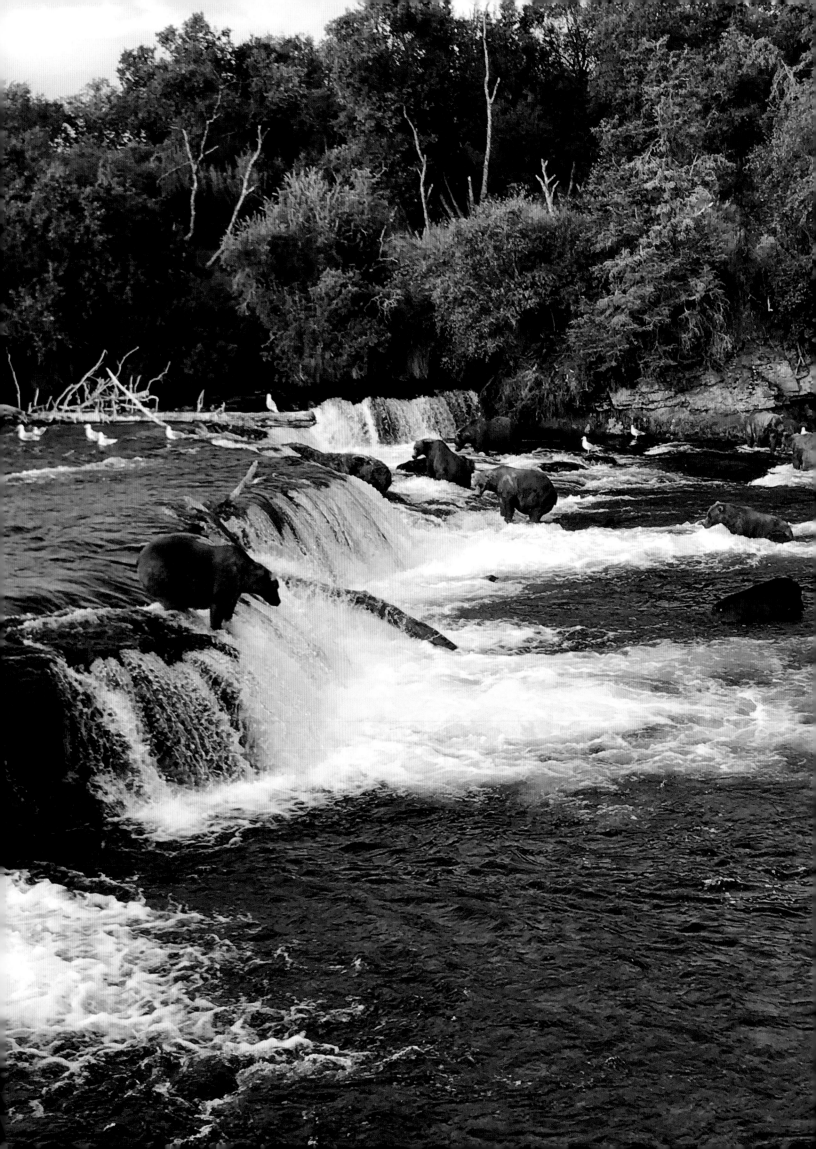

1980

Katmai National Park

ALASKA

Bears rule here.

You have to want to get to Katmai. The only modes of transit into Katmai are boat or float plane, usually from King Salmon. At Katmai there is the main lodge, a camp store, a visitor center, and a few cabins available for overnight guests. No food can be taken outside—ever. The kitchen in the main lodge serves up three basic and hearty meals a day. The very small bar there sells beer, wine, and a few mixed drinks (but the bartender is excellent). Before any guests are allowed to check into lodging, they must attend Bear School. This mandatory class is conducted by park Rangers in a small building just up from the shore. (At the end of class you will be given a Bear School pin. It's awesome. You can't have mine.) There are three main activities: The Valley of Ten Thousand Smokes, hikes led by Rangers and historians/naturalists, and watching grizzlies.

Novarupta, the most powerful volcanic eruption of the twentieth century, occurred on June 6, 1912. Few people know about it. In 1912 Alaska was not yet a state, and communication was slow. Some of the effects were immediate, but it took months

before the extent of the damage was known. The park service offers a tour to the Valley of Ten Thousand Smokes. We cannot recommend enough the historian/naturalist guided tour that starts from the visitor center. Your guide will take you to visit very old partial and rebuilt native dwellings. This was a particularly active cultural and social area. When Europeans moved here and Novarupta exploded, the native population moved elsewhere along the coast.

And then there are the bears. The primary place to see them is a raised platform some fifteen feet off the ground and about thirty yards from a waterfall where the grizzlies perch. While all the national parks have been magnificent, there have been just a few scenes that have rendered us speechless with such power and raw beauty: thirteen grizzly bears, standing in rushing water, roaring, catching salmon as they leaped out of the water, trying desperately to swim upstream.

Bears rule here. That is Katmai National Park.

- AB

Late August in Katmai,

Summer closing
her long purple lashes
of fireweed.

It took fifty-four years,
three days,
three airplanes,
and one boat
to get to this island
of grizzlies
and old Athabaskan ways;

remnants of the earliest people
beneath our feet.

How many begats
led us back here,
toward the Bering Land Bridge
from where we came?

How many years of
crisscrossing the planet
before arriving back
to a land so rich
the salmon leap to us.

There is a word I am looking for,
something primal;

something that echoes
like the roar of bear
among the falls;
some ancient sound
my soul will know
as home.

- kk

Numbers on Naknek

Three flights—
and now forty minutes in a water taxi
to get to Katmai.

Plus two marriages.

My explanation? This is me
shrugging one shoulder
but not both.

It's a gray day, fifteen people on the boat,
nine of which were women,
and five of those
strawberry blondes.
What were the odds?

But sorry.
This is a personal equation
with layered numbers.
You didn't come over for that.
You might not be interested.
Go get a piece of cake and a cup of coffee
from my measured kitchen.
It's twenty-two steps from your chair
to the stove.
I know. I used to make that trip.
As you go you might count
three narrow windows
and an abandoned fork on the table.

Your comfortable chair
with its four square immovable legs
will be waiting for you.

When you get back
I might already have left.

When you are ready
abandon your fork.
Sum things up.
Close the equation
of the three windows
firmly behind you.

- AB

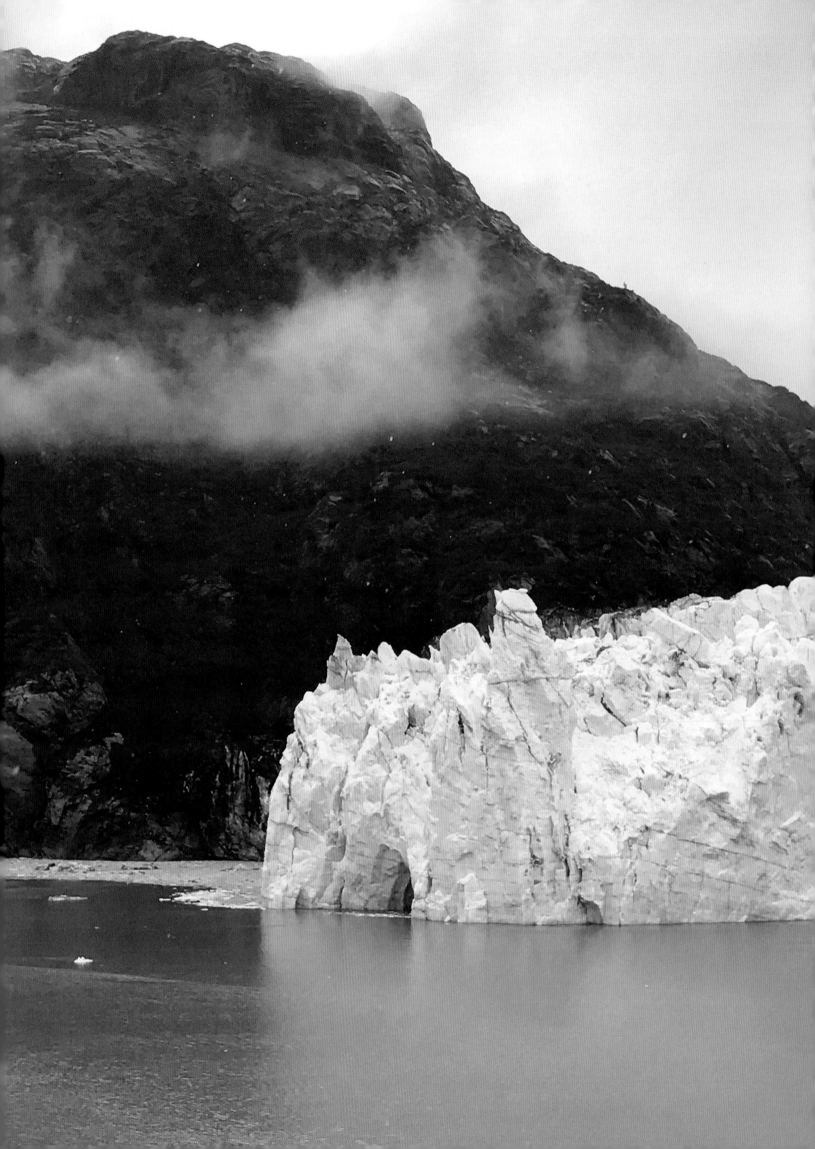

Glacier Bay National Park

ALASKA

We highly recommend a visit to Glacier Bay National Park by boat. This was one of the most exciting trips ever—exploring the inner coast of Alaska from the water.

On board, a naturalist, with lessons daily, helped spot whales as the water turned into midnight blue. The ship stopped at places like Ketchikan, Juneau, Skagway, then the pearl of Glacier Bay.

Everyone, in their lifetime, needs to experience a glacier. In Glacier Bay, the big boat stopped, and at 5:45 a.m. three amazing women Rangers climbed aboard by rope ladder to teach us about these glaciers. Here, the snout of the glaciers flow down with gravity to the edge of the ocean.

We would wait and watch and listen for what the native Tlingit tribe call the *White Thunder*—the big boom of a glacier as it moves forward off the land and slides into the salt water. The sound, the thunder, comes first, and we search the coastline with our eyes in wait for it—the great *calving*: pieces of the glacier falling into the ocean. There is still great mystery here: I believed I heard the calving first, then saw it. Alan believes he saw it first, then heard it.

By size they are called icebergs, bergy bits, and growlers. They sizzle and pop in the salty ocean waters.

We idled for hours on deck, hugging the ship rails to hear and see and feel the winds from the glaciers. There is nothing on earth like it. And after the glacier thunders and falls into the water, there is a *blue* visible on the remaining glacier that lasts a little while until the oxygen fades it.

It is a blue like nothing else on earth; a blue you will spend the rest of your life trying to describe.

- kk

Quietus, Late August, Alaska:
Salmon Carried Off by Eagle

We felt him,
eagle only
three wing-beats away,

absorbing
our every stir,
our frenzied hunger

to push life
upstream, forward.
His eyes stunned. He cocked

his head. I
felt the scurry
of squirrel, the dive

of snow hare
into its hole.
I felt the sun tilt,

this arctic
desert shift, then
the pierce of talons–

coup de grace
in my sockeye
flesh–the exquisite

arête
of mountain top
only seen in death.

arête– 1. *The aggregate of qualities, such as valor*
 and virtue, making up good character

 2. *a sharp, rugged mountain ridge produced*
 by glaciation

quietus– (*kwa -E-tus) A finishing stroke; what ends it;*
 a release from life

- kk

Arctic Lesson

To say it clear: the graupel and the wind,
the rime that forms along the rail, the pulled
in cowl, the hands caressing coffee cups,
and then there is the thunder of the calving wall
that we see before we hear. Count one and two
then five or maybe six and then there is the
thunderous reading of the glacial gospel,
the thousand-year-old word. In following salute,
the benediction is repeated, and spoken yet again,
in fizzing waves that slap with open frosty hands
against the ship. Love the sermon. Stay on the deck
as long as your hungry heart will allow.
Let your cheeks flush. Wipe your eyes clear
of salty tears.

- AB

1980

Gates of the Arctic National Park

ALASKA

Gates of the Arctic is the northernmost national park in the United States. It is entirely *north* of the Arctic Circle. To be here, to be standing in the rushing Noatak River, changes a life forever. Forgive my surge of sentimentality, but to be in a place with no other signs of humanity, among tracks of grizzly and caribou and wolf, you cannot help but feel one with this great earth.

Gates of the Arctic, the second largest and least visited national park, includes over 8.4 million acres of land exactly the way it was created. There is not one building, not one road or one trail or any kind of passageway into this permafrost glory except by foot or boat or plane. To come here is to be completely on your own, completely self-sufficient, completely at the mercy of changing weather and hungry grizzly bears, and to have the most thrilling adventure of your life. Plan carefully, pack bear-proof. The arctic is totally wild and difficult to travel, with tales of even the most experienced hikers managing only five miles per day. Up here, northern lights are not called northern lights, but just the *Borealis*, because you don't have to look north, you simply look up.

The name Gates of the Arctic was coined by Robert Marshall, who came to Alaska in 1929 looking for "blank spaces on maps," but the real story of Alaska resides in the ancient people who have lived in the Brooks Range for more than eleven thousand years, following the great migrating herds of the Western Arctic caribou that still traverse these wilds. The caribou are life—every part of them blessed and used, from the meat to the skins to the sinew dried into thread for clothing. The Inupiat (Inupiaq) Eskimos and groups of Athabaskan Indian people appeared throughout this region traveling across the ancient Bering Land Bridge, and still today, eleven indigenous communities survive by subsistence hunting and gathering inside the park, in many of the same ways of their ancestors. This is a land of deep spirit. Nothing is wasted. Community and cultural knowledge is survival, and to live here you must be in sync with the rhythms of the earth. The living is real and deliberate, and a great gratitude abounds.

Here you understand that the earth is forever. We, however, are mere visitors.

- kk

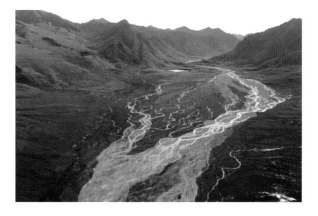

duplicate
duplicate

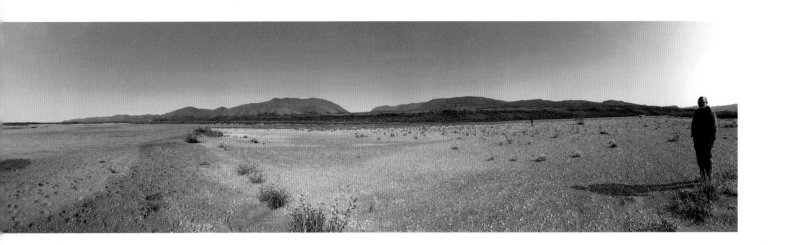

The Hungers

I stood in the Noatak River
amid fresh tracks of grizzly and wolf
and caribou,
the bush plane landing on the banks.

There is no other way in,
no other human prints.
No other sound but river's hunger.

We have forgotten these desires–
we, appearing like two-legged moose calves
to the famished grizzly.

We have forgotten our animal roots–
how to speak to one another,
lost our tail,
forgotten to take only what we need
when we need.

We have forgotten
the strengthening fear of survival–
that we are separated only by
the power of fire
and the grace of a God
who tweaked our brains
a tiny bit more than the others.

There is poetry in the burst
of pure white tundra swans
and dark kettle ponds;
in the way salmon feed every living thing here.

And when the fish is caught and cleaned,
its bones are given back to the hungry river
with the Inupiaq blessing:
Be Made Again in the Water.

- kk

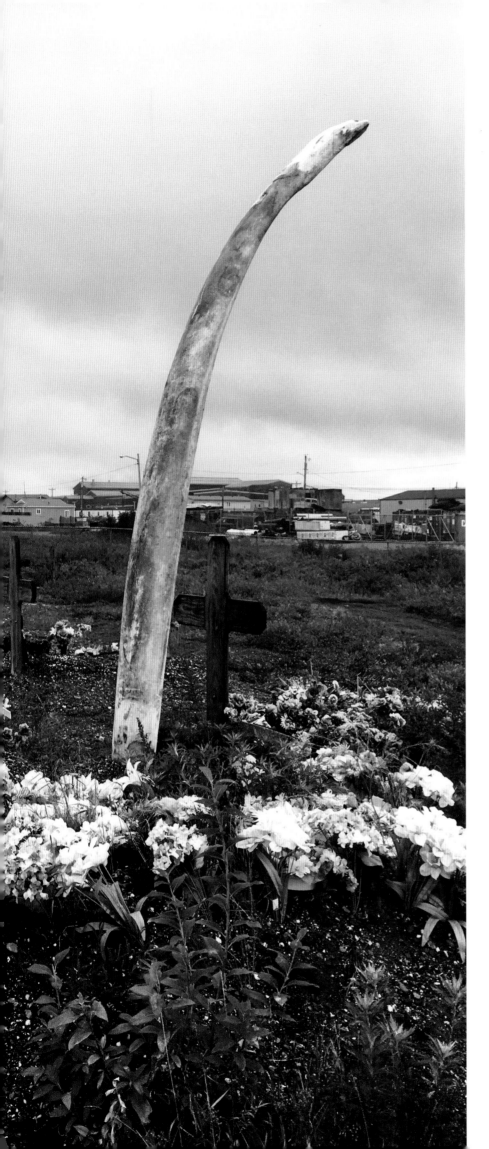

Gates of the Arctic: Washed

Following the Ambler River
Is not something
You thought
You would ever need to do.

The guide books do not mention
It takes four flights
To be baptized
In the Noatak river.

And that is what
Unformed lips at the font
Could never remember
To tell us years later.

There had been a small drone
In their roseate ears
As they exchanged
One path for another

Weeping, fists of helplessness,
Mouth wide open
Asking forgiveness
For being so small.

- AB

Whale rib grave marker,
Kotzebue, Alaska, gateway to
Gates of the Arctic.

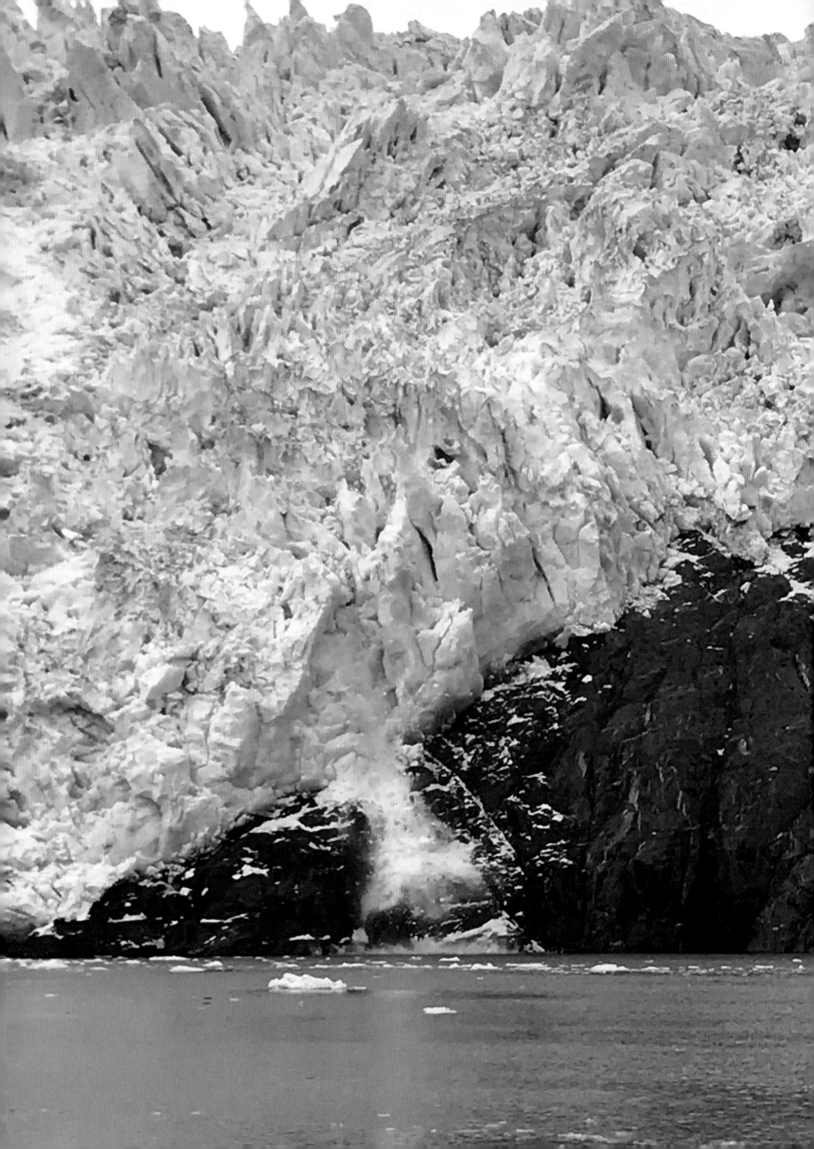

Kenai Fjords National Park

ALASKA

Everything you thought you knew about this world changes once you visit this wild frontier—indeed the last frontier. Your ideas of what the word *grand* means takes on an entirely new attitude. Kenai Fjords is one of the most unexpectedly rich national parks, and one of the easier Alaskan parks to get to.

While you are there, be sure and take the Alaskan Railroad with its glass top and dining cars. It is an old world way to travel between Anchorage and Seward and something you will never forget.

The 607,000 acres of Kenai Fjords National Park were named December 2, 1980, with the Harding Icefield as the park's queen. The Harding Icefield, on top of the Kenai Mountains, was once a huge ice sheet that covered most all of Alaska in the Pleistocene era, and now feeds thirty-eight glaciers. Summer is the time to visit, of course, and a trip up to Exit Glacier is the thing to see. Along the road, there are year-by-year signs beginning in the 1800s marking where Exit Glacier used to

be. It is a sobering journey back to the farthest point (where, at this writing, Exit Glacier was in 2010), which puts into perspective how fast Exit Glacier is melting. Soon the park will need to carve new trail so visitors can still see the glacier.

All of humanity has lived in an ice age, and indeed, we are *still* in an Ice Age, and will be in one as long as one glacier still exists. As you stand in front of Exit Glacier, you feel the katabatic winds it creates, hear the pops and creaks of gravity pulling it down the mountain about eleven inches each day, listen to the rush of melting rivers inside. There is nothing like the feel of it, the smell of it, the sound of it. Go see a glacier. Don't wait. Give yourself this gift of earth that will change your life forever.

Alaska changes everything.

- kk

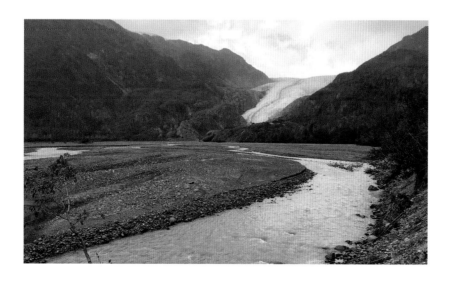

Kenai Fjords

They birth without warning–
milk grey waters
fast flooding from glaciers.
Each year tallied in retreated miles.

Scientists say we are still in an ice age,
and will be
until the last glacier is gone.

I find comfort in that–
a settling of my soul
atop the Harding Ice Field,
Forty glaciers descending below.

I don't want to live in a world without ice.
I don't want to be that hot survivor–
that white hare in the
brown tundra

Give me white thunder.
Give me icebergs and growlers
sizzling in the sea;

a freezer of blueberries,
a pantry of smoked sockeye;
let me live off roadkill moose,
and a 1905 sourdough named Beauregard.

Every day we hiked up
the white beast of glacier;
cooled in its katabatic winds.

It moans and pops and shifts.
It thaws into blue-grey waters
finally free after 12,000 frozen years.

I don't know what to offer
back to this lush earth
of Black Spruce and crow berries,

to the summer sun lifting over the peak,
the icy Fjords singing with Orcas,

but this is the world we were meant for;
a deep reach into topaz waters,
our hands, numb with glory.

- kk

Kenai: Communication and Respect

I'll confess: I usually travel with a bottle.
It's what civilization has done to me.
But it's useless to buy whiskey here.
There's no drink stronger than the catabatic winds.

Go on. Get on the charter boat.
You can stand beside the Captain,
inner ear tumbling,
knees constantly popping in the rocking.

The deck, and your mouth, will be as dry
as a Temperate's birthday.
That Captain man won't point at anything.
He'll just nod his head

toward sea lions,
a pod of killer whales,
Aialik about to calf into the fjord.
Not like he couldn't extend his arm,

even with the sea chop,
but this place is stronger
and bigger than any whiskey—ever.
He'll use words.

Or maybe a head nod.
He'll blink at you,
making sure you understand.
He might glance and notice

you, now,
keeping your hands in your pockets
(when they aren't holding the rail.)
He'll huff out, satisfied.

Getting off the boat, later,
my knuckles were white
from curling so hard.
I needed a drink,

but knew now there would be
nothing strong enough.
So I chose not to ask
that foolish parched question,

not willing to try and interpret
the knowing smiles and head tilts
leaning me toward
the nearest pub.

- AB

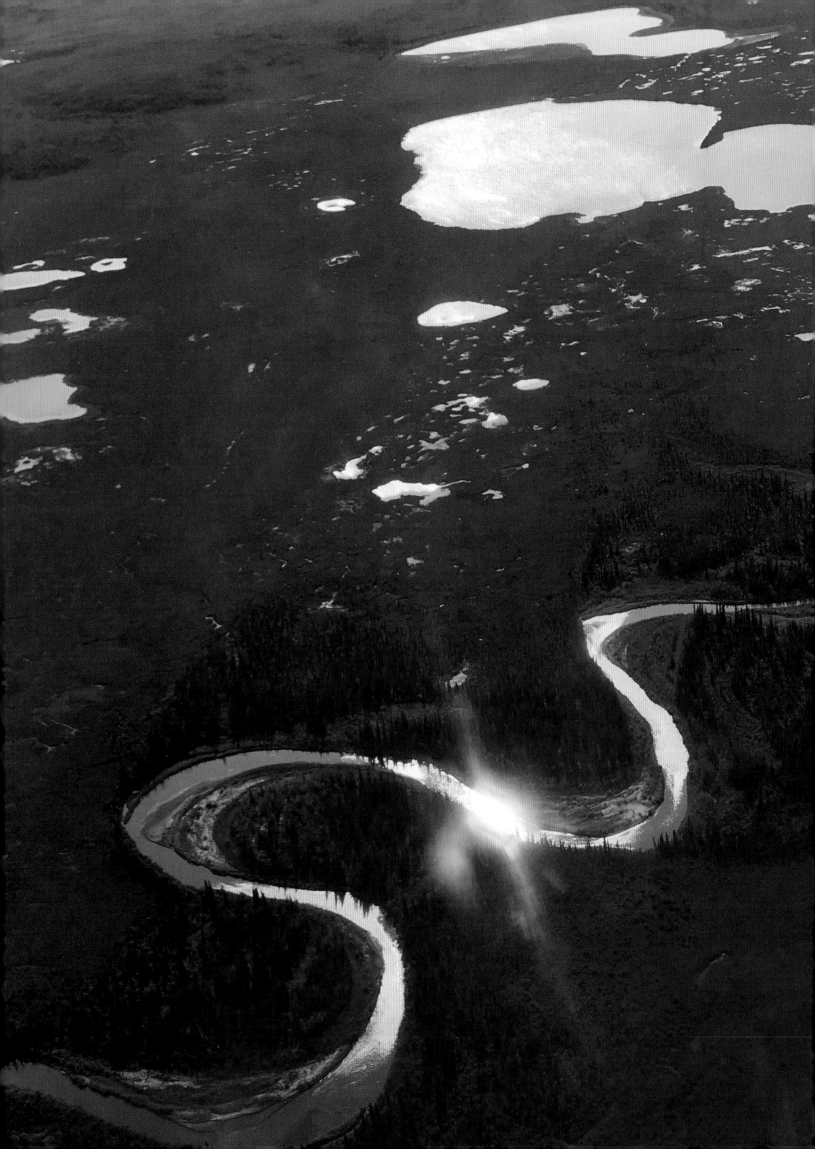

Kobuk Valley National Park

ALASKA

There are other national parks that are centered around sand dunes, but there is nothing quite like Kobuk. This park is completely above the Arctic Circle. There are no roads. It is wilderness. You can hike in, come in by canoe along the Ambler or Kobuk Rivers, or fly in by bush or float plane. Most of the flights are available from Kotzebue, but some services are available from local villages. Call ahead and make arrangements. You must be aware of the fickle weather: wind, rain, ice, snow, and, especially, arctic temperatures may delay or totally cancel your agenda to visit the dunes. Be flexible in your plans; conditions can disrupt all agendas.

The dunes were formed thousands of years ago when glaciers ground the rocks into smaller and smaller grains. When the glaciers retreated it's believed that slowly evaporating water levels carried the sand into a dry lake bed. No more sand is being generated by glaciers. The wind is distributing the sand dunes even more now.

The sand is a light brown, more granular than powdery. From the air it appears like a huge brown-gray wave. While the area is covered with sand, this park is not a desert. There are tufts of sparse grass, and it is likely that if you bush plane into the park, as we did, the first prints you will see on the sand will not be human. This is the area of the great caribou migration. Hundreds of thousands of caribou cross the arctic reaches every year. Moose, bears, wolverine, elk, and wolves, among others, cross the dunes on a regular basis. Regardless of your transport method, when you land be aware you are only a visitor. This is a land of subsistence. This is a land that existed long before you. Tread lightly.

- AB

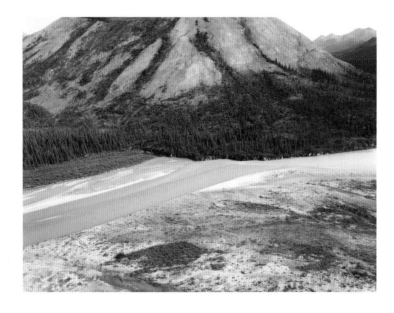

Kobuk Valley

One day these sand dunes will disappear,
the fertile flora slowly taking them over.
The story of this world, ever in motion.

Time is a fluid thing–
The earth turning,
the waves, endless;

these dunes, dropped by glaciers
that crept up the mountains
thousands of years ago;

dunes dry as Egyptian sands
in this extended hot-flash
of earth, when Cleopatra

soaked her ship's sails with perfume
that Marc Antony could smell her
before he saw her;

her essence, still mingling in the winds.
How rich this life.
How lush a world that carries us

for even just a little while:
two handfuls of decades;
perhaps a few dozen summers

that we might live and love
so fiercely,
we dare be deemed worthy

to have tread such a place;
to have knelt down and touched
the very beginning of time.

-Anthropologists found Cleopatra's vials,
 reinvigorated her scent

- kk

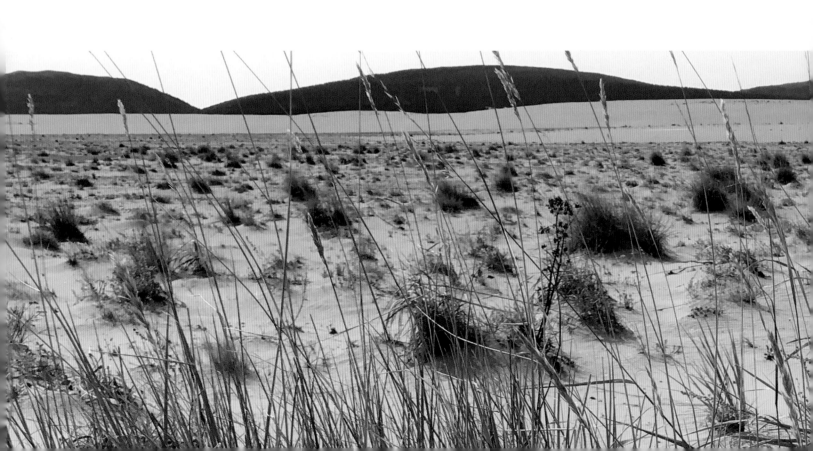

The Sand Dunes

Some places you may imagine you are someplace
else.
You get there and you lean into your partner and say
this building looks like Rome
or do you recall that singular river—the one with the
scows
and green paddle boats—
or do you still dream about that ride along the streets
of Tokyo?
The bustle here is reminiscent of that.

Kobuk is not any of those places.
When we landed we were told to
step on the tires to climb out of the plane.
It was just us and the pilot and an hour flight
over the Ambler River
and seeing too many glaciers to count.

When we got there we didn't remember
the questions we were supposed to ask.
And we certainly didn't play mental

connect-the-dots. There was nothing in our memory
to attach the line to. The sand did not provide an
anchor.

The entire time we were there
we never talked about the dark,
or a sweet wine from Napa or
leaping from sampan to sampan.

We realized we were not big enough or brave enough
to even ask how the sand got here,
how we got here,
how there was no ocean,
how the mountains were miles away.

By the airplane the pilot, full of languor,
whistled to himself.

The ghosts of thousands of elk
migrated before our eyes.

- AB

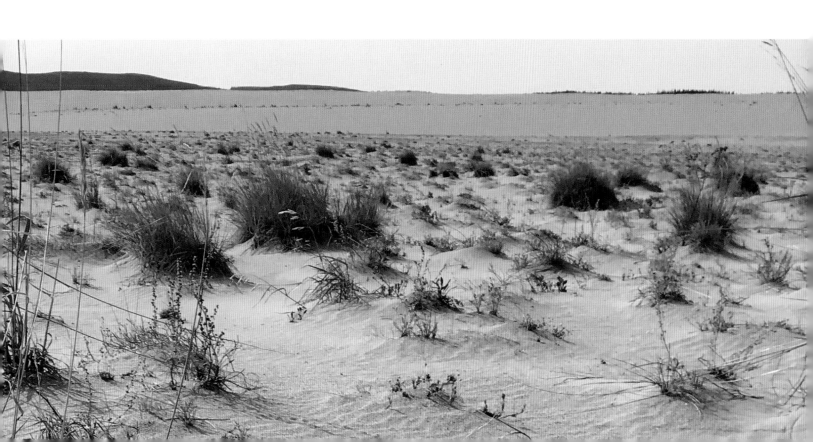

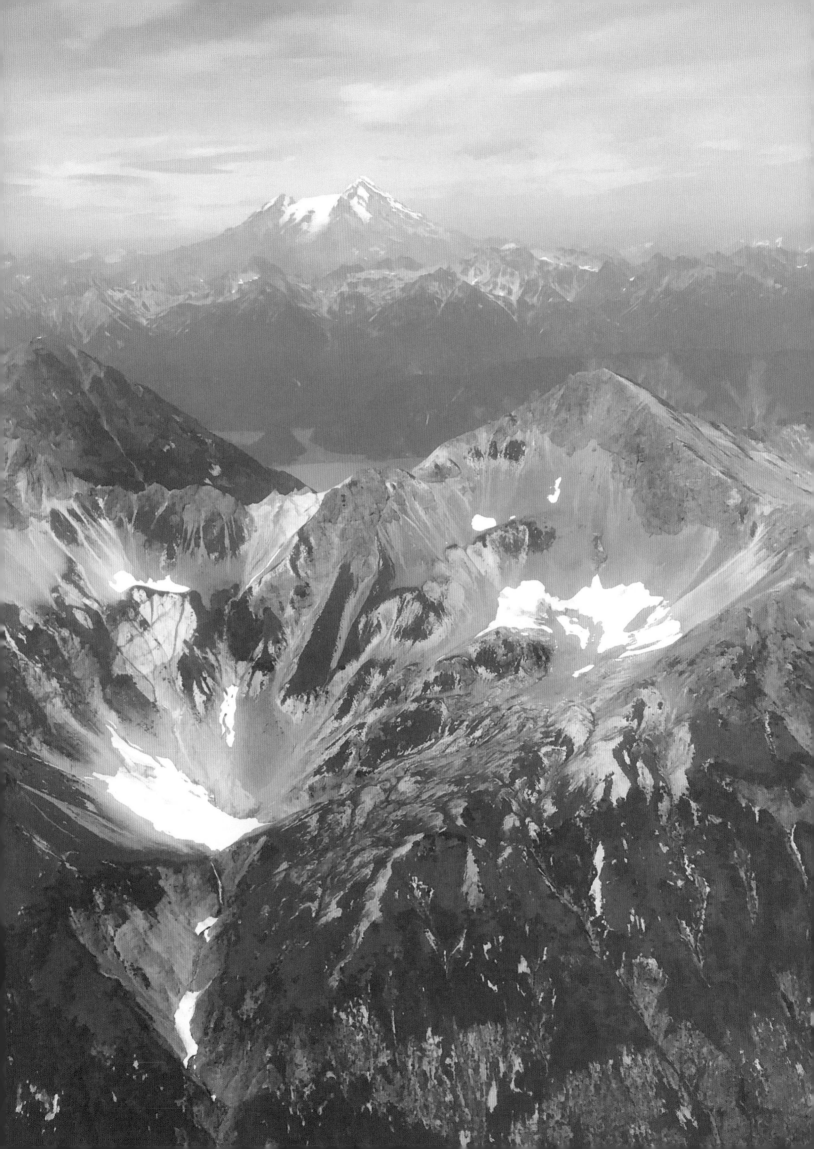

Lake Clark National Park

ALASKA

Maybe it was the fact that we were physically exhausted from our daily eight-plus mile hikes through Katmai, singing loudly—always on the lookout for grizzlies crossing the path.

Or maybe it was just the exquisite beauty of Tanalian Mountain opening her arms as our floatplane landed at Port Alsworth on Lake Clark, but we clamored off the plane, balancing the floats to the graveled beach, set down our one carry-on and one backpack each, and breathed deep.

It is another world here—pure air and glacial-silted turquoise waters, silky and still, the salmon having already made their run. All around, in 360 degrees, so many mountains and glaciers that they have no names. Checking into the Wilder B&B, we left the wilderness on the doorstep, just feet from the runway. It is full of every comfort and a tub! OH! a tub! In the first twenty-four hours I took four baths. We both slept fourteen hours straight.

Here we explored just a few of the massive 4,030,006 acres. We rested, the Visitor's Center chock full of indigenous stories of natives in their own language, and we took Alaska's taxis: the bush planes, flying over the many glaciers, the many snow-capped peaks, the smoking volcano of Iliamna Mountain.

I have said before: Alaska changes everything. One cannot see what we've seen and felt what we have felt, without being totally and completely changed. You suddenly realize, amid the witness of this virgin earth, that what matters in this wide-wide world is the love of life: joy—the kind of joy deep in each cell, the kind that circumstance and daily routine and cruelty can't touch; the kind that can't be altered; the kind fused into the heart. This is what Alaska does—it reaches into us and finds that joy.

In the deep DNA of this traveler, something in Alaska feels like *home*.

- kk

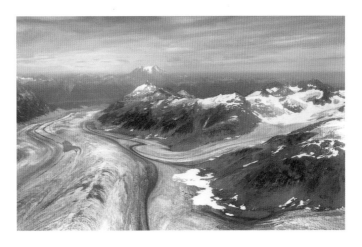

Lake Clark

The pulse of salmon
has come and gone,
making its wild way upstream, inland.

Lake Clark, becalmed,
double-hulled, all sails dropped,
the waters, turquoise still.

We're in the middle of it here:
history.
Dena'ina ways all around,
salmon drying racks, caches;
not one road in four million acres.

There is a memory
I'm trying to touch upon;
something ancient that ties me here,
a spawning fever.

I listen closely to the stories,
watch natives dig willow roots
to tie fish traps.
I wonder how long a soul can search.

I run my hand through the fox pelt.
I have entered these glacial waters.
I, the displaced artifact
finally coming home.

- kk

After Flying over Iliamna and Redoubt
We Played Horseshoes

You'll need to be willing
to paddle through the rotten ice
of your former life to get here.

You'll think you'll want to axe down some black
spruce.
You'll yearn for the hollow sound of loam
as you step outside every morning,

You'll need to be willing to accept
lichen beneath your feet
instead of the toneless flat note of concrete.

You'll need to be willing to walk everyday
in the shadow of Tanalian,
be blessed by ash from Redoubt.

There are rivers inside the glaciers,
copper bleeding in the mountains.
Cottoned fireweed will snag on your jacket.

This was what was going through our heads
when we gripped the iron of the horseshoes
and hooked our thumb on the toe.

When we aimed and arced our arm back
and let the steadfast thing go,
then, then, did we exhale.

Our thoughts released for a few seconds.
We were quiet. We didn't look at each other.
It didn't matter where the horseshoes landed.

- AB

Wrangell-St. Elias National Park

ALASKA

Wrangell-St. Elias National Park in southeast Alaska, encompassing over thirteen million acres, is the largest of all the national parks. You can access the park via the rivers (the primary routes being the Copper and Tazlina), float plane, bush plane, or hiking, but there are only two main roads that go a respectable distance into the park—the Chitina-McCarthy Road and the Nabesna Road—neither of which the rental car companies want you on.

There is almost no way to describe the overwhelming majesty of this park. The mountains and rivers seem to go on forever. Glaciers seem to nestle in the crook of every mountain. As large as the park is, trails are comparatively few. With little to no scars from civilization the skies are incredibly clear. And yes, you can see the northern lights from here.

Vista after valley after cirques after frozen lakes. Bear. Moose. Wolf. The bursting of fireweed. Birds in colors that your eyes can barely grasp. It will be impossible to go back home to traffic and concrete and drive-through restaurants.

Something will be replaced inside you that you didn't realize was holding you back. I know. I stood on a hill, listening to roaring glacier-fed rivers at the base of a mountain, staring at a far-off snow-covered range (including Mount Drum, over twelve thousand feet)—and became aware that something had changed. When I returned to Texas I quit my job. I realized I could not see what I saw and go back to a mundane life.

A caution: this is the largest of all wilderness areas. If you do decide to hike, with or without a guide, let someone know where you are going and your expected return time. The mosquitos, the ice, the rivers, the wind are unforgiving. You are the visitor. Prepare. And ready yourself for the experience of a lifetime.

- AB

Egression

I knew I had to leave today,
when great skeins
swung their arrows to and fro
over my head.

I rolled down all the windows,
and the moon roof.
I could not hear them.
Could Not Hear Them.

The Denali bus driver said it best—
how being in Alaska
made him unfit to live anywhere else.

I have become unfit to live anywhere else.

I struggled with my ears,
tried to tilt them canine forward
toward the geese,
but all I heard was traffic.

I knew what they were singing—
about the White Thunder before the glaciers calve,

the way the wind smells blowing over
Wrangell's icy peaks.

I cannot bring all of myself back
from that permafrost frontier,
the thick life of it—

the run of the salmon,
the way the midnight summer sky
holds the sun
like a pale blue nightlight;

the way the rest of the world culls into
the green borealis;
how it falls away
like breath.

Egression: a going out

- kk

To Walt Whitman

Walt, you should have been with us.
You would have liked
the confluence of the Copper and Tazlina River,
the gray clouds that hung on the horizon
like the curtains of Valhalla,
the eagles that nested in the defiant stone cliffs,
the suggestion of thermal mists at the head
of white, dry, mountain streams.

How many people had been there before us?
More moose than human I think.
Or the bulk of bear. It belonged to them just as much.
They are the population and governing body.
If faced with such hoary, antlered, and clawed ownership
would you still have been so democratic
as on the prairie, the hills of Boston?
Is this what you meant?

There were no demarcations,
no fences keeping us from rowing the raft in,
tying off, wanting to inexplicably count
the rounded, river stones,
the need to touch the denuded branches
of the river-carried trees.
Nothing between us, any of us,
even from you if you had been with us,
—nothing between us and the
slow gnarling, gnashing of glaciers
if our feet had chosen to take us.

If we quit listening to our breathing enough
we would, you would, finally have been able to hear
some subduction of forgotten tectonic plates
tilting the dark side of our heart
up to the rarely-seen sun.
As we got off the raft
a wild dog watched us from up-bank,
neither quizzical nor judgmental.
Just an observer. As if to say, only,
"Walt, stay a while.
There's plenty of room.
The snow is coming.
There will be no one to tell us
we don't belong."

- AB

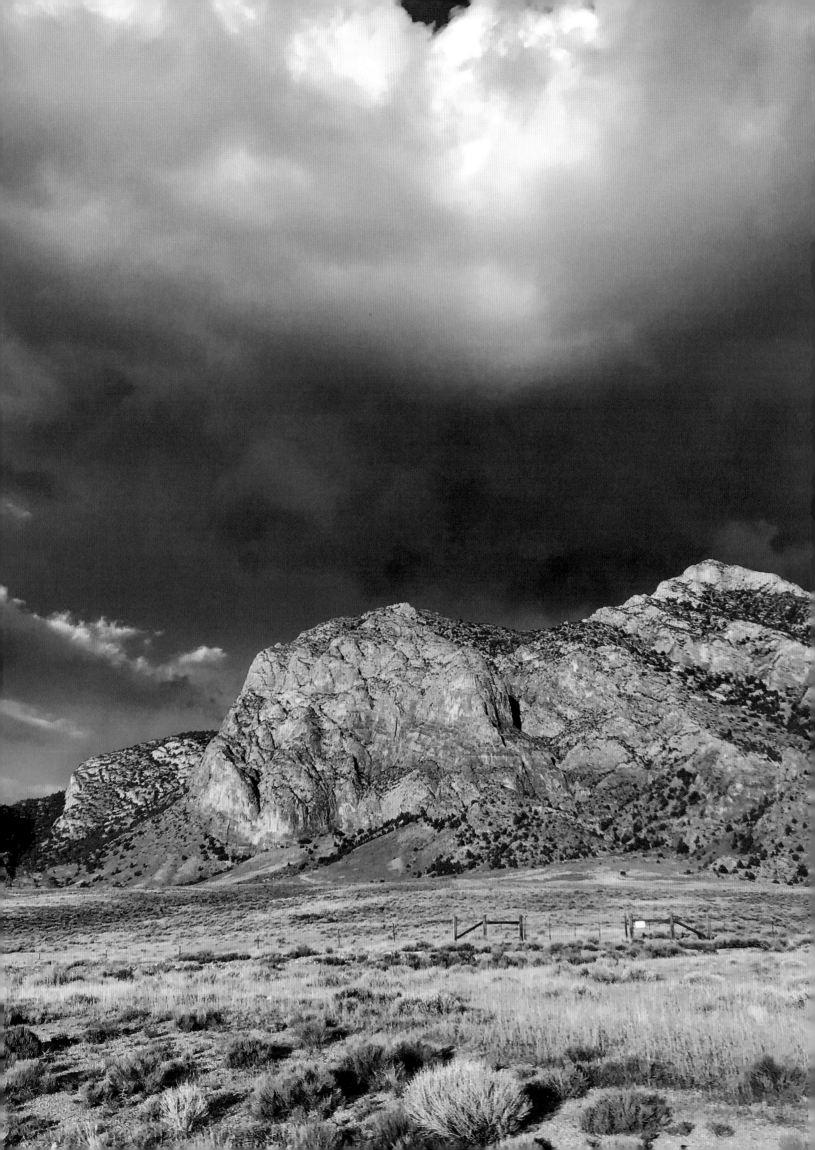

Great Basin National Park

NEVADA

In our three-tiered list, we both put the Great Basin in our top favorites of national parks. It might be the quietest place we have ever been—perfect fodder for poets or anyone seeking to find solace, inspiration, and guidance in their lives.

And getting here, *oh yes*, is definitely part of the healing journey. First *grasshopper*, you must travel down Highway 50—what *Life* Magazine named in 1986 as the "Loneliest Highway in America," which passes through twelve states coast to coast. But the best section of it is right here. The vista is wide and uninterrupted.

And if you happen to be out at night, take the time to look up—the Great Basin has some of the darkest skies in the contiguous US. Two-thirds of Americans can't see the Milky Way, and 99 percent of us are afflicted with light pollution. You won't realize until you come here how light pollution negatively affects both wildlife and human life. Here, your internal clock is reset. Nature stretches as far as you can see. Even the birds whisper.

If you come in the winter months, catch a glimpse of the Heart in the mountain by the park entry sign. There are the Lehman Caves, full of active stalactites and stalagmites and shield formations—at a constant 50 degrees. There is a glacier here. Yes, a glacier. Yes, this is a desert. This is the last glacier in Nevada.

And there are groves of Bristlecone Pine Trees, the world's oldest living trees. They can live to be five thousand years old. Imagine what was happening in the world the years before the Bristlecone Pine named *Prometheus* was cut down in 1964. The park says it best: *"Pyramids in Giza were built, the Roman Empire rose and fell, Mayan cities boomed and collapsed, the Ming Dynasty came and went."*

And sadly, we know about Prometheus because he was cut down by a graduate student doing tree-ring research. The justified outcry led to the designation of these 77,180 acres as the Great Basin National Park in 1986. This secret place, my friends, must always be preserved and protected.

- kk

The Cirque: Nevada Great Basin

We parked where the road closed,
hiking forward on foot,
snowshoes strapped to our backpacks.

April is still winter on Wheeler Mountain,
the grey tulle of clouds
a heavy halo on the peaks.

Two miles up, we found a mini-meadow
curved within cedar, white pine, aspen,
ponderosa, bristlecone–
a perfect cirque for poets.

I have never been anywhere as quiet as this–
the occasional hawk; the occasional plane;
the snow, the rain–all water is their own,
flowing Great Basin center–
not east or west to the seas.

Maybe . . . this is Eden,
remnants of mankind
seen only in asphalt or airstream.

What we know is
we have this mountain to ourselves,
if only for a little while,
our lives not even one ring
in the 5,000 year-old bristlecone pines.

What then are we,
in our brief and fleeting moment
but gifts to one another?

Here, let us share this cup of water;
let us spread our coats;
let us warm our bodies in the sun.

- kk

Great Basin National Park

The silence here is
like that of an ex-lover
who has finally forgiven you
but still doesn't want to talk.

You still aren't sure what you did.
But you'll be headed up the road,
past the cave, past the viewpoint
of the glacier, and then up to the parking lot.

And then you walk even farther.
It's something you have to do
to the bristlecone pines
who have been still,

standing there, pointing with the wind,
hanging on to stones,
something they cannot swallow whole.

And here is where the heart of silence is.
The ex-lover who has finally forgiven you.
It's time for you to realize
even if you aren't sure what you did

that there's a silence past silence,
limbs twisted by wind and years,
reaching for something,
and still refusing to let go.

- AB

National Park of American Samoa

AMERICAN SAMOA

It is hard to describe paradise.

My first instinct is to tell you not to come. Don't come. Don't. The coral reef is one of the most pristine coral reefs in the world. You will touch it. You will wear sunscreen in its waters. You will kill it.

The fruit bats are a marvel; their three- to four-foot wingspans falling across you in shadows in the daytime will make you think of prehistoric flying dinosaurs.

The rainforest is alive. It breathes. It does not like people. The Aitu evil spirits live there.

The Fa'Samoan way of life is theirs. Don't mess with it. Don't bring your culture into theirs. Don't take photos of them. Don't stand in their shadows. Approach them and their lands with reverence. Be respectful.

The Samoans believe the tattoo originated in Samoa, the hunters bringing the boars' jawbones and tusks to the holy ones, who carve out needles and dig up plants to make their ink. It is still a sacred, religious act. This is the one national park we visited that we still dream about; the one park trip where we came back with a permanent cultural artifact.

- kk

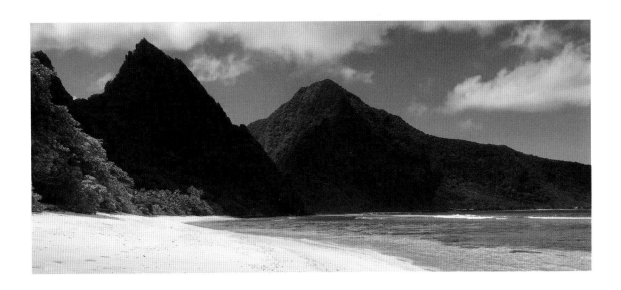

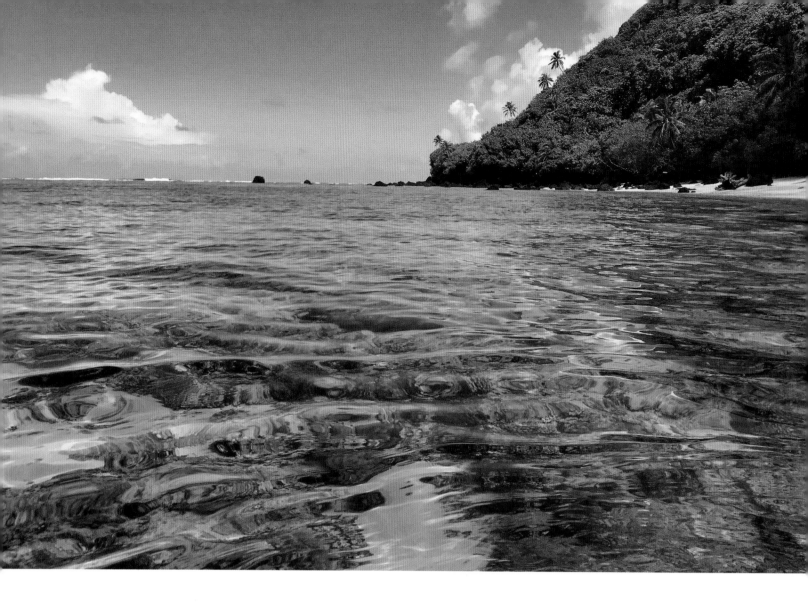

Aitu

Aitu–evil spirits of Samoa

They said Nothing on this island can hurt you.

But I hear the Rainforest
when I close my eyes;
the way it chuffs the curtains in and out.

It rustles;
a soupçon of sound.
Not even birds venture deep within.

But every morning, her caretakers are there
at the meager border of their land–

with lawnmower
or weed whacker,
sometimes the intimacy of machete,

six feet from the cabin,
slicing back the ankles
of woody legs

and those green viney arms
that grip the windows
in the night.

- kk

Ofu

In the morning the starling
wakes us with the urgency
of a farm rooster.

The breakers on the coral reef,
a few hundred yards away,
insist they have not slept.

If I take the road just as the runway ends
I know, even at this early hour,

the fruit bats, as big as cats,
will be shimmying down the breadfruit.

With each step along the diced beach
the rain forest rustles toward me,
the sand abrades sixty years of my name.

- AB

Dry Tortugas National Park

FLORIDA

Dry Tortugas is approximately seventy miles from Key West, only accessible by water or air. Seven islands and a coral reef make up the park, but the heart of the park is the nineteenth-century structure Fort Jefferson. You get to Fort Jefferson by taking the Yankee Freedom charter out of Key West. There are other concessionaires who can offer smaller boat charters or sea planes. You can also visit a lighthouse that still stands on one of the islands.

Designed to be part of a chain of forts along the southern coastline of the United States, this is one of the few that were actually built. It was both fort and prison. It was originally constructed by slaves, but as the number of prisoners increased, the need for slave labor decreased. While the fort was built to withstand sustained bombardment, and there are scores of slots for cannon, the fort never had to face any direct opponent. In theory it was built to protect the seaways between the gulf coast and the east coast. There were ideas it could serve as protection for the North during the Civil War, and, for a while, it did serve as a miserable jail for prisoners of war. (In fact, one of the most famous inmates was one Samuel Mudd, who treated John Wilkes Booth after he had assassinated Abraham Lincoln.) In 1888 the fort's military role ended, and it was converted into a quarantine station. Even so, it was a strategic location during the years preceding the Spanish-American War. Take the time to take a Ranger-guided tour. Walk along the moat. There is fascinating history in the shells and gravel beneath your feet.

Be aware there is no lodging on the island, but there are a small number of campsites. If you plan on staying then you need to bring in everything. The park is called Dry because there is no fresh water. Learning the history of the failed architectural attempts to try and capture rainwater in cisterns is fascinating. It was a doomed endeavor; the design was flawed. Construction started in 1846 and continued on for almost thirty years, but it was never completed.

- AB

Desideratum

Key West/Tortugas

The perfect Poinciana of Indian Summer;
a flame that stops you mid-stride—

one you cannot help but reach for,
the wild crayola of petals;
thick fallen sugars
of Key West.

How brilliant a God
who knows
how the exact mix of yellow and red
could twist
the wet edges of a heart
into something so glorious;

an anthem
a declaration

this is what it means to take breath in and out;

what it means to coral
at the ocean's floor
beneath current
that swivels and pulses
and makes salty love
to the fishes
and blind seaweed.

This is what we want most:
the sweet shock of life
to make us gasp;
to make us
think fire and persimmon;
to make us bite the fierce lips
of a lover.

- kk

Prayer for Epiphany

On a hard dry substance you have to engrave the truth
— ADAM ZAGAJEWSKI

But if I had, like this place, 400 cannon
to fire at the shambles

of my former self,
before I knew of this history, this boat ride,

would it be enough
to raise me to the level

of insight of why I was truly here?
Would my old prayer be enough

to bring an angel down
from the Heavens

even just only to explain
why here, why this moment,

why this moat,
why these bricks, why this barrier?

Or would she only
stroke the heads of cormorants,

ruffle her own wings
like the fin motion of stingrays?

Then reach down into the dry wisdom
of false cisterns

and pour me a handful
of dust?

- AB

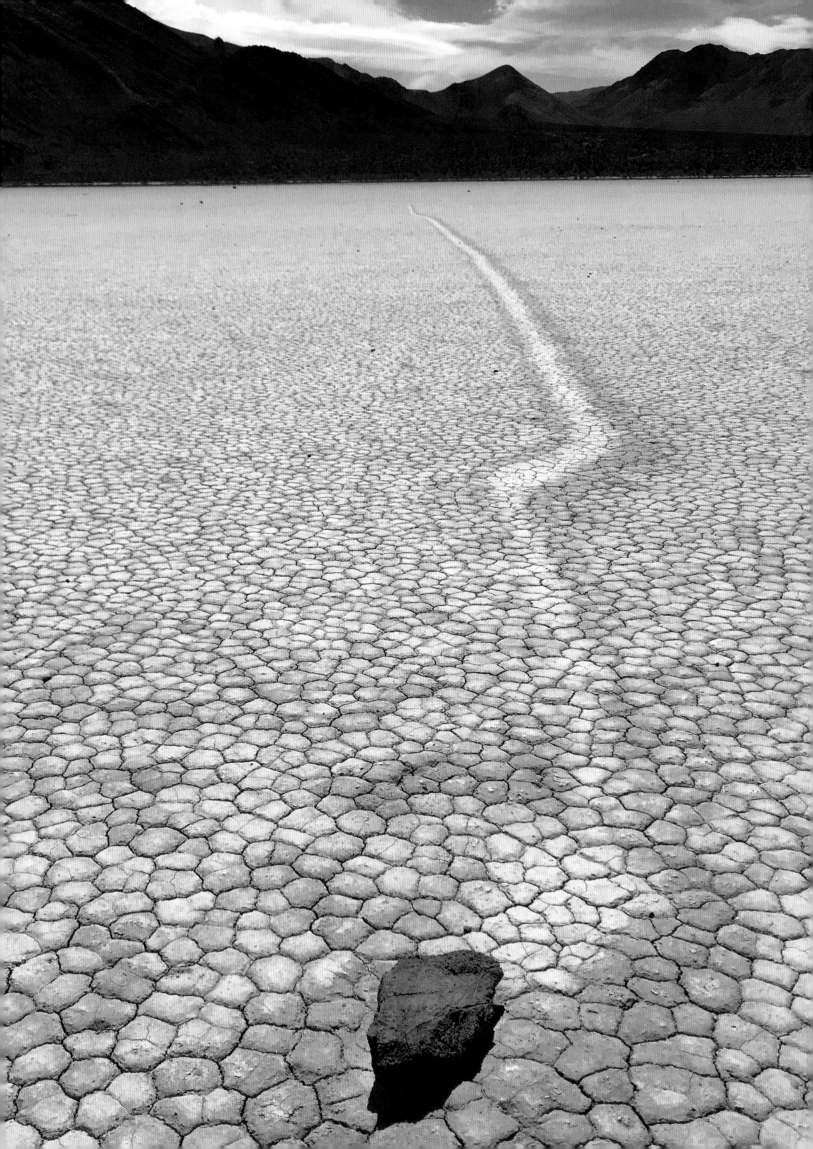

Death Valley National Park

CALIFORNIA AND NEVADA

Death Valley. The very name carries a connotation that is not far removed from the truth. The point of lowest elevation in the Western Hemisphere—282 feet—is in Badwater Basin. (The sign for Sea Level is halfway up the mountain past the parking lot.) There is a trail out onto the salt flat just past the Badwater Basin sign. It's a mirage. The trail goes and goes and never seems to end. There's nothing there except a flat trail and, who knows how far away, a mountain range. This captures the very nature of Death Valley. The largest park south of Alaska, Death Valley lies in the Mojave Desert and was designated a national park on October 31, 1994, a date that seems wholly appropriate. The park is so big, so dry, so diverse, and so absolutely cooked that there is no way to describe all there is to see. We recommend that you need to see the Sailing Stones—but only if you have the full day to get there and back. You must rent a jeep. You will be provided with a case of water, a can of air in case you have a flat, and a satellite phone in case you get into trouble. Then prepare yourself. You are about to travel at least two and a half hours along one of the worst single-lane gravel roads you can imagine. About halfway along make sure to stop and take pictures at Teakettle Junction. It is a good place to get out and stretch your legs. The hot, practical, quirky charm of Teakettle Junction will work on you when you see it. Your destination is the playa, and the sailing stones. The sailing stones, rocks that weigh anywhere from a few ounces to hundreds of pounds, travel along a dry lake bed—with no visible means or method of propulsion. They leave tracks. And they don't always head in the same direction. Some will "suddenly" turn at angles, stones will follow stones, stones will go back the way they came. Yes. It is as befuddling as it sounds.

Visit the Artist Palette. Minerals within the soil streak the hills with blues, greens, pinks, oranges, and yellows. There is more to see here than you will have time for. This park is vast, dry, and relentless, but the roads between primary locations are good. Mind your speed. From north to south, east to west, drives through this vast landscape of changing color and scorched terrain are worth every second.

- AB

**Rain Shadow and the
Racetrack Phenomenon**

Four hours into
Death Valley's back country,
96 degree desert. Springtime,

standing next to rocks that somehow,
some way,
move on their own
across this reptilian sea bed:
earth ancient as time.

Some, but not *all*,
in various stages and directions of movement,
yet still as . . . stone.

The only proof, the long tracks etched into the
Playa.

Some scientists say,
though less than two inches yearly of rain,
that it's ice that displaces these stones.
Some say rare floods are to blame.

But we
say nothing at all,
Nature, the truest religion:
that unnameable opening
between you and your God.

We look to the hills.
We walk through the rocks
as if just one could explain;
this, the Valley
in the shadow
of rain.

- kk

Racetrack at Death Valley: The Sailing Stones

We can't slow our eyes down enough.
These rocks have a pace measured in decades,
slow views even our grandparents took.

The ground seems cracked and tiled beneath our feet.
We can't measure a mile, or two, with any spackle of
certainty.
The only thing moving, far off, is the curling heat.

There are glyphs here past translation,
stories and trails only the stones know.
The boulders seem to stop en route to contemplate.

We bend over, squint, try to figure it.
But sooner or later we straighten up and look
at the dry rim of mountains around us.

The playa displays us all.
We wonder how we might be viewed from above.
In time what wake we will leave.

- AB

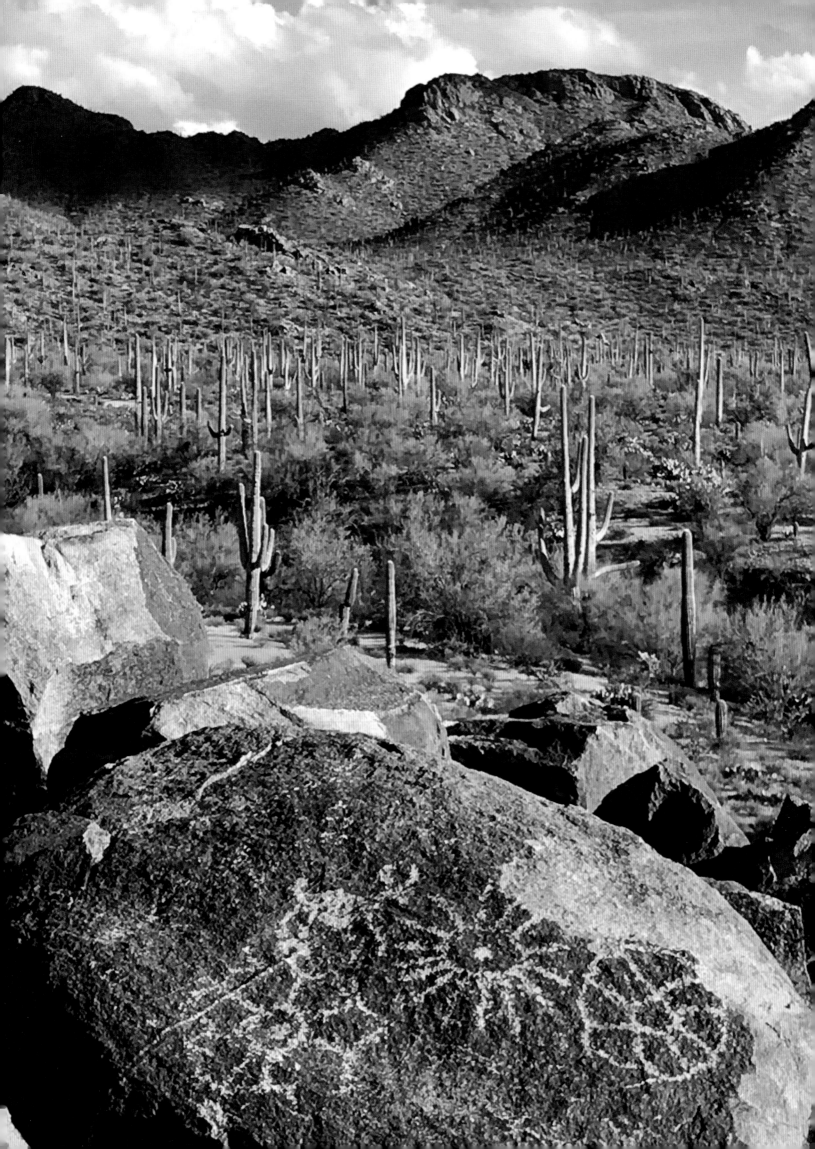

Saguaro National Park

ARIZONA

Saguaro National Park contains the most iconic image of almost all western movies: the multi-limbed saguaro cactus, standing like a prickly soldier—or like battalions of soldiers guarding the stone-rugged hills outside Tucson, in the heart of the Sonoran Desert. Between the lines of spears, the green hide of the cactus harbors animals, especially birds such as woodpeckers, quail, owls, hawks. If you are lucky, at the feet of the cactus you may also see coyotes, desert tortoise, or a gila monster sunning himself.

A saguaro may only grow an inch in its first ten years—and it may be a hundred years old before it produces its first arm. The largest cactus in North America, ten to fifteen feet tall, with multiple arms, it has withstood drought, flood, disease, and the encroachment of man. Its biggest threat is invasive plant species; there is a competition for water and nutrients that in earlier years the cactus did not face. There are more than enough drives and trails in the two units of the park, both with marked trails, to keep you occupied for several days. Walk up the Signal Hill Trail to see the petroglyphs; as you stand on top of the observation hill you will see what ancient people saw.

The ground just off the trail is its own ecosystem, so always stay on the trail. Animals depend on falling cactus, flowers, and other plants like the ocotillo and lechuguilla for home and protection, and there are snakes hiding in the shadows and under stones that you may not see until they are disturbed.

Even though the cactus can generate millions of seeds over a lifetime, very few actually sprout. This mega-fauna doesn't grow fast enough to survive disease or encroachment. Without protection, the growth would not be self-maintaining.

Above all, stay in the park until right before the sun goes down. In the thickening shadows you will swear there are voices in the tines, movement, and some type of immediate life. They are people standing there, guarding the desert, raising their arms in a kind of holy pose. The tines of the cactus seem to have a kind of nimbus, as if they are holding onto the desert light.

- AB

Pilgrimage: Saguaro National Park

It was as if we stepped back in time,
the zucchetto heads of Saguaro
holding their breath,
frozen two hundred years–
twenty, thirty, fifty feet tall–
standing sentinels
long before the two-leggeds.

It takes seventy-five years before they grow
those
candelabra arms.

Sometimes I feel as if I was born
in the wrong century;
yearning for something I'm not exactly
sure of,
this pilgrimage here,
a long, inexplicable journey for salvation.

Gila monsters rustle this lush desert floor
like orange and black slippers.
Lizards scurry from ironwood to cholla.

All the while, Saguaros stand,
as they always have,
stretched like Swiss Guards,
spears up and ready
in this tiny, holy nation.

- kk

The Scorn of Fortuitous Things

At the end of this trail, on the ridge-top, there were two benches:
One looked out to the valley and Tucson's named streets.
At night there would be dotted lines of lights.
In the clarity of afternoon it was a grid dissecting the valley.

But the other bench faced the other way,
back to the desert,
at the old green giants, waiting,
wave on wave. They didn't care about street lights.
They didn't need it. A little water, maybe a nursemaid tree
to get them started, and they would outlast us.
But no Gargantua or Pantagruel here. There's nothing ribald
and nothing satirical or crude. They never needed that.
Most of them knew our grandmas, and maybe
our grandmas before that. They'll hold up all their arms
as long as time lets them.
They know the joke
is on the other side of the ridge.

- AB

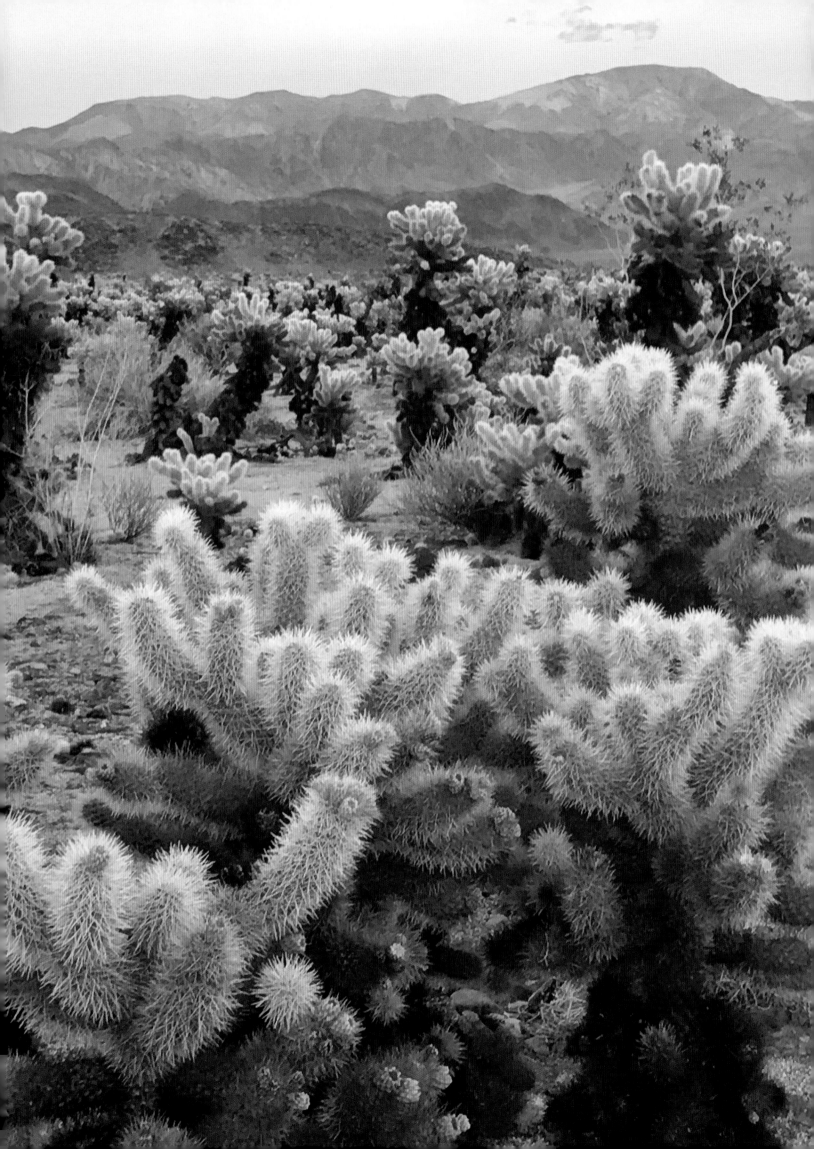

Joshua Tree National Park

CALIFORNIA

There is nothing exactly like a Joshua tree. It grows only in the Mojave Desert. A member of the yucca family, it can reach heights of up to forty feet. Its arms, or branches, unlike those of the saguaro cactus, are not uniform or symmetrical; they tend to twist and curl, and there are distances of ten, twenty, thirty feet or more between them. Allow several hours to drive through the park. There are paved roads, but many are only dirt. Four-wheel-drive vehicles or mountain bikes are recommended for those—but stay on the road. The ecosystem is fragile enough without wheels tearing up the small plant crust that might take decades to grow. The trees themselves may take fifty years to reach full height and are not as tenacious as larger, hardwood trees. With increasing numbers of visitors to this area, the danger to these unique trees is immediate.

This is a rock climbers paradise. It's tempting to climb unaided and unroped. That is workable in many situations, and downright fun. Most of the boulders are close together and stable. It is less easy to climb down—and the rocks, with few exceptions, tend to look alike. Trails and handholds, especially in dim light, can disappear. Check with the Rangers about maps for climbing. Don't over-estimate your abilities. But if you are a seasoned climber, this park is about as good as you can imagine.

Sections of Joshua Tree were used for mining. It is not unusual to find artifacts from those days: wheels, gears, rusting carts, and all manner of rods and nails. Try to figure the pieces out, but leave them in place. In a few days the wind and sand will conspire to cover them up. You may even find native artifacts. It should all stay in situ. It will be a secret between you and the park.

You'll notice as you explore there is a sharp dividing line between the two deserts. Certainly the rocks change, but the vegetation, especially, is different. There are far fewer Joshua Trees, and suddenly the terrain will be a hip-high forest of cholla and prickly pear. We can recommend the trail through the Cholla Garden, but mind the thorns. Some of these cactus have been known to throw their stickers—and they are tiny, tiny, tiny.

- AB

Pontus, karla's beloved dog. He made it to thirteen years old and thirty-one national parks.

The Rocks Speak

In the silence,
the voice of the rocks whisper
Come. Listen.

They speak of their igneous journey
up through lava–
a million years ago just a blink
in their god-days.

Here, it is *STILL LIFE WITH BOULDERS.*
It is lime green lichen
and geometrics;
rocks as rough as pebble pavement.

What faith to live beneath them,
to lie beneath them at night.

They say *Rain is good.*
Sun is good.

They say they feel the eyes
of every star in this studded night,
every slithering thing
that has sss'd across their skin.

These boulders are mountain skeletons.
They are vertebrae and femur
and the twenty-six bones of unflinching foot.

Across this world,
chaos tumbles, whips, screams . . .
yet the rocks wait for us
like the steadfast God of the West.

Come Come, they say,
The peace.
The poise.
The glorious rest.

- kk

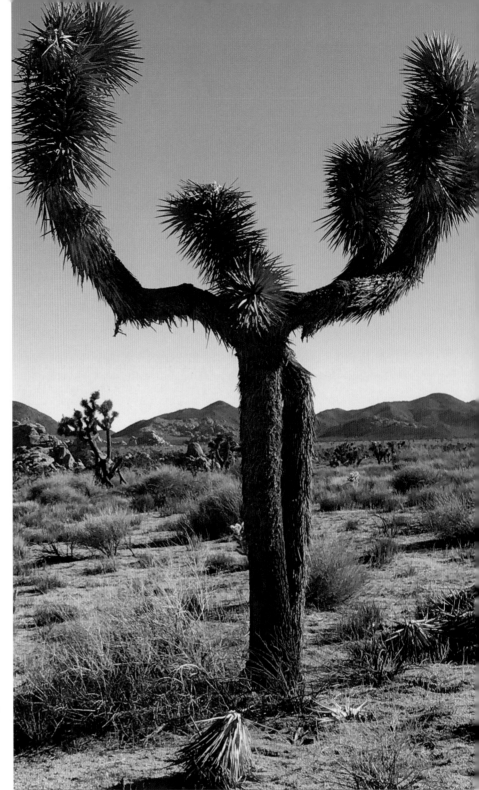

A Minimum of Direction

Well, yes, as a matter of fact,
I do agree with those of you
who are practically critical:
everything at night in this park does look the same.

Driving here she told me,
in order not to get lost,
she had tied small rags to the limbs of trees
to indicate a crossroads or turn or dip.

Something less than a map,
something more than a sign.
I guess technically it was a sign,
but she still had to interpret those dangling banners.

She was quick to point out
that of the brief, dusky, glimpses she'd had,
before ebony darkness came in
with the speed of a cheap tourist,

the boulders were unique,
like the sleeping shoulders of giants,
and the army of Joshua trees made her feel safe,
soldiers, arms bristling and waving at alert.

I have heard it said that it is relatively difficult
to sift poets out of a crowd.
The syllables make the lines of their faces
unintelligible.

It would be much simpler
if someone would assist with the scansion
of their lines, if not their faces.
It would probably be enough

if someone well-read would write little notes in the margins,
to explain the forms and indulgences.
At a minimum a moderator might have
clarifying, sticky pieces of paper passed out after the reading

that say, "This line was a metaphor,"
or "This word started the conceit
that was fully explored in the next
metal-folding-chair-twelve-pages."

Or, in this case, simply, torn little rags
that would help me climb back
over the boulders
to a fortress in the desert

with walls of stone, armed guards at the ready.
And in my lap, the perfect volume of poetry
that needed the barest minimum
of explanation.

- AB

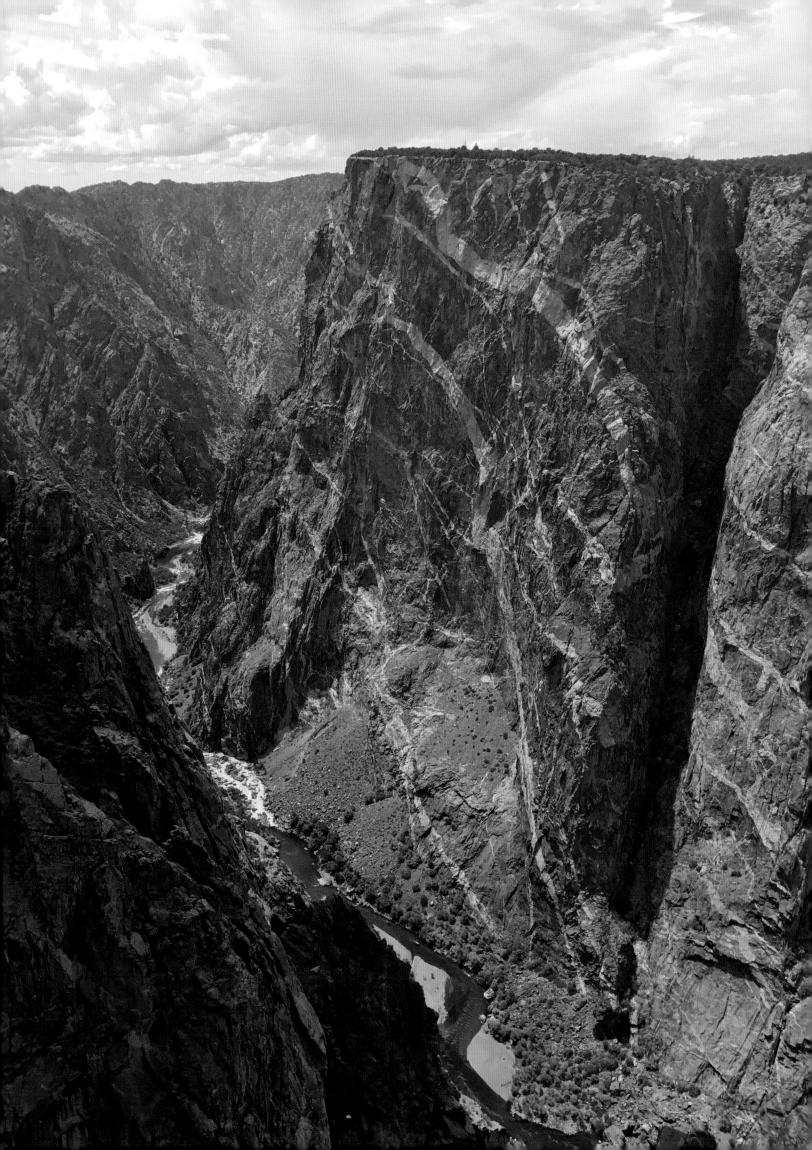

Black Canyon of the Gunnison National Park

COLORADO

There are two routes to the bottom of the Black Canyon of the Gunnison: The East Portal Road, a little over an hour from top to bottom along paved and twisty asphalt. This route dead-ends at Crystal Dam, which controls the flow of the Gunnison River. A small parking area and several picnic tables are located there. Despite the calm appearance of the water, the current is swift. The other route, less recommended, is by a trail. In some sections you need to hold onto a chain embedded in the stone—and poison ivy is plentiful.

The canyon was formed by the slow erosion of the Gunnison river through ancient rock, and the canyon gets deeper at the rate of a hair's thickness a year. Even from the height of over a thousand feet you can hear the river roar and see the white caps as the water urgently pushes downhill. Some places in this canyon are so deep that the sun only reaches there half an hour a day. The drop of the river in the canyon is steeper than the Colorado River in the Grand Canyon. The lookouts and turnoffs almost seem intimate. The canyon is right there—awe-inspiring, intimidating, and dark.

There are two main entrances to the park, a south end and a north end. There is no direct connection between the two, and the drive between can easily take two-plus hours. Views are spectacular regardless of the entrance you choose.

Probably the most iconic view is toward the south end. Over two thousand feet tall, the Painted Wall Cliff is streaked with waving lines of pegmatite that stand in startling contrast to the darker rock of most of the canyon. This is one of the most impressive sights in all of Colorado.

During the spring, summer, and early fall, driving through the park is easy. Weather controls access, especially on the north side. There are multiple winter activities, but always check with the park service first. This is one of the least visited of all national parks. It is classified as a dark sky park, so check out any available Ranger programs.

- AB

Resting in a Holy Spot:
Where White Waters Turn Still

It makes sense
this river
sounds like rain–
a fierce train
of great news.

I knew snow well,
watched it descend
muted and white;
felt the rushed way
Summer coaxed it

to confidence;
this boundless burst,
this dire flight we
swallow, coolness
sinking mouth to

belly, then banked–
to sleep like babes
stretched across church
pews, head on their
mother's hot lap;

Sunday morn
all year long,
this endless
singing; this
endless song.

- kk

Types of Falling

Others have written poems
about falling in,
but maybe not about Gunnison
and falling in at the same time.

There is falling in love
and falling for a joke
(although sometimes
they are the same thing).

There is a great scene
in The Magnificent Seven
where Steve McQueen
talks about a man falling out of a building.

It might really apply here.
There's also falling and breaking your hip,
falling off a ladder,
falling off your shoes.

Please note I am totally ignoring falling leaves,
falling stars, falling rocks,
falling rain, falling Dow futures,
or, my favorite, falling prices.

All of that other falling
will become miniscule and simply annoying
when you are stepping along the edge
of the cliff opposite the Painted Wall in Gunnison.

You will swear that
if you could only get a closer look
then you could read a message
in the waving white pegmatite lines.

It's essential to remember common sense
and gravity. Forget what Steve McQueen said.
It's best to let your en route translation
stay incomplete.

- AB

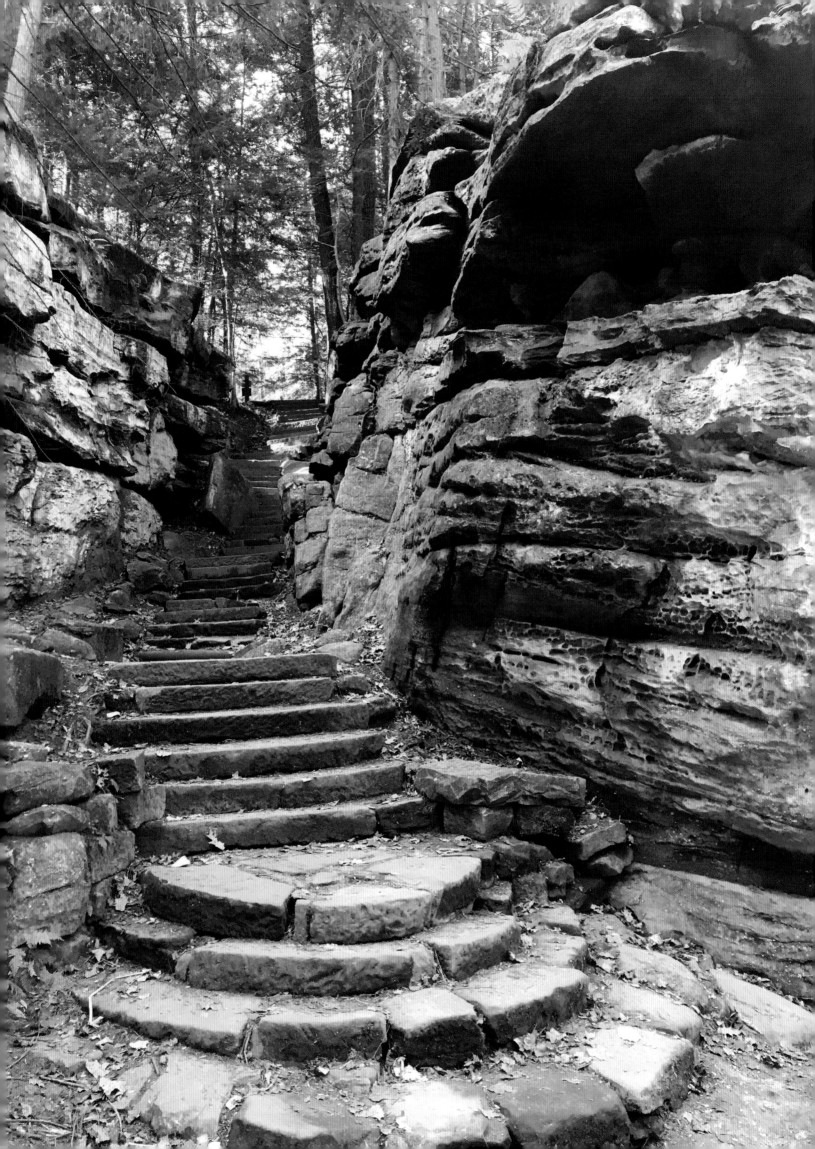

Cuyahoga Valley National Park

OHIO

Slightly south of Cleveland, Cuyahoga is a park tied inextricably to US history, or, more specifically, industrialization, westward expansion, and the Ohio and Erie Canal system. Centered around the Cuyahoga River, there are miles of hiking and biking paths. Just outside the Canal Visitor Center is Lock 38, the last operational lock in the park.

The Cuyahoga Valley Scenic Railroad will take you through forested lands of oak and hemlock—giving you a good sense of what the terrain was like one hundred to two hundred years ago. Board this at the Peninsula Depot Visitor Center. Check ahead of time for times, costs, and other boarding points.

While activities that involve actually getting in the water of the Cuyahoga River are discouraged, there are several other ways to be active and be en-tertained in the park. Go to Brandywine Falls. It is a short hike with multiple locations on a wooden pathway/platform for photographs. Spend time on the loop path admiring the accessible stone walls called The Ledges. Under the filtered light of the canopy trees you will feel removed from civilization. The main part of the trail is a loop; total walk time, without any side exploring, might take two hours. You will be able to find some time to yourself in the various stone hollows and crevices.

This park is an easily-accessible escape for the city dwellers of Cleveland and Akron. Take some time, walk the trails, and learn about the canal system that helped industrialize America.

- AB

Hara-kiri: Cuyahoga, the Lesson Park

-suicide or any suicidal action; a self-destructive act.

What steps led us here,
to a river burned thirteen times?

This was premeditated dumping,
industrial waste,
sewage brazenly loosed into the pristine mouth
of the river–
human toxicity on every level:

a deal with the devil:
yes, yes, our city will prosper >
yes, yes...our river will die.

We all live downstream.

In the Eden of our lives, we choose again
the unhinged mouth of darkness;
half a century later,
these waters *still* not safe for human or beast.

Let us put the Cuyahoga in a snow globe,
watch the settling swirl of chemical sludge,

poisoned fish,
dead birds,
decaying hides of deer;
choking brown steam in place of sky.

Let us put it on every mantel next to
photos of our heirs.
*Here, my children, this
is the world I give to you.*

What kind of people
do this with intention?
Who starves his own flock,
cripples his own adobe,
spoons cancers
to the tongue of his sons?

Sadly, the answer is simple:

We do.

- kk

Cuyahoga National Park

Sometimes we have to go to class.

The hanging clouds of chalk
obscuring our view,

sparks from a passing train
impossibly igniting everything.

Our chin sitting lazily
in the palm of our hand.

Or maybe our head lying
on the flat plane of our arm,

the fingers pointing at the birds
singing out the window.

Out there, somewhere, you can hear it.
There is a train and sparks from the iron grinding
parts,

scratching a conflagration there in the dry grasses,
the very surface of the water itself.

- AB

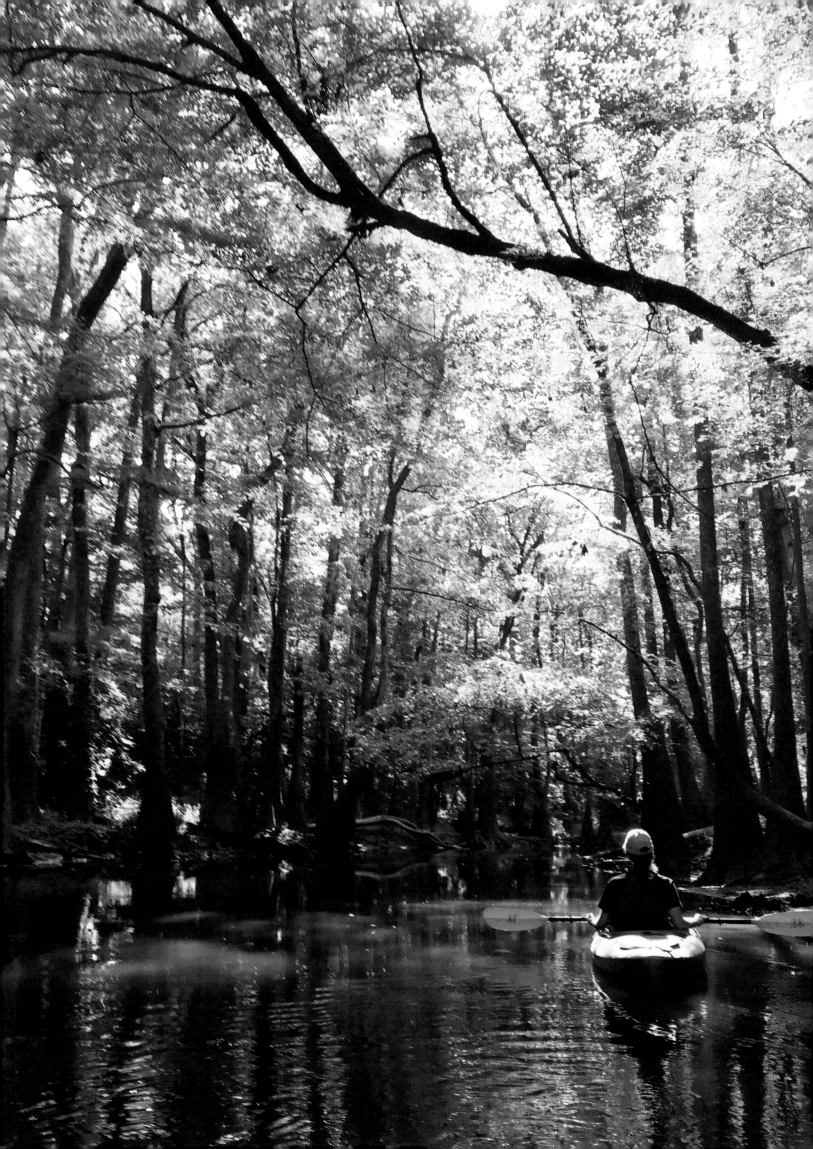

Congaree National Park

SOUTH CAROLINA

Congaree is one of the ten least-visited national parks—a shame, because it is one of the more accessible and beautiful. Cypress and loblolly pines rule the forest, with mosquitos as the defending soldiers. It was originally called Congaree Swamp National Monument, but this is not a swamp. It is a slough, similar to the Everglades—a vast area of slowly moving water.

In a few particular weeks, nature puts on a fireworks show here: synchronized fireflies. There are only three places in the United States, and very few other places on earth, where fireflies gather and blink simultaneously. As if the sheer childhood magic of fireflies was not enough, in this park they turn on and turn off at the same time. Not in a wave, not just a small population, but bright enough to make you blink. Thought to be part of a mating ritual, although no one is exactly sure, the event occurs at slightly different times each year.

There are trails through the park, many leading to giant cypress trees. If you have the opportunity, take a hike with the naturalist John Cely. He will provide much more information and insight than you will get from signs and brochures. Just outside the visitor center are trails, some of them on elevated boardwalks, some going down to the Congaree River. The light and life are different among the cypress trees. If you consider stepping off the boardwalk, it's best do so with a Naturalist or Ranger. The Dorovan Muck is deceptively unstable—and hungry. You can sink to your knees within seconds.

The park is centered around the Congaree River. Canoe and kayak tours are available and recommended. You will get to see how rich and incredibly diverse the slough actually is. Creepers, vines, moss, and cypress roots might have been in place for hundreds of years. But make sure you are adequately prepared. Just outside the visitor center is a Mosquito Meter, set by hand each day. While putting on repellent is discouraged around the fireflies, it is almost mandatory on any of the trails. Wear long sleeves, netting if you prefer, and be willing to concede your hike to the bugs if they become intolerable. If you visit during the cooler months, there will be less of a struggle.

- AB

Naturalist John Cely,
Congaree National Park.

Cedar Creek,
Deep in the Congaree

During the Civil War, escaped slaves fled to
Congaree and created communities there.
Many baptisms were held in Cedar Creek.

It's the dip of paddle
in seamless current,
the heavy need of silence.

Not knocking the kayak;
not speaking;
letting water have its way.

Turtles stretch legs
on old logs.
Warblers echo
in and out of the slough.

There are so many secrets here,
even the river cannot stay its path–

flood and death–
dark-eyed deacons
slamming the pulpit.

How many baptisms can one river hold?
Escaped slaves molding new life
from Dorovan muck and amber waters.

Devastation will always come,
so we wait for calm;
for a sun that steams off
all past pains.

The oar slides in
and up,
loosing tiny droplets.

Brown water snakes
warm in the branches.

Hushed,
we line the riverbanks,
dousing the blessed kayaks
one by one.

- kk

226

Congaree: Seeing It

Earlier in the day I had led him
down a slope of Dorovan muck
and helped him climb into the front of a
two-person kayak.

My blind friend asked me
to hold his cane while I paddled.
I described for him
the knees of the cypress,
the many kinds of ivy, the tupelo, the pine.

He stroked his face clear
of floating cobwebs, trailed his fingers
in the green water of Cedar Creek.
I told him to beware: snake hanging in a tree ahead!
He laughed but quietly said, "Where?"

Then there was night, because he wanted to,
defying mosquitos,
on the trail to see the fireflies.
We locked arms. He walked beside me,

until we reached a bench,
just off the trail, to sit.
I told him they are yellow-green
and constantly moving.
I reached out; one landed on my hand blinking.

I took my friend's hand and convinced the bug
to crawl there.
He tilted his head as if
he were looking,

his pale cloudy eyes
like omniscient moons
that hung, seeing all, over the swamp.

- AB

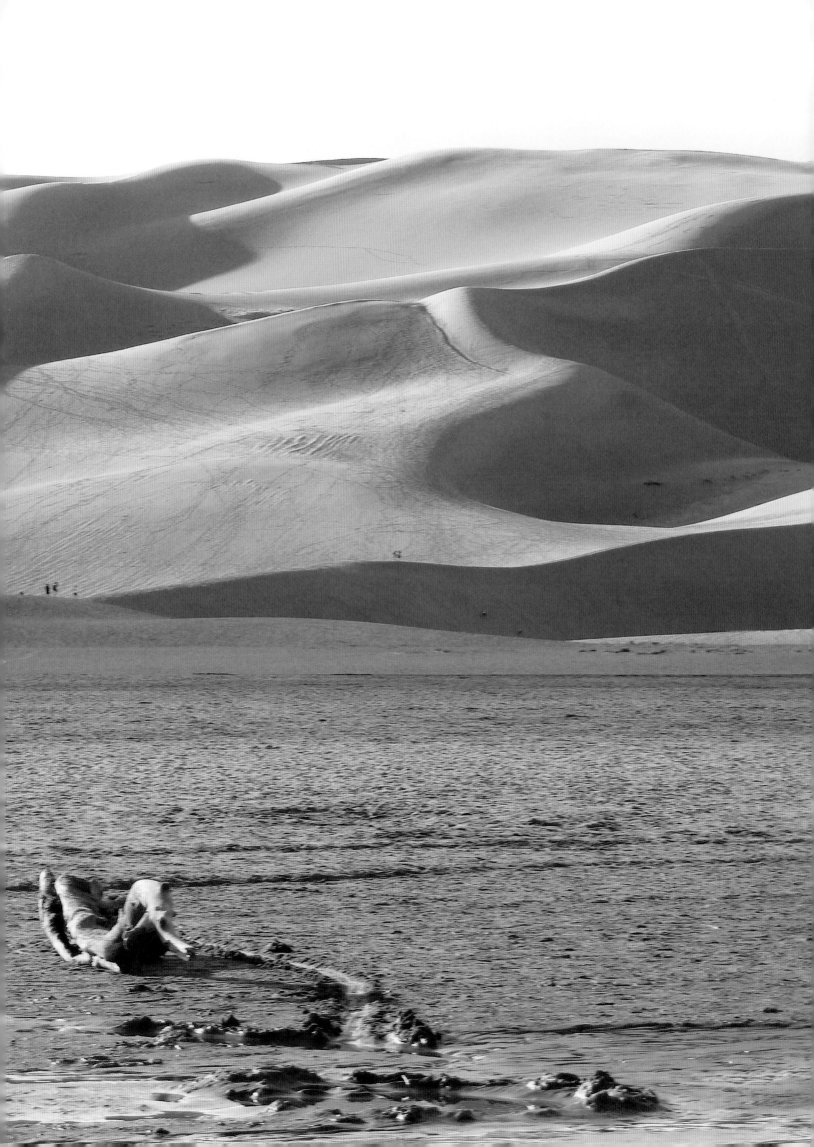

Great Sand Dunes National Park

COLORADO

The Great Sand Dunes in Colorado are the tallest sand dunes in North America. They can be climbed, but be aware that distances can be deceiving. First you need to cross Medano Creek. Then you have to hike across most of the smaller dunes to begin the climb up Star Dune. There is no path, and you will be walking uphill on sand that can reach temperatures as high as 150 degrees.

Camping is allowed in designated areas. And there are hiking trails. The most common activity is just playing in the sand, like on a giant beach. You can rent a boogie board and a supply of wax at a concession just outside the park. You carry the boogie board to the top of the dune of your choice—and slide down! You'll learn quickly that some dunes are steeper, and deeper, than others. Also remember that when you slide down, you eventually have to climb back out.

On the access road to the park is the turnoff to Zapata Falls. To get there is a fifteen-minute drive up a rough road (four-wheel drive recommended), then a half-mile walk up an uneven trail—to a shaded, flowing stream. You will probably see returning adventurers putting their shoes back on. Do not be dismayed if their toes appear chilly blue. Yes, the water is cold. To see the falls properly you need to be willing to walk into the water through narrowing stone walls.

You will pass a short distance through a cave and finally end up at the falls. The noise will fill your ears. You will begin to wonder about the mysteries of the earth where water can be forced up through stone hundreds of feet—only to fall back down again, cold, chilling, remarkably rejuvenating. You will be standing almost directly underneath the falls. You will certainly be blessed by the spray.

The Great Sand Dunes is also a night sky park with a large outdoor amphitheater. Check on the park calendar to see when there are night sky programs. We were lucky enough to watch a program during a meteor shower. The sky was full of stars.

- AB

Great Sand Dunes

Perhaps Tecumseh was born on a night like
this—
Perseid Meteor showers—

stars shooting left and upward,
zig-zag, horizontal—
pure nocturnal Poetry.

Couples lean closer under the Mexican blanket;
Frank Family wine in plastic cups;
Park Rangers reciting 1833 Leonids stories.

This is night,
and this is fire rushing forward.

We could have been watching tv,
but we were here,
Great Star Dunes sand
still in our shoes;
feet still purple from frigid Zapata Falls.

What a life
that shoots and hurls;
what a life
that screams,
even in the dark, quiet moments:

"More, God
please,
more
more."

- kk

Tecumseh is Shawnee for "shooting star."

**The Perseid Meteor Shower
and The Party Line**

When I was younger
our telephone was on a party line.
If you picked up and heard a tone,
what you knew and hoped for,

then it was okay to call the pharmacy
or plumber or a carpenter friend.
But if you heard a blank space
then someone was already there,

talking but interrupted.
They knew you were listening now.
Did they want you to know their secrets?
And did you want to hang up?

Driving to the dunes there will be
a tone in your ears. And even with
the pulse of Medano Creek
there will be that buzzing

of an incomplete something
miles and hours behind you.
Stay for the evening show
and the Perseid Meteor Shower.

Stay for the easiest presentation
the Rangers ever made:
Gathering you all in an outdoor amphitheater
they will pick up a giant black telephone,

as big as themselves,
and they will point the ear end at you
and let you hear the other voices
of sand and time and fire.

- AB

231

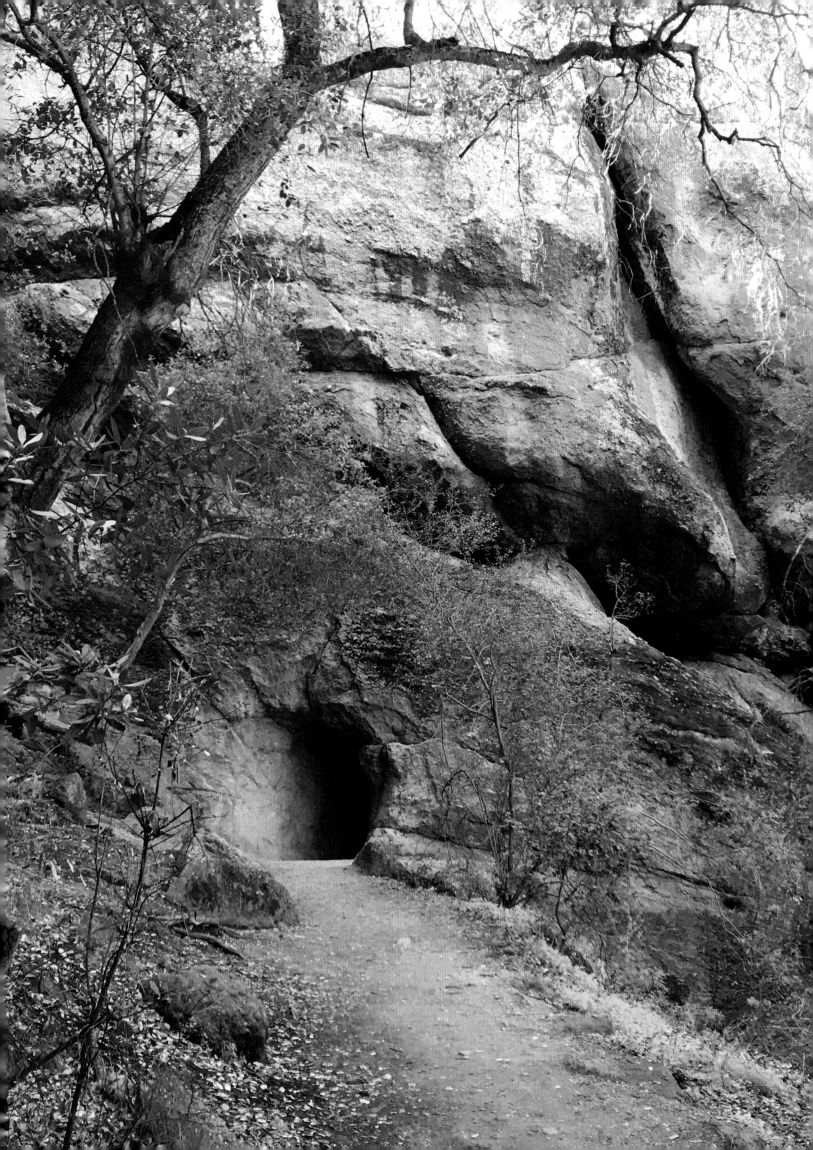

Pinnacles National Park

CALIFORNIA

A relatively new park that wasn't even on our radar, Pinnacles wasn't designated until January 10, 2013. The 27,214 acres protect and preserve not only the unusual volcanic spires created twenty-three million years ago, but thirteen kinds of snakes, seventy kinds of butterflies, four hundred kinds of bees, over five hundred kinds of moths, and larger creatures such as the mountain lion and the endangered California Condor with its nine-and-a-half-foot wing span. The condor was released in Pinnacles after becoming nearly extinct in the 1980s. To catch a glimpse of a condor stirs something ancient inside of us all.

But the remarkable, geological thing about the actual Pinnacles is the fact that they move northwest along the San Andreas Fault, toward San Francisco, two inches each year! Think about that. Two inches each year. Who could ever say that this earth is not a living, breathing entity?

It was a very wet March when we visited, and the surrounding hills were Ireland green and rolling—the perfect location for orchards and vineyards such as the delicious Chalone Vineyard, named after the Chalone Peak in Pinnacles National Park. Located just beyond the gates of the national park, we dutifully paid them a visit after our daily trips to the park.

- kk

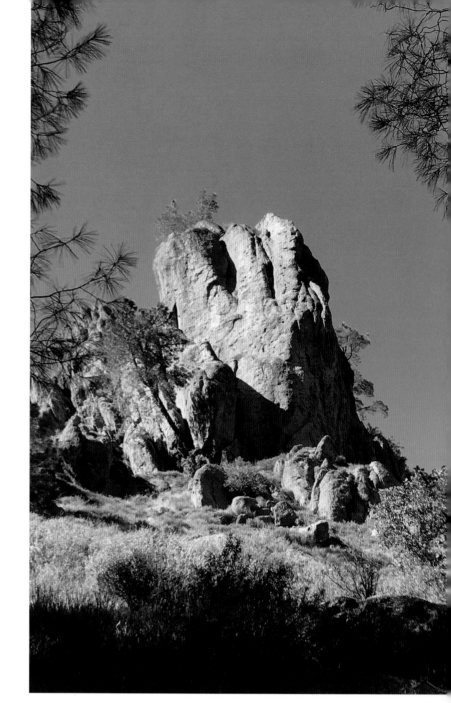

Remus Street, Pinnacles

Caesar would have killed for this place–
huge, smooth, green mountains that rival Ireland.

He would have donned a vessel,
braving eastward winds to Monterrey,
built his empire upon these rocks,

a sea of vineyards–
pinot noirs and chardonnays fit for a king;
February pomelos and minneolas
unheard of in Italy;
Condors to perch upon the Emperor's shoulder;

the Roman Empire ultimately meeting its destiny
on the San Andreas Fault.
Romulus and Remus high in the Pinnacles
and Caesar by their side
in his slow wild conquer to the north.

- kk

*Remus and Romulus are twin brothers whose story led to the creation
of Rome. They were suckled by a she-wolf. We passed Remus Street daily
en route through Pinnacles National Park.*

Pinnacles: Hiking the Talus Caves

In hindsight, how foolish was this?
We knew that the mountains moved,
and we knew that the caves were formed by falling,
but we still went.

The cave taught us a new kind of faith,
something temporary,
something that involved holding our breath,
taking what might be one last look at the sky.

Ultimately it brought us down to our knees
just to crawl out.

But there was more to the lesson.
There, there, in the sunlight
were people climbing up on ropes,
like they were ascending Babel,
their toes and fingers
cleating into fault-line stones
that might, or might not, hold weight.

I wanted to point back,
warn them, but they were smiling, laughing
at the baptizing splashes of darkness,

those gaps in the earth
that only guaranteed Fate.

- AB

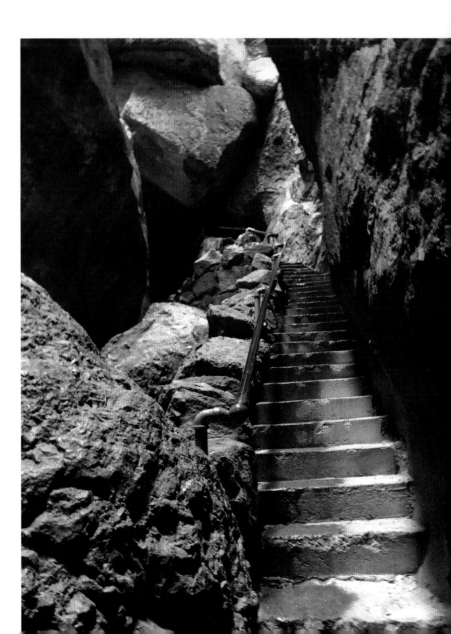

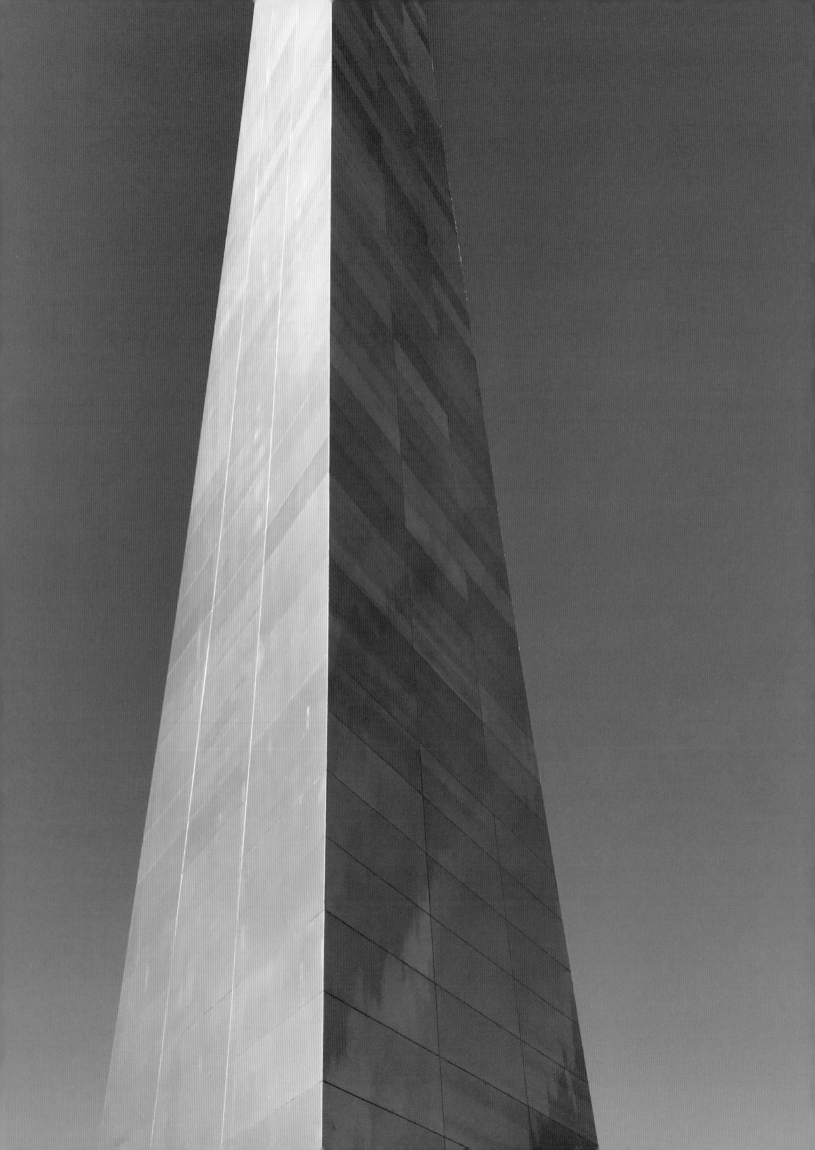

Gateway Arch National Park

MISSOURI

At the beginning of our tour in June 2016, there were fifty-nine American national parks. During our tour, three more parks were added: Gateway Arch, Indiana Dunes, and White Sands National Parks. We were curious about Gateway Arch, why it was named a park instead of a memorial, being a completely man-made structure: 630 feet tall and 630 feet wide: sixty-three stories tall. There are trams inside to ride to the top. On clear days, you can see for thirty miles, see the Mississippi River below. The Missouri River meets the Mississippi River only fifteen miles north.

The Arch symbolizes the gateway into America's West. The 1803 Louisiana Purchase doubled the size of the United States; the previous US border was the Mississippi River itself. President Thomas Jefferson knew the importance of exploring these new lands—especially to find a passageway to the Pacific Coast. In May 1804, he asked Meriwether Lewis to be in charge of this mission. Lewis asked his friend and former military commander William Clark to join him, and the campaign began. Along the way, they acquired the help of Shoshone Sacajawea, and headed west. These three are my heroes. I wear their coins about my neck. I thought of them often on this tour, espe-

cially when I asked fellow Texas Poet Laureate Alan Birkelbach to join me on our own expedition. He agreed to go with me in about thirty seconds. I wonder how long it took Clark to agree.

This park commemorates not only the Westward Expansion, the indigenous Mississippian peoples who came before, the iconic Voyageurs who fueled the fur trade down the Mississippi and Missouri Rivers, but also the expansion of American ideals in the Old Courthouse, where the Dred Scott case for freedom from slavery was heard, as well as the case initiated by Virginia Minor, the suffragette who sued to achieve voting rights for women.

On February 22, 2018, Gateway Arch was designated. Its ninety-one acres are small for a national park, but the ideals of American freedom, on all levels, are definitely something worthy of preservation and protection.

- kk

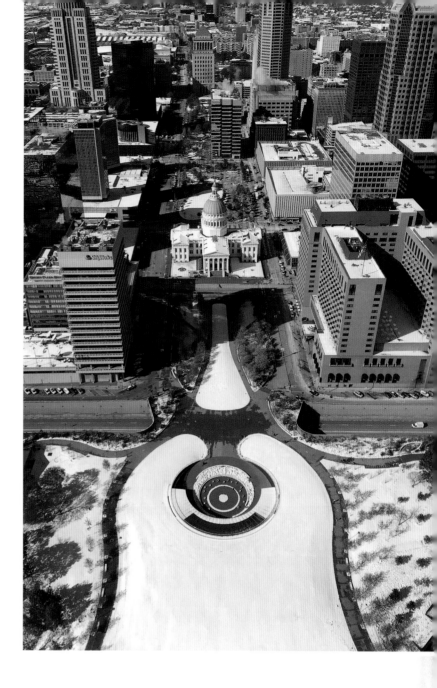

"And the Thing Was Done"
-Announced at the end of construction
of Gateway Arch

Perhaps it was the city nights,
the city lights glowing like Osage fires:

the Ni-U-Ko'n-Ska* who lived here
where the Missouri and Mississippi meld.

Still, you can feel them,
and when you squint just right,
you can still see them camped beneath
that great silver rainbow;

feel the fanfare of the Corps of Discovery
shoving off down the levy.

Were it not for Saint Louis,
there would be no Westward Expansion,
no path to these great National Parks:
America's stunning cathedrals.

Tonight, the flare and burn of meteor
lit the arch as we held our breath,

our eyes, following it
like the pointing arm
of Meriwether Lewis—*westward*
beyond city; beyond civilization—
to that unknown place we all yearn for
in the undiscovered darkness.

- kk

Children of the Middle Waters

Gateway Arch

This river is the kind of place where eyes open wide;
paddle boats and sawyers and unexpected floods.

Most folks walk around and accept the snarls in their lives,
those roots and shallows that slow them down.

Those souls can barely handle normal cargo,
the unthankful children, the little-seen spouse.

They drift like spirits, flotsam and jetsam,
something on its face floating by.

But this place, this arch is for those other folks,
those folks who rose above.

They said, "There's something else out there.
If I step out from this water and climb high enough I can see it.

I am needing, I am willing to swim, paddle, or row,
to see that land, that land of my tomorrows

in that immeasurable west."

- AB

Indiana Dunes National Park

INDIANA

At first this seems like one of the unlikeliest of the national parks, especially compared to Kobuk or the Great Sand Dunes of Colorado— yet it is one of the most biologically diverse units within the entire national park system, and, importantly, has managed to establish a balance between a nature-based park and an urban park. It sits on the southern shore of Lake Michigan and serves not only as a beach playground but also as a fascinating hiking and biking area. Here, in the Indiana Sand Dunes, the National Park Service is exactly fulfilling their mission: preserving and protecting natural, cultural, and historically significant places. Chicago is within sight to the west. Just to the east are more remnants of industrialization, and safely protected between them is fifteen miles of shoreline that is unlike any other park—alive and constantly moving.

The current high dune in the park is Mount Baldy at approximately 125 feet. It is called a living dune, meaning that it constantly moves, especially inland. It slowly but surely covers buildings, trees, and roads. In prior years, especially in the period when the park was designated a National Seashore, the public was allowed to climb and romp all over Mount Baldy. Then there was the discovery of what were called decomposition chimneys. Scientific explanations vary, but the reality is the same: sudden narrow chutes open in the sand, and, in some horrific circumstances, people literally get swallowed by the dunes. Ranger-guided hikes to the top of Mount Baldy are still available, but unrestricted access is no longer allowed. Thankfully there are still miles of safe and accessible beach for the public to enjoy.

The beach is constantly working its way onto the roadway. Be especially careful in the winter: the wind blows cold and wet onshore from the lake, and a thin film of ice can easily form on the roadway. The ice will form frozen lacework in the bushes along the shore. A beautiful sight—like delicate cold spiderwebs.

On the map, and in the travel books, it will seem far away and small. Take the drive, take the time. Pay attention to this little slice of land that is determined to have its own inexorable life.

- AB

Terminal Snow

One degree and the snow begins
its silent dazzle across Lake Michigan–
over the mastodons and wooly mammoths
that once ruled
when glaciers were all the world knew.

Could they have imagined these colors
of orange and green;
the way the snow sifts upon fallen leaves.

This, the season's first snow:
the terminal snow of summer.

And on the shore, the levees burst,
these glacial Great Lake waters
taking back dunes
time worked thousands of years to build.

In an instant, the ice melt,
the exposed earth,
then water–

the big beasts laying the last of their kind
deep beneath the snowfall.

Winds whip the waves,
the spray freezing downed trunks
along the shore;

the dunes, ever so slowly
lumbering their massive mountain of legs
back towards dry earth–
as far as this life can go;
this one, magnificent, wild ride of life.

- kk

Mount Baldy

We got there as winter
was turning spray into
ice nets that draped
from branch to branch.

We'd read ahead of time
that the dunes were reclaiming
the land beyond the shore.

We had to admire that type
of determination, something
that ignored the boundaries
of expensive yards and driveways.

At Mount Baldy there were tendrils of sand
covering both the bottoms of trees
and reaching over the road.
We were the only ones there

except for a volunteer.

Good thing they closed the dune he said.
It was moving,
devouring
what was left in those houses.

He pointed uphill
like a Greek prophecy.

His face and hands were flushed
with the mysterious cold tales
the sand only told
in passing.

- AB

2019

White Sands National Park

NEW MEXICO

Our youngest national park at this printing: White Sands, NM, was named a national monument in 1933, and a national park December 20, 2019, making it park number sixty-two of sixty-two in our "Words of Preservation: A Poets Laureate National Parks Tour." Many of us visited as children—it is still a place of family gatherings, all ages and sizes sledding down the white hills, picnicking, and cooking out. Being here brings out the child in us all.

It is a brilliant white in every direction, and is actually tiny grains of gypsum, broken down into crystals from selenite from the surrounding mountains. White Sands is home to the largest gypsum dunes on the earth and in the solar system—it can be seen from space! While ancient peoples came here to hunt Wooly Mammoth and Giant Sloths ten thousand years ago, modern man has put his indelible mark here as well. During World War II, the US Military built the White Sands Missile Range and Holloman Air Force Base in the Tularosa Basin. It seems an unlikely place for a national park: nestled between two areas of missile testing and bombing sites. The missile range was one of the major locations of the Manhattan Project, which developed the first atomic bomb: it was tested just outside the park at 5:30 a.m. July 16, 1945. Still today, visitors must check for park closures during scheduled rocket launches.

White Sands is a fitting end to our journey. All the parks still work hard to find the delicate balance between modern life and the preservation and protection of our ancient earth. The torch is now passed on. In all you do, please consider the next seven generations. That is the only way our world will survive.

- kk

We leave you here, at the end of our quest. Fellow Poet Laureate Larry D. Thomas said that just one visit to one national park is enough for most people to last a lifetime. We were given the grace to visit all sixty-two national parks. For yourself, pick one. Pick several. Pick all. Become what Alan and I call a *Quixote* (someone who pursues the impossible dream of visiting all of America's national parks). If you are open and willing, they can change your life.

Yellowstone was the first national park in the world. Now there are national parks across the globe. There's a reason for that. Man is desperately in search of serenity. Sixty-two national parks are only the beginning of wonder. May you seek it. May you find it.

See you on the quest.

- Dos Quixotes, kk and AB

How to Carry the Moon
-The White Sands are actually gypsum,
 which is crushed selenite (named for the
 Greek goddess Selene).

We see the white silks;
the billowing cloak of the goddess
as she chariots the light
across the night sky.

She rises in these winds
astride her white-winged horses.
She stirs the deep poetry of ache.

The ancient Greeks knew,
pressed selenite into temple windows
to feel moonbeams sifting through;

they knew the love of Selene and Pan:
knew that the very way the moon
gazes upon the mountains
could save us all.

Step sweetly on this hallowed ground–
shoeless as the crescent moon upon the gypsum;
the torch passed,
now ours
to carry on.

- kk

Letter from the Dunes

Is it raining there,
There in that strange place you live?

I write this letter to you as I sit here,
Watching the experimentation.

I fear I will run out of space
Before I run out of words.

Yesterday there was a wide-eyed confederacy
Of young people diving hungrily

Into what I could have told them
Was a pink thing, not a white thing,
not a white slope.

I could have told them that tomorrow
Is always pink, even for me, even now.

I saw the young people
Sliding down the dunes

On anything that would ease friction.
How could I tell them

As old as I am,
As many lovers as I have kissed,

It was the moisture in the sand
That would always make them slow down.

Is it raining there? These young people,
They do not understand water in their fingers,
belly, and brains.

I wanted to applaud and say
Yes! Try it all now! Paper, rock, sleds

Lean into it, lean away, make a track,
Follow other tracks.

No one will care about you tomorrow
I could tell them; Your tracks will be gone.

You are trying so hard to be dry and fast
I should have said.

I want to say this with a hungry certainty:
Is it raining there?

I will be home tomorrow
With a ravenous humidity.

- AB

AFTERWORD

Now that you have shared the poets' journey, which began at Yellowstone, America's first national park, and ended at White Sands, our newest, it's time for you to begin or renew your own adventure and to find your park.

While few of us can endeavor to visit every one of the sixty-two national parks that Wallace Stegner called and Ken Burns echoed in his PBS series, "the best idea we ever had . . . " we can all benefit by visiting at least one of these amazing places and hopefully, making it your own place to find renewal and wonder.

In the summer of 2018, fires were raging in Northern California and would culminate later in the disastrous Camp Fire that destroyed my home town of Paradise, California. Against that backdrop, fueled by climate change and drought, my new friends karla k. morton and Alan Birkelbach made the journey from Redwood National Park (passing through the devastation of the Carr Fire that decimated much of Whiskeytown National Recreation Area near Redding) to visit me as their host and tour guide at Lassen Volcanic National Park.

I was worried that the smoke that had dominated our skies would take away from the breathtaking alpine scenery of my favorite place on Earth, but miraculously, we had a clear day to visit the park that September day. Karla and Alan were accompanied by their publicist Kelly Kirkendoll on this one particular park trip, and we set out to explore my park.

While special to me, I knew it was but one of their amazing visits to every unit of the National Park System. On our way, I was impressed by many things. In their curiosity about everything they saw, and the note taking, and discussions they had, I knew they were collecting thoughts and impressions that would lead to their amazing poetry.

I have led many new-time visitors through Lassen Volcanic National Park—like the cast and crew of the former NPR show *Dinner Party Download*. As much as I enjoyed that experience, this was truly an experience on another level. Never had I had a more appreciative and engaged tour group than my three guests.

After showing them azure-blue Lake Helen, where the greatest amount of snowfall accumulates in California each winter, we proceeded on to many stops, but I will always remember our experience at the aptly named Devastated Area, where a series of volcanic-induced debris flows, culminated by a pyroclastic blast, wiped out the conifer forest and meadows that existed up until May 19-22 of 1915.

I especially remember the glow on karla's face when I handed her a rock, a piece of flow-banded dacite pumice from May 22, 1915. "You can't pick up many rocks with an actual 'born on' date." The response I got was heartfelt. "Wow."

In the months after our visit, nearly every week, I got wonderful postcards chronicling their ongoing journey and especially remember the ones from the Alaska parks like Gates of the Arctic. My new friends were on an epic adventure that included so many bucket-list check-offs that it boggles my mind to this day.

Fortunately, we can all experience that adventure through their literal "Words of Preservation." Many American public servants begin their jobs on our behalf, with the pledge to "preserve, protect and defend" the Constitution. I wish we would all make the same pledge to our national parks.

These treasures are under attack from chronic neglect through underfunding (while the Rangers in the iconic hats can't say that—I can) and the existential threat of climate change that is apparent to anyone who takes the time to explore and observe them over time.

Our social and natural history are bound up in the national parks.

I hope you will join me and do all you can through volunteerism, your political stances, and your support through the many conservation foundations that directly defend these places that, as Stegner reminds us to this day, are "the best idea we ever had."

For those who actively seek to undermine the federal protection of our wild places, I say unto them, as karla and Alan wrote, and country singer Lisa Carver so lyrically phrased it, just *"Go Around."*

—DAVE SCHLOM

Host and creator of Blue Dot on PRX/NPR podcasts, naturalist, and volunteer for Lassen Volcanic National Park

ACKNOWLEDGMENTS

We owe a lot of people thanks. There are too many to list, but we are so grateful to the following people and groups who gave us extra support and encouragement on this quest. It was such a big project and we met so many amazing Rangers. Each and every park was an adventure. To the following we thank you for the *extra* — but to all we send our deepest gratitude.

Pendleton Woolen Mills

Joshua Tree National Park

Guadalupe Mountains National Park

Big Bend National Park

Great Basin National Park

National Park of American Samoa

Rocky Mountain National Park

Mammoth Cave National Park

Katmai National Park

Patrick and Andrea Marshall

Entrada Institute

The Gage Hotel, Marathon, Texas

Big Bend Conservancy

Brewster County Tourism Council

Visit Big Bend

Mimi at Espresso y Poco Mas, Terlingua, Texas

Michael Martin Murphey

Lisa Carver

Kathy and Gary Brazelton

Dave Schlom

David Vela

Michael Reynolds

David Smith

Caryn Davidson

George Land

Eric Smith

Ed Welsh

Karen Garthwait

Maija Lukin

Scott Burch

Vidal Davila

Sarah Taylor

David Larson

Eric Brunneman

Greg Cunningham

Robert Alvarez

Jim Richardson

Su'a Wilson Fitiao

Reggie Meredith Fitias

Deb and Ben Malae

Wendy Ostgaard

Sandy and Allen Shroyer-Beaver

Richard and Sue Schmidt

TCU Press – Melinda, Dan, Kathy, Becca, and Molly

Charles and Dominique Inge

Tamsen Hert

Derrick Kinney

Johnny D. Boggs

J.P. Morgan

Dwayne and Machele Wilson

Kelly Kirkendoll

Coleen Spalding

And to all those angels who showed up in our times of need such as the man at Alaska's King Salmon Airport who let us use his phone, or the woman from Lubbock, Texas, who let us into her Alaskan restroom, and Santa Claus from San Antonio in Wrangell, plus, especially, our families for their unending support and patience.

Special thanks to the following entities who published poems:

Tennessee Williams Museum, Key West: "Desideratum"

Pendleton Woolen Mills Blog: "Guadalupe Mountain"

Western Writers of America Roundup Magazine: "The Bering Land Bridge and the Badlands" and "Horseback through the Badlands: The Borealis"

Boulevard Magazine: "Alaskan Mnemonics"

San Antonio Express-News/Houston Chronicle: "Enchanted"

REFERENCES

We pulled information from the Parks and Park Visitor Centers as well as

-nps.gov

-National Geographic Guide to National Parks of the United States

-59 Illustrated National Parks by Joel Anderson & Nathan Anderson

ABOUT THE AUTHORS

karla k. morton is the 2010 Texas Poet Laureate. The author of thirteen poetry collections, she is a member of the Texas Institute of Letters, twice an Indie National Book Award winner, a Betsy Colquitt award winner, an E2C Grant recipient, and a National Western Heritage Wrangler Award Winner.

Alan Birkelbach is the 2005 Texas Poet Laureate. A member of the Texas Institute of Letters, he is the author of twelve volumes of poetry and is the winner of the Western Writers of America Spur Award, the North Texas Book Festival Award, and was twice a finalist for the Indie National Book Award.

Texas Poets Laureate **karla k. morton** and **Alan Birkelbach** visited every US National Park. This map represents the order in which they visited the parks beginning June 20, 2016. This key gives the park name and the page number where the park appears in the book.

1. Yellowstone National Park, 1
2. Grand Teton National Park, 77
3. Great Sand Dunes National Park, 229
4. Mesa Verde National Park, 25
5. Joshua Tree National Park, 213
6. Channel Islands National Park, 157
7. Dry Tortugas National Park, 201
8. Guadalupe Mountains National Park, 125
9. Hot Springs National Park, 65
10. Badlands National Park, 153
11. Wind Cave National Park, 21
12. Black Canyon of the Gunnison National Park, 217
13. Glacier Bay National Park, 169
14. Denali National Park, 49
15. Wrangell-St. Elias National Park, 189
16. Acadia National Park, 61
17. Cuyahoga Valley National Park, 221
18. Great Smoky Mountains National Park, 89
19. Biscayne National Park, 161
20. Everglades National Park, 85
21. Big Bend National Park, 109
22. Saguaro National Park, 209
23. Petrified Forest National Park, 117
24. Great Basin National Park, 193
25. Zion National Park, 57
26. Congaree National Park, 225
27. Glacier National Park, 29
28. Yosemite National Park, 5
29. Haleakala National Park, 45
30. National Park of American Samoa, 197
31. Hawai'i Volcanoes National Park, 41

32. Redwood National Park, 133
33. Lassen Volcanic National Park, 37
34. Crater Lake National Park, 17
35. Rocky Mountain National Park, 33
36. Canyonlands National Park, 121
37. Arches National Park, 145
38. Mammoth Cave National Park, 105
39. Carlsbad Caverns National Park, 81
40. Virgin Islands National Park, 113
41. Pinnacles National Park, 233
42. Sequoia National Park, 9
43. Kings Canyon National Park, 97
44. Death Valley National Park, 205
45. Capitol Reef National Park, 137
46. Bryce Canyon National Park, 73
47. Grand Canyon National Park, 53
48. Voyageurs National Park, 141
49. Isle Royale National Park, 101
50. Theodore Roosevelt National Park, 149
51. Katmai National Park, 165
52. Lake Clark National Park, 185
53. Kobuk Valley National Park, 181
54. Gates of the Arctic National Park, 173
55. Kenai Fjords National Park, 177
56. Olympic National Park, 93
57. North Cascades National Park, 129
58. Mount Rainier National Park, 13
59. Shenandoah National Park, 69
60. Gateway Arch National Park, 237
61. Indiana Dunes National Park, 241
62. White Sands National Park, 245

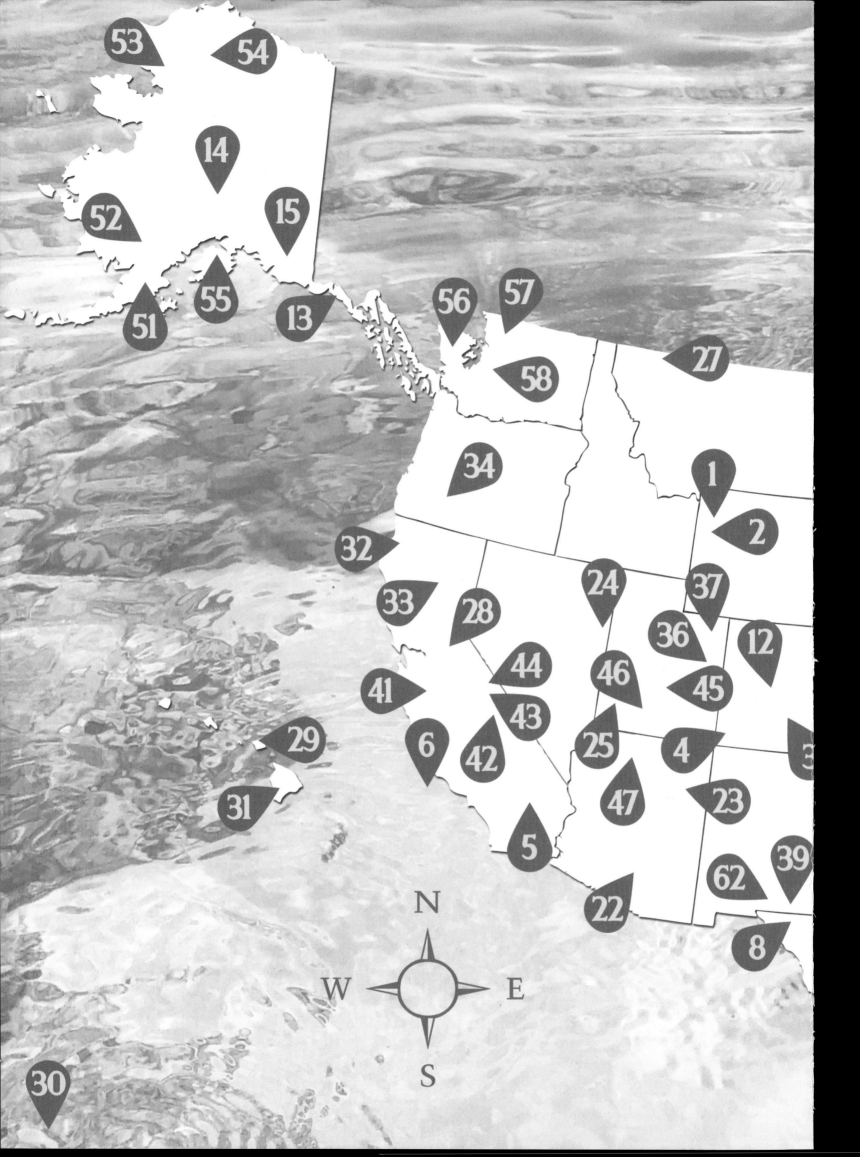